CONTEMPORARY ART IN THE
MIDDLE EAST

CONTEMPORARY ART IN THE MIDDLE EAST

**black dog
publishing**

london uk

FOREWORD

Assembling a survey of contemporary art from any region is a challenging exercise from the outset; after all, geographic proximity does not necessarily translate into cultural homogeneity, and yet for such a survey to make sense, it does need to find a wider coherence within the body of work it presents. In the case of the Middle East in particular, there is an added layer of complexity. A regular feature of news coverage in the West, it is already often reduced to a series of misleading stereotypes and, if you follow the influential Orientalist argument first proposed by Edward Said in the 1970s, this form of cultural reductionism is fairly entrenched. The challenge that faces a book such as *Contemporary Art in the Middle East* is not simply to avoid the pitfalls of these popular misrepresentations of the Middle East, but to actively confront them, and in doing so open up the incredible cultural diversity of the region in a more complex way.

There is of course another implicit premise in the title of this volume: that the Middle East actually exists as a defined geographic area. And yet it is a construction from the outside; its borders are notoriously fluid, and issues of inclusion are hotly contested. The works within these pages have been chosen through a process that has favoured inclusion over exclusion, so that the artistic 'map' that is marked out touches the very edges of the loosely described 'Greater Middle East', but it is by no means intended to be the conclusive word on which countries do or do not make up the region. Rather, in attempting to represent the Middle East, it also intends to open up the very debate that its title takes for granted.

Contemporary Art in the Middle East answers to the complexity of the region with a vibrant clash of dialogues across all boundaries. Artists featured in these pages oscillate from the established conceptual rigours of Mona Hatoum to the pop photography of Shirin Aliabadi; from the striking text-overlaid portraiture of Shirin Neshat to the restrained calligraphic minimalism of Golnaz Fathi. All rub up against each other in a collection that defies fixed categories, shifting instead through different artistic registers according to more subtle themes. It is a surprising, sometimes contradictory, yet structurally navigable collage of visual material that reflects the personality of the region itself.

The issues of representation, categorisation and distinction hinted at here have run throughout the construction of the book. Nat Muller in her introduction elaborates on these many questions and arms the reader with the tools to navigate them. Also provided are discussions that open up some of the most complex areas of artistic debate in the Middle-Eastern art world today; in order to push dialogues further, these often misunderstood contexts are given a deeper focus. Lindsey Moore addresses preconceptions and Western fascinations with issues of gender in the Middle East before moving the conversation into fresh territory with an in-depth look at the work of Zineb Sedira; Suzanne Cotter builds on her personal discussions with Lebanese artists Walid Raad and Akram Zaatari to explore the problems of documentation and history in Lebanon, and TJ Demos uses artist Emily Jacir as a case study to open up the issues of operating within Palestine both as an artist and an individual.

Finally, it is almost impossible to enter into a discussion of the cultural context of the Middle East without reference to Edward Said's hugely influential *Orientalism*, and an extract is included in the appendix, followed by an overview of the critical responses that immediately ensued upon its first publication in the 1970s. This is followed by a series of new interviews with major figures operating within the region, providing a taste of how the Middle-East art world is being interpreted through the eyes of some of its most influential commentators.

Ultimately the hope is that *Contemporary Art in the Middle East* will both deal with the many nuances of contemporary artistic representation in the region and allow the reader to consider them for themselves, providing an opportunity for new debates that move discourse into more progressive territory, so that the art, too, can be viewed from a fresh perspective. The questions raised here are designed to generate new ways of thinking; they are not intended as a final word but as a stimulus for the reader to explore further.

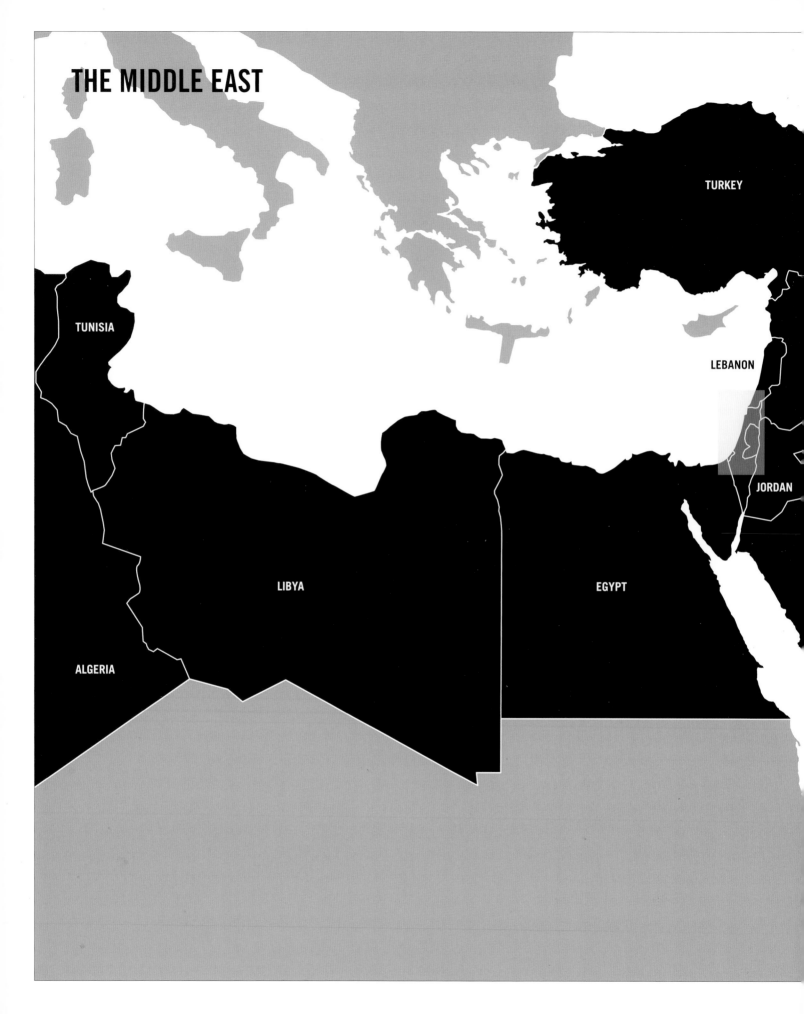

THE MIDDLE EAST

TURKEY

TUNISIA

LEBANON

JORDAN

LIBYA

EGYPT

ALGERIA

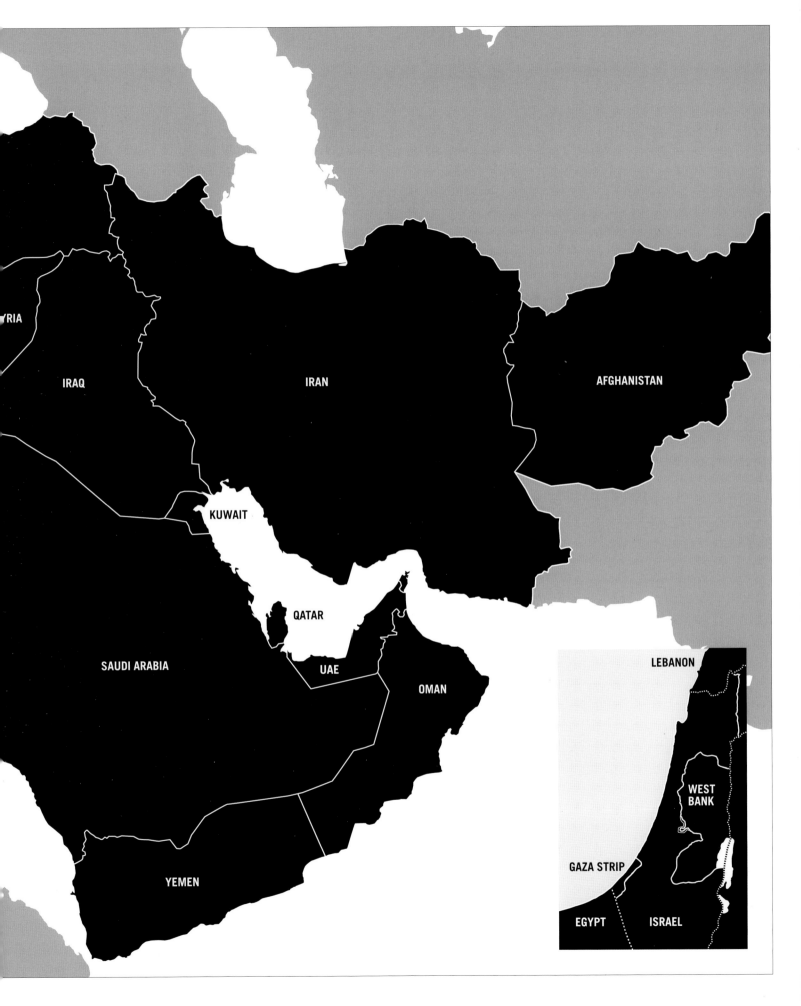

ESSAYS

CONTEMPORARY ART IN THE MIDDLE EAST
NAT MULLER

INTRODUCING COMPLICITY

Writing an introduction about contemporary artistic production from a specific geopolitical region is always Janus-faced. No matter how the author attempts to direct her readers' conditioned gaze towards looking differently and beyond the Othering eye; no matter how many arguments will be amassed to make a case for specificity and the heterogeneity of things, the author is already complicit in a game that attempts to offer the reader an epistemological framework for navigating a specific cognitive topography. Of course this is what introductions usually intend to do: contextualise an editorial process or intent, touch on tangents that will be developed further in the publication, offer an overview of issues at hand, or outline a polemic. Yet in the case of this subject matter—contemporary art in the Middle East—the gesture of offering an 'introduction' will always be contentious. It will always in part reproduce the narratives it attempts to critique, simply because even the most modest comparisons and artificial juxtapositions will be difficult to avoid. This is the case especially if the notion of the geography at hand is a contested one. The area in question here, often designated and grouped as 'The Middle East'; 'MENA' (Middle East and North Africa); the 'Arab world' or the 'Eastern Mediterranean', either for practical purposes or for ideological reasons not completely devoid of a neo-Orientalist sting, is also loose in terms of inclusion. In opening this discussion then, a necessary focus that emerges is the question of how, in a region so stubbornly defiant in the face of rigid territorial, religious, ethnic and cultural categorisation, one is to map, introduce or outline the state of affairs of contemporary art.

The past ten years have seen a growing interest in contemporary art from the Middle East. This is not least due to the founding of several seminal arts and culture initiatives. In Cairo, the Townhouse Gallery, 1998, Mashrabiya Gallery, 1982, and the Karim Francis Gallery, 1995, shook the fundaments of the art world as Egyptians knew it with the Nitaq Festival in 2000. Located across different venues within the throbbing Downtown area, remote from the government's palaces of the arts, the Nitaq Festival was a multi-disciplinary breath of fresh air, introducing a new generation of artists into the scene as well as a myriad of new(er) media, such as video and photography. In effect it induced a potential for change, and an opportunity for developing new working modes and focusing on disciplines other than those favoured by the conservative government-run institutions. Such initiatives have emerged under different circumstances elsewhere, in the form of Al-Ma'mal in East Jerusalem, in 1998, and Ashkal Alwan: The Lebanese association for Plastic Arts in Beirut, in 1994. Characteristic amongst these is a *modus operandi* that is grassroots, and geared towards the local. Only in the past five years or so have places such as the Townhouse Gallery and Ashkal Alwan 'internationalised', in part as a result of the growing institutionalisation of these ventures, opportunities in the art market and increased collaborations with European and other partners, and also as a result of a heavy reliance on foreign funding. The subtle shift from a practice that concentrates on the local towards a practice that includes the regional and the international can be traced through the Home Works Forum, Beirut's cutting-edge contribution to contemporary art debate, organised by Ashkal Alwan under the auspices of Christine Tohme. This interdisciplinary event features lectures, panels, exhibitions, film and video screenings, publications, and is organised every 18 months, when political conditions permit. Its first iteration in 2002 was titled A Forum for Cultural Practices in the Region: Egypt, Iran, Iraq, Lebanon, Palestine, Syria, and focused on the concept of dislocation amid the current political and economic climate of the region. In 2003 the 'regional' epithet was dropped and over the course of the past few years both participants and audiences have become increasingly international. A younger generation of artists

and culture workers have followed suit and founded independent collectives, galleries and art spaces featuring programming that confidently oscillates between maintaining an awareness of global art developments and catering to local audiences. Examples of these include ACAF: The Alexandria Contemporary Art Forum in Alexandria, 2005; CIC: The Contemporary Image Collective in Cairo, 2004; Makan in Amman, 2003, and the recently opened Beirut Art Centre, 2009.

Nevertheless, many cities still fail to deliver a choice of venues offering diverse platforms for contemporary art. Most opportunities to show contemporary art are still nestled within festivals and thus remain ephemeral. Cairo boasts an international Film Festival, a (qualitatively poor) government-sponsored Biennale, and Photo Cairo, a festival with an emphasis on photography and visual culture. The precarious political situation in Palestine has made it difficult to organise large-scale projects, yet initiatives such as the Riwaq Biennale for Art and Design have been seminal in offering a podium for artistic discourse, practice and exchange. Recently the Gulf has been trying to catch up on its rub with contemporary art in the form of Abu Dhabi's much-reviled cultural prestige project on Sadiyaat Island (which is set to include a Louvre and Guggenheim), the Art Dubai Art Fair, established in 2007 and held in the luxury beach resort of Jumeira, and the revamping of neighbouring Sharjah's 20-year old Biennial by its visionary new president Sheikha Hoor Al Qasimi and its artistic director, East-Jerusalem's Al-Ma'mal founder Jack Persekian. Despite the global crunch—with Dubai being especially hard-hit—the competitive culture wars and extravaganza between the individual emirates continues with The Abu Dhabi Authority for Culture and Heritage (ADACH) launching its platform at the Venice Biennale in 2009 (curated by renowned French curator Catherine David), and the UAE Pavilion also at Venice (curated by Swiss Iranian curator Tirdad Zolghadr).

Having said this, the generic image of the Middle East, known to the West from 'bad news', wedges artists from the region in the rocky power dynamics of playing into expected perception and representation, and countering the latter. In catering to a local audience there are subjects and media that are off limits, sensitive or prone to censorship, and conversely when addressing an international audience, artists from the region are expected somehow to personify the historical and national(ist), as if their practice were only valid with a country code attached to it. In addition, when engaging with the international art world, they also face what Egyptian academic Dina Ramadan has called the "objectification of the artist". Ramadan argues that non-Western artists are stripped of their individuality and are expected to act as a mouthpiece for "the collective" (the Arab, the Muslim, the Egyptian, the African, the Other), as well as being caught between having to represent enough "modernity" and "authenticity", while maintaining a balance so as to avoid accusations of "imitating the West", or of folklore. Recent exhibitions certainly prove Ramadan's critique on "the collective". In the past few years Europe has seen a number of exhibitions focusing on contemporary art from the 'Middle East'. The most well-known here are DisORIENTation, Berlin, Haus der Kulturen der Welt, 2003; Images of the Middle East, Copenhagen, 2006; Arabise Me, V&A, London, 2006; In Focus, curated by Predrag Pajdic, London, 2007; Catherine David's recent Di/Visions, Berlin, 2007–2008, and Unveiled: New Art from the Middle East, Saatchi Gallery, 2009. Similar to the large Balkan exhibitions held at the end of the 1990s and the beginning of the millennium, these large regional exhibitions serve to introduce the public to contemporary artistic production from the Middle East, and aim to provide contextualisation by means of lectures, debates and film screenings. Quite different from the Balkan exhibitions, though, is the fact that in a post-9/11 world, with xenophobia and Islamophobia steadily on the rise, the stakes of perception and representation are higher and more heavily charged.

Other exhibitions have focused more narrowly on specific countries or cities, wherein the exhibition titles speak for themselves: Catherine David's project Contemporary Arab Representations, 1998–2006 (covering respectively Beirut/Lebanon, Cairo/Egypt, Iraq); Cairo Modern Art in Holland, 2001; Dream and Trauma: Moving Images and the Promised Lands, Berlin, 2005; Out of Beirut, Modern Art Oxford, 2006; The Present Out of the Past Millennia / Contemporary Art in Egypt, Kunstmuseum Bonn, 2007; Fokus Agypten: Past/Present, Hildesheim, 2007; Cairoscapes,

Berlin, 2008. While these projects certainly have their merits, their mere scale and point of departure encapsulates their flaws. Too big and comprehensive to make a strong artistic statement, they end up homogenising instead of diversifying. In addition, though heavily curated exhibitions, by their format and inception they can quickly be perceived as being representative of artistic production of a particular scene, when in reality they merely show a selection, dependent on the curator's personal preferences and contacts. The by-product of a 'representative' approach—intentional or not—is that a canon is created. Art from the region is brought to Europe and the lens through which it is viewed—or the pre-conditioned gaze, if you will—is one of Otherness. Often particular topics are stressed, such as the position of women, (the lack of) democracy, and Islamic iconography. It thus often ends up institutionalising that which it aims to critique: a neo-Orientalist bazaar, where the goods become indistinguishable, because they are all exotic. Even if excellent work is being shown, these exhibitions often veer from the 'celebratory' to the 'didactic', wherein individual subject and aesthetic positions are difficult to reinforce. Moreover, politics and other societal issues seem to override multiple interpretations, so that the reading—by corollary—is turned into a collective 'Arab' or Middle-Eastern one. Perhaps these exhibitions are a necessary evil, yet if we want to lay out conditions of focusing on a contemporary practice, we have to look further and beyond the identitarian markers of ethnicity, politics and geography, important as they may be, and let the art first and foremost speak for itself—or in other words, let the socio-political and historical undercurrents speak from the art, rather than the other way round.

A SUBJECTIVE ART MAP OF THE MIDDLE EAST

Palestinian-Jordanian artist Oraib Toukan seems to have picked up on the West's desire to reshuffle conceptions of the region on a continuous basis. In her work *The New(er) Middle East*, 2007, she reminds us that the whole region has for centuries been subjected to foreign rule and partitioning —under the Ottomans, the French and British mandates, and most recently through the political and economical meddling of the United States. In the form of a playful puzzle, consisting of nation states represented by white foam magnets, she offers us the opportunity to reorganise

our map and interpretation of the region. Whether we start out with a blank territorial map with only Palestine and its 'undetermined' status as fixed and unmoveable, or whether we reassemble the scenarios of our predecessors, the countries—stripped from their political and regional context—become hard to recognise and are reduced to meaningless objects we can shift around in our composition. Our moves appear to be inconsequential, yet with every gesture we *de facto* do create an alternative vision and geopolitical blueprint of the Middle East. Extended to the realm of artistic practice, we could view Toukan's work as a navigational tool which reminds us that the topography of our decisions, and the meanings we create through them, is never innocent, as much as no map is ever neutral. In this respect it is also important to note that any introduction to art in the Middle East will, at some point or other, also have to deal with what is 'off the map', and not *in* but *on* the outside. Here the diasporic and exilic experiences of artists of and from the Middle East, and the subsequent narratives they produce, are a factor that must be reckoned with, especially in the case of Palestinian, Lebanese and Iranian artists.

Beirut-based arts and culture journalist Kaelen Wilson-Goldie has pointed out that within contemporary art in the region, there is a preoccupation with "engaging history and memory on the one hand, and reactivating the urban and the cosmopolitan on the other".[2] In the case of Lebanon, barely any local funding for the arts is available beyond that provided by private sponsorship and international donors—the first Lebanese Pavilion at the Venice Biennale in 2007 was erected with a $100,000 budget, all private Lebanese and Italian money; not one ministerial pound went into the venture. Suffering bouts of protracted political crisis and sectarian tension after the assassination of former Prime Minister Rafiq al Hariri in 2005, the echoes of Lebanon's Civil War of 1975–1990 still reverberate through the episodes of instability and a general lack of (functional) institutions. This is reflected to a degree throughout the art scene, where its capital Beirut—though an art hub for the region and beyond—is still very much in need of more versatile contemporary art venues. Art manifests itself habitually in ephemeral festival contexts or sporadic projects. The Lebanese state

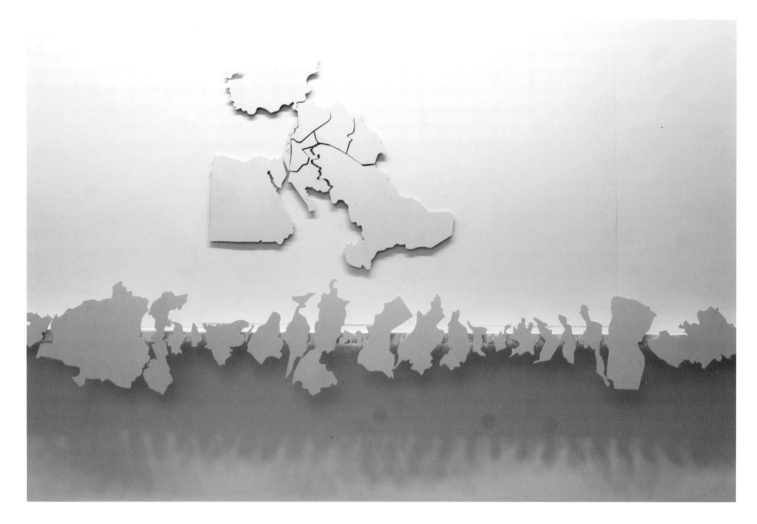

has consistently failed to provide narratives and take a historical responsibility with regard to the Civil War, even after the Ta'if Accords, which ended 15 years of civil strife in Lebanon. Many Lebanese artists such as Akram Zaatari, Tony Chakar, Lamia Joreige and Nadine Touma have been dealing for over a decade with the ghosts of the Civil War and the nation's amnesia that ensued, by exemplifying a wilful stubbornness to excavate personal and collective memory and tell narratives that have become sedimented in the rubble of destroyed buildings. Artists such as Walid Raad, Khalil Joreige and Joana Hadjithomas, Rabih Mroué and Lina Saneh explore the slippery line between the mediation of historical truth and the instrumentalisation of truth fabrication. It is here where the tricky relationship between fact and fiction is examined. Their relation to their medium and the value of the document as a conveyor of information is always a cautious one. Inherent in any kind of mediation is a *double entendre*. For example Rabih Mroué's video *Face A/Face B*, 2001, takes as its base a cassette recording of 1978, sent to the artist's brother who was studying in the USSR. The audio message alternates between a personal photo archive and Mroué's voice-over. Sound is always heard without images—the screen goes black, and images are shown without sound. By using a fragment of personal history, the work simultaneously deconstructs the medium used for the piece (video, where moving image and sound come together—here torn apart),

and its limitations. It is clear that any technology used to convey intimacy and a deeply personal narrative is *a priori* inadequate and fabricated. A younger generation of Lebanese artists, such as visual artist Mounira Al Solh, photographer Randa Mirza, performer Ali Cherry and audio-visual artist and musician Raed Yassin, are experimenting with different formal and aesthetic languages to express political and identitarian matters, which vary from the mundane and the integration of pop culture, to the self-reflective gesture of questioning the role of the artist within the (art)world. The short video pieces of Ziad Antar, in particular, refuse to engage with anything directly political. His pieces are all about the performative, and to an extent the illusion, clumsiness and rehearsed nature of performance. We see this in *Tambouro*, 2004, where the artist slaps a beat to his chest in the shower, *Wa*, 2004, wherein two kids sing to a synthesiser, or the brilliant *La Marche Turque*, 2006, and *La Corde*, 2007. In *La Marche Turque*, a pair of hands play Mozart's *Turkish March* on a sound-muted electric piano; all that can be heard is the rhythmic thumping of the keys. In *La Corde*, a young man is rope-skipping. At first his movements are simple, but as they grow bolder and more complex, every time he gets entangled in the rope, he sheds a piece of clothing: a kind of rope-skipping strip poker. Both exercises somehow seem futile: music without sound; an endless loop of unsuccessful skipping experiments. But it is precisely the

absurdity of these failed efforts in the absence of any objective that makes Antar's pieces so enthralling, playfully commenting on the Lebanese contemporary condition of political stasis, failed performances of governance and power-sharing experiments. Politics are played out on a micro-level here, and they are inextricably linked to the rehearsal of a performative illusion.

Whereas the Lebanese suffer from a 'de-institutionalisation', it can be said that the Egyptians suffer from an 'over-institutionalisation'. A nasty remnant of a failed Nasserite nationalist project stretching well into the soft dictatorship of the current president Hosni Mubarak's reign (since 1981), Egypt's institutions are plagued by bureaucracy, inefficiency, cronyism, over-staffing and corruption. So, too, for the government-sponsored arts institutions such as the old-fashioned sculpture and painting-oriented art academies, the dilapidated museums and contemporary art spaces. In contradistinction to Lebanon, the State does support culture. Egypt was, and still is to this date, the only Arab and African country with a permanent pavilion at the Venice Biennale's Giardini. Their participation even won them a prize for best pavilion in 1995. Nevertheless, the

rift between the conservative scene patronised by the state and the largely foreign-funded 'independent' scene has produced a fragmented artistic community, which eventually works to the detriment of artistic merit at large. In addition, articulations of the contemporary within an Egyptian context are weighed down by an epic Pharaonic past, and an equally epic dream of pan-Arab modernity and independence, personified by the republic's second charismatic president Gamal Abdel Nasser. Also reductive tourist and Orientalist imagery of Cairo as *Oum el Dunya* —the Mother of the World—have not aided in engendering more complex and layered understandings of Egypt as a cultural capital. It seems as if many Egyptian artists are attempting to work through the present by opting for a mechanism that hybridises the nostalgic with the current. Khaled Hafez blends present-day superheroes with ancient Egyptian gods in his painting; Huda Lutfi on the other hand operates as an urban bricoleur, piecing together everyday objects from perfume bottles, dolls and junk found at the Souq el Gumaa (Friday flea market) with female iconography from Ancient Egypt, pop culture and Indian culture. Notable also is a fascination with trying to fathom the sprawling urban metropolis of Cairo, as articulated in

the work of photographer Maha Maamoun who takes issue with tourist images of the city; visual artist Hala El Koussy, who becomes an urban narrator capturing the city's ambiances; Lara Baladi, who critiques image-making, or Ayman Ramadan, who integrates Cairo's invisible working classes into the gallery context. Others, such as Tarek Zaki, Basim Magdy and to some extent the more recent work of Hassan Khan, have consciously refused to make any clear references of locality and Egyptian history in their work, concentrating instead on a conceptual imaginary.

Inter-regional mobility, or simply the lack thereof, is a problem most culture workers suffer in the Middle East. The obstruction of movement is of course exacerbated in the case of the Palestinians, where closures, travel bans and road blocks make mobility under occupation increasingly difficult and painful. Developing and maintaining a cultural scene requires a minimum of mobility on the part of audiences and artists, of people coming in and people going out. In Palestine there is a strong artistic tradition where the post-*nakba* generation of artists, such as painters Sliman Mansour, Kamal Boullata and visual artist Vera Tamari, have been highly influential[3]. Overriding themes within current Palestinian practice—be that in Palestine, within the Israeli Green Line or in the diaspora—stem from the harsh reality of living under occupation: displacement, exile, memory, violence, identity, loss and home. Due to the democratisation of video, in cost and production, and the relative ease of distribution (DVDs can be sent by courier when physical mobility is constrained), video art and short film have gained much popularity amongst the younger generation of artists. Visual artists Jumana Abboud and Rana Bishara mix the performative in their video or mixed media installations, while photographers Rula Halawani and Ahlam Shibli have earned international acclaim. Fed up with being cast in the role of either the victims or the terrorists, in mass media on the left and on the right side of the political spectrum, there is a generation of Palestinian artists who have placed the quandaries of perception and representation, and their subsequent roles as artists and as Palestinians, at the core of their work. Their main strategies come by means of humour, hyperbole and futurologist projections. The work of Larissa Sansour, Jumanna Manna and Wafa Hourani

are just some such practitioners. Whereas many Lebanese artists in effect perform an active archaeological act of memory retrieval in order to understand and explain the present with an inward look, Palestinian artists—with daily life and art 'under occupation'—often perform a gesture of remembrance and exegesis turned outwards, so that the rest of the world will not forget their plight. Also here the archival is of importance, as in Emily Jacir's ongoing project "Material for a Film", started in 2004. On the one hand it operates as a homage to the Palestinian author, translator and activist Wael Zuaiter (assassinated by Mossad agents in 1972), wherein Jacir meticulously shows and documents Zuaiter's personal belongings, but on the other hand it also effectively reclaims an artistic history and legacy that has been brutally smothered and is to this date still being curtailed under Israeli occupation. Conceptual artist Khalil Rabah, on the other hand, has in his fictitious museum project *The Palestinian Museum of Natural History and Humankind*—which names, archives and catalogues Palestine's natural and cultural heritage— brilliantly redeployed the museum as an institutionalised site of power and authority, for an art project that is eventually highly political in content.

If the above has tried to indicate and briefly contextualise modes of artistic production and their respective conditions from a perspective of geography and socio-politics, then how can we think through the latter by departing from the works themselves? Indeed, as Lebanese artist and architect Tony Chakar has commented in an e-mail conversation with Stephen Wright, "Could art find its territory in these uncharted territories of difference?"[4] In other words, is it possible to discuss the production of meaning by challenging aesthetics, medium, theme and format, and other methodologies, before bringing everything back to the sphere of the historical and political? The remainder of this discussion will dwell specifically on artistic strategies that, either by implosion or eruption, counter-poise stereotypical and clichéd forms and means of representation. Whether subtle, confrontational or humorous, or on a meta-textual level or in-your-face, these strategies dissect the anatomy of a semiotic system which is *a priori* biased and tainted. In many cases the ideological scripts are laid bare by implicating the spectator in a power struggle

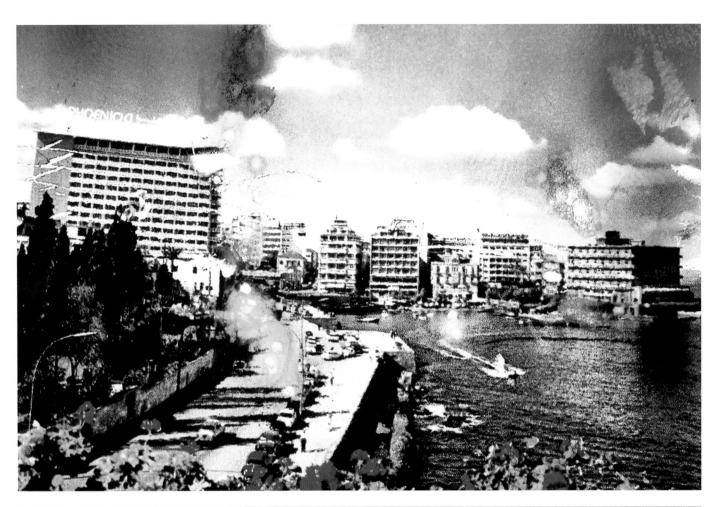

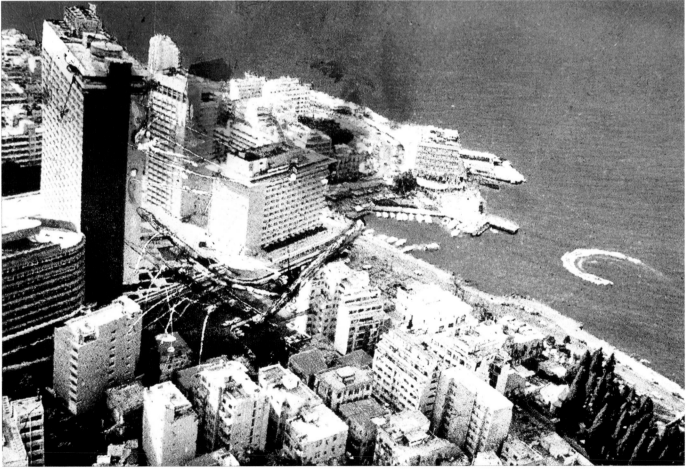

between perception and representation: responsibility and agency are in the eye of the beholder. Media images in, from and of the Middle East seem terribly monochrome, more often than not regurgitating undifferentiated tales of violence, conflict, fundamentalism and bloodshed. How then to make these images specific, or undo them, or offer that which lies in the interstices of what can be experienced, heard and seen, and cannot be subjected to a monolithic reading?

THE IMPOSSIBILITY OF REPRESENTATION
AND THE FETISH OF THE REAL

It seems as if the artist and filmmaker duo Khalil Joreige and Joana Hadjithomas have made the aforementioned the thesis of their latest feature *Je Veux Voir*, 2008, starring the French cinematic icon Catherine Deneuve and Lebanese actor and artist Rabih Mroué. A road movie to the battered South of Lebanon after the 2006 Israeli July war, but also a meta-text about filmmaking post-war, the work documents how the fictional space of cinema bleeds into the real. In effect, it grapples with the impossibility of really being able to 'see anything' after disaster, and eventually it shows us nothing. The fact that this is a feature film, that is, the medium of cinema, starring Catherine Deneuve as herself, eerily fictionalises the plot. The depletion of images and the impossibility of meaningful representation is something that also occurs in previous projects of Joreige and Hadjithomas. For example, their well-known series *Wonder Beirut: The Story of a Pyromaniac Photographer*, 1998–2006, show us postcard images of photographer Abdallah Farah who published a series of postcards in 1968 highlighting notable tourist destinations and the once-extravagant hotels along the Lebanese seaside. During the early stages of the Lebanese Civil War in 1975 the photographer started burning the negatives of the photographs, mimicking the city consumed by fire. Here again, the choice of medium, the postcard, the snapshot carrier of utopian perfection and desirable reality, the prime vehicle for the tourist and orientalist gaze, is turned inside out, and in the process collapses. Its function has become completely altered. Whether Joreige and Hadjithomas question the iconography of war in cinema or photography, in their work they develop an uneasy relationship between fictive scenarios and what could have been real. Temporality becomes scrambled and echoes

of the Civil War bleed into the current day. Yet what characterises the work is a refusal to fetishise the real.

A similar strategy is undertaken by Iraqi artist Adel Abidin in his video installation *Common Vocabularies*. Here he illustrates the instance when the spectator ceases to comprehend anything of what is by default an incomprehensible situation, namely war and occupation. Abidin's refusal to provide us with meaning comes to the fore when the logic of language collapses. A looped one-channel video shows us a seven-year old Iraqi girl, not a native speaker of Arabic, as she struggles to pronounce a dictionary of war uttered by a male voice: "massacre", "suicidal", "ration share", "elections", "terrorist", "fucking bad luck", "improvised explosive device", "hegemony", "occupation", "reconstruction", and so on. This is indeed the international common vocabulary of violence, known to most through the news feeds, not through experience. The tongue-twisting is almost comical, but is in effect a repetition and cyclical rehearsal of horror without content; these words have become devoid of meaning, and have morphed into soundbytes to which we have become accustomed. In that sense, the deliberate refusal to couple linguistic signifier with its image, offering instead just the one screen-shot of the most innocent of messengers—a child—is a refusal on the artist's side to engage with generic imagery. Again, linguistic and visual representation have become inadequate. Accompanying the installation are stacks of take-away cards with the key words written in Arabic script, their phonetic Latin transcript, and English translation. The cards' uniformity and disposability signal the incapacity of language to genuinely express the traumas of war, and simultaneously remind us of their short-lived, expendable news value.

Palestinian photographer Tarek Al Ghoussein confuses notions of the exilic, the refugee, the possibility of flight and the weight of obstruction using stereotypical perceptions of the Palestinian as terrorist or *fedayeen* ('freedom fighter'). Born in exile in Kuwait, and now resident in the United Arab Emirates, Al Ghoussein's photos encapsulate the essential properties of the diasporic: hope and obstacle. In his striking *Self-Portrait Series*, 2002–2003, Al Ghoussein depicts himself as a lone figure wrapped in the emblematic

keffiyeh (traditional Palestinian headdress), appearing out of place in the nondescript locations in which he finds himself, whether he walks down a sand hill demarcated by red tape, stands in front of a tunnel blocked by heaps of sand, or walks briskly past a truck, a boat, a plane or a house in ruins. The sense here is simultaneously one of menacing potential and of incumbent stasis: should he be read as the quintessential terrorist, hijacker, suicide bomber, or as a refugee in his own country (or another), whose mobility is curbed? Al Ghoussein suggests it can be both or neither. In later work Al Ghoussein writes himself increasingly out of the image, and in his *A, B, C Series* of 2004–2007, he depicts slabs of concrete, walls, mounds of sand and tents. These conjure images of the Separation Wall in Palestine, refugee camps, checkpoints and immobility, yet they can again be read differently too. Instead of solely viewing these places as sites of obstacle, we can also view them as sites of construction—in a metaphorical sense, but also within the context of the building frenzy in the UAE. It is this ambiguous symbolic value that can be attributed to Al Ghoussein's nondescript loci that constitutes the forte of his work.

THE URBAN VERNACULAR: THE CITY AS METAPHOR

Cities such as Cairo, Beirut, Baghdad, Tehran, Jerusalem, Ramallah, Dubai and Damascus invoke a whole legion of connotations, ranging from the historical, the Orientalist, the touristic, the religious, the imaginary, the political. The urban within this context can never be perceived as just a location: it is also a condition, a symptom, a trope, a curse and a blessing. So much more than just a habitat, the contemporary ontologies of these cities are intertwined with historical and imaginary layers, where the city functions as an existential cut, a metaphorical wound, as a beloved, or as a refuge. Cities like Jerusalem are lamented and coveted, Baghdad is mourned, Beirut mythologised, Dubai is envied, and so on. What do these cities yield to artists who have made them their homes—permanently or temporarily—as residents or as long-term visitors?

Conceptions of the urban and the territorial have been addressed in contemporary arts quite profusely over the past decade or so. Mapping, psychogeography, the urban vernacular and architecture all feed into artistic practices.

However, we can discern again a desire to transcend the real; to tread into other territories in which real cities do not allow us to dwell. For example, Lebanese artist Marwan Rechmaoui is primarily interested in urban and rural dynamics, and demographic transformations in urban space. In *Beirut Caoutchouc*, 2003, a huge map of Beirut is manufactured from car tyres, on which the audience is invited to walk. Hopping within seconds from one part of the once-divided city to the other, the installation recalls how, during the war, crossing from the Western part (primarily Muslim) to the East (primarily Christian) and vice versa was an arduous and risky endeavour comprising long waits at checkpoints and vulnerability to sniper gun fire. Rechmaoui's rubber map, though, can never attain the functionality of a regular city map: its monochromatic greyness, devoid of any markers (hotels, banks, mosques, churches, tourist attractions, street names and so on), wipes out the city's fragmented demeanour pertaining to class, religion and ethnicity. The viewer can literally stand with one foot in East and the other foot in West Beirut, leaving a footprint with equal weight on both city parts. The map merely draws on the contours of space, yet the narrative still has to unfold. In a later work, *Spectre*, 2008, the artist has created a 420 x 225 x 80 cm grout, concrete, glass and aluminium replica of a 45 year-old building he had lived in for five years. The building was evacuated during the 2006 war with Israel. Obsessively reproducing every minute detail, down to the traces left behind by its inhabitants, *Spectre* is not a small-scale replica of reality. Rather, stripped of human presence, this skeletal architectural structure resembles many of the buildings gutted by civil war that scar Beirut's cityscape, and which force the viewer to construct their own narrative of meaning and history. Yet Rechmaoui's construct becomes self-referential, an enclosed symbolic entity, and is therefore not *per se* about anything outside itself. It combines the generic with the specific within its formalism. Here there is no past or futurist scenario imagined, but it is—indeed—a spectre of the past, and hence also it attains this sculptural monumentality because the artist has ceased his quest for the real.

Palestinian artist Wafa Hourani on the other hand projects his quest for the real into the future. In *Qalandia 2047*, Hourani offers us a detailed scale model of how he envisions

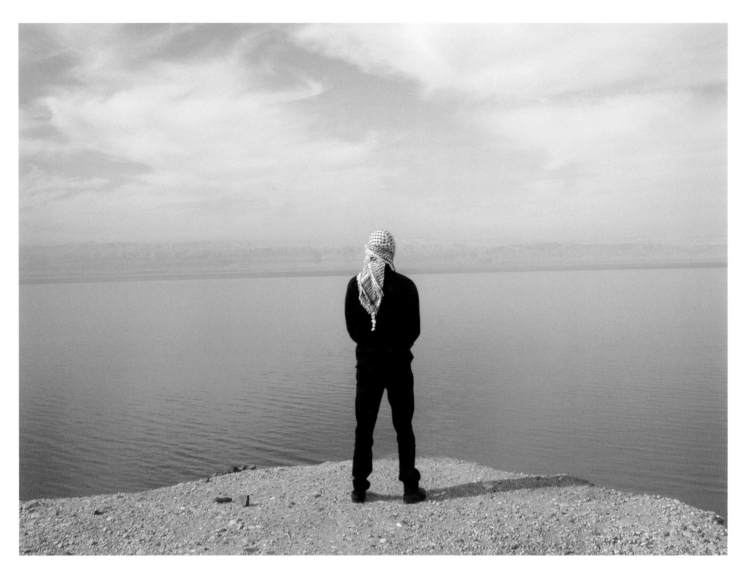

the Qalandia refugee camp, exactly a century on from the date when the inhabitants were evicted from their homes following the creation of the State of Israel in 1948. Situated on the road from Jerusalem to Ramallah, Qalandia camp and the Qalandia checkpoint encapsulate literally where Palestine has been divided and cut from its roots, territorially and historically. Scarring the area around Qalandia is the Separation Wall, which Hourani in his maquette has dressed with mirrors on the Palestinian side. This in part suggests frivolity, but also implies that when the rest of the world is sealed off, a narcissism occurs as the gaze is forced back onto the self. On the other side of the wall, a menacing airstrip with fighter jets reminds us that, 100 years on, little has changed. Hourani's *Qalandia* is strewn with minute and playful details, such as sports cars, TV antennas sculpted into decorative forms and figures, colourful rooftops, flowerpots, photographs, graffiti and even a real goldfish swimming in a fishbowl. Yet it remains a ghost town, a doll's house of the occupation, beautified by ornament and mirrors, seeped in inertia. The artist has mapped out a vision as architect, archaeologist, chronicler of a past, and future forecaster. Nevertheless, like the goldfish, he remains trapped in a space too confined, in a history too dictating.

Perhaps it is Egyptian/Lebanese Lara Baladi's most recent work *Borg el Amal* (*Tower of Hope*), 2008, that really manages to combine a harsh urban reality with an artistic vision of utopia. Originally a photographer engaged primarily with the production of visual experiences, Baladi has in this "ephemeral construction" moved beyond the image and stripped the representational down to its essence: a skeleton of brick and cement. Baladi has chosen to turn the social and political eyesores the Egyptian government so desperately wants to conceal into her inhabited *objet d'art*. Inspired by the red brick informal architecture around Cairo, she has erected a nine-metre tower on the government-run Opera Grounds, the main venue of the Cairo Biennale 2008, for which this project was commissioned. Housing a symphony, based on Henryck Gorecki's *Symphony #3*, and mixed with donkeys braying, the installation turns one of the most reviled animals in Egypt and the housing of the poor into an edifice that is accumulative: informal architecture, an artwork, a political and artistic manifesto, a parasite, tower of Babel, tower of hope, a shelter, a music box, a prison, a refuge, brick and cement, all in one. Baladi's *Tower of Hope* is a homage to humanity, and to the inventiveness of mankind to survive—no small feat in a mega-city like Cairo.

MARWAN RECHMAOUI
Beirut Caoutchouc
2004–2008, engraved rubber, 3 x 825 x 675 cm,
as installed at Saatchi Gallery, London
Courtesy the artist, photo: Matthew Pull/
Black Dog Publishing Ltd.

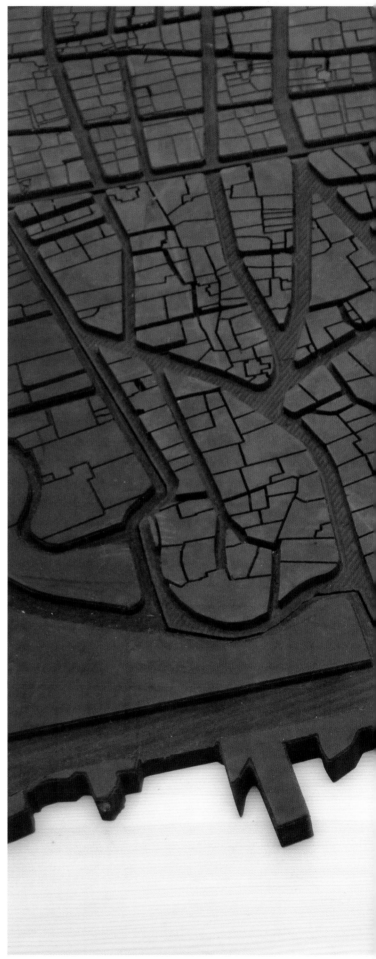

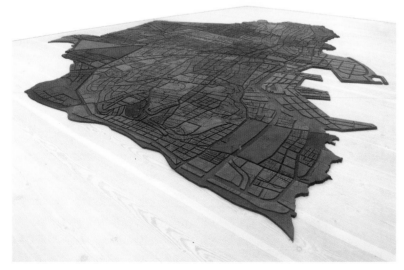

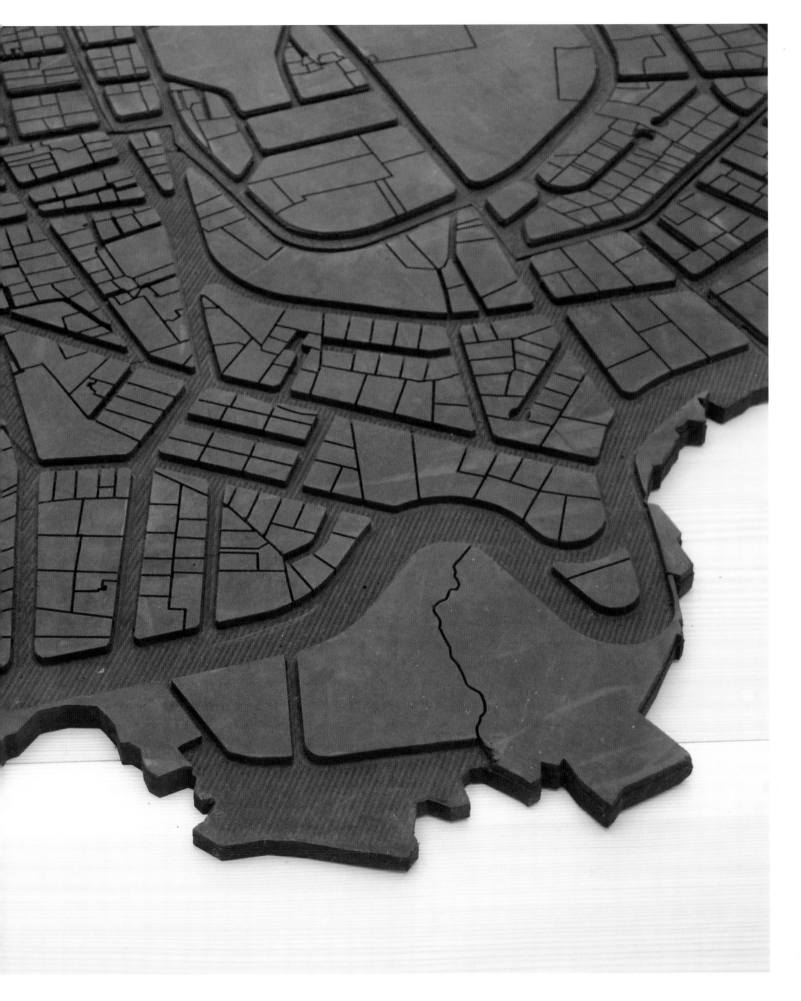

The roofless building, with its staircases leading up to the sky, suggests that hope is always a possibility and fate is not set in stone, even in the most bleak of circumstances.

MIRROR IMAGES: THE ROLE OF THE ARTIST

Artists take on many roles: witness, archivist, architect, activist, critic, cartographer, storyteller, facilitator, trickster, dreamer. It is within these myriad of positionings that practices can be found that take exactly the role performed by the artist as artist as reference. By corollary the possibilities of art to exist as an autonomous entity are probed and stretched, as is the directive power of the artist within that process. As aforementioned, artists in and from the Middle East experience more pressure from local and international parties to perform a certain role and adopt a criticality other than their Western peers. If art becomes functional and is solely utilised as ersatz where other discourses cannot penetrate, it loses its symbolic force.

Lebanese artist Mounira Al Solh has interrogated issues of identity and aesthetics by weaving together matters related to Lebanese politics, diaspora, immigration and the condition of the art world. In her video installation *As if I Don't Fit There*, 2006, Al Solh performs the role of four fictional artists who have stopped being artists, and now hold other jobs. The split screen shows us a video of the former artists, filmed in a way that references an art historical or other representational cliché, and the reason behind their decision to quit art without regrets. Highly ironic, Al Solh endlessly seems to be questioning her own *raison d'être* as an artist. The format she uses is almost one of a *tableau vivant*, hence monumentalising her artists and inscribing them into the ever-changing annals of a fictitious art history. In a quirky way this stands testimony to how the performance of ceasing to be an artist is a grand artistic statement in and by itself. In the seven-minute video *Rawane's Song*, 2006, Al Solh mocks the various expectations heaped upon her as a Lebanese artist, while the lens remains on her red-shoed feet as they walk aimlessly around the room. This is interspersed with iconic—but very personal—imagery: her Lebanese passport, passport photographs, cassette tapes of the Lebanese singer Fairouz, and her passport framed within the French *tricolore* while she whistles the Marseillaise,

echoing Lebanon's flirtation with all things Francophone. In effect, Al Solh admits that she has "nothing to say about the war", that she does not feel "typically Lebanese or Arab", that she is not ready "to defend the Palestinian cause", and that every time she did want to make a work about Lebanon's unfinished wars, she failed. The artist's own unease with roles she is called upon to perform yet cannot, and her own insecurities regarding how to mesh the identitarian, the aesthetic and her own positionality, turn Al Solh's work into a wonderful playful index of failed and desired expectation.

This stands in sharp contrast to the work of Palestinian artist Larissa Sansour, who divides her time between Bethlehem and Copenhagen. Whereas Al Solh shuns a fixed categorisation as Lebanese artist and is weary to take on any role, Sansour embraces it to an extreme in an accumulative identity. She has in past years focused her work on suggesting alternative roles for the Palestinian subject. Often humorous and bordering on the absurd, in her videos she scripts a performative hybridity into Palestinian subjectivity by referencing Western pop culture, ranging from spaghetti westerns and American sitcoms to horror films and science fiction. Her aim is "to set the viewer off balance, breaking stereotypes of ethnicity as well as clichés in the framework of art display"[5]. In that sense, Sansour can opt to be the desperado gunfighter (*Bethlehem Bandolero*, 2005), the girl next door (*Happy Days*, 2006), the menacing Arab (*Sbara*, 2008), the astronaut (*A Space Exodus*, 2008), the superhero (*The Novel of Nonel and Vovel*, 2009), the artist, and Palestinian, all in one. Indicative of the schizophrenia of the Palestinian condition, it also highlights the importance of performing identity, and the strong roleplay necessary for survival.

Perhaps, in conclusion, it makes sense to end where this discussion started and return to the notion of complicity. Meaning and comprehension are often not to be found in grand narratives or the wish for big truths. More often than not it is the journey that will shed light on big questions, rather than the destination. This idea is illustrated in Lamia Joreige's video *Full Moon*, 2007, in which the artist over the course of a few years, tries to recapture a poetic moment of seeing a beautiful full moon when driving from her home

in Gemayzeh in East Beirut to Raouche in West Beirut. The same journey is repeated each time in a different way, with light and traffic and radio broadcasts subtly altering the experience. After 20 minutes of mesmerising repetition we tend to forget that the initial quest was the moon. When finally the moon is shown to us, the feeling is not one of catharsis; rather it becomes an insignificant detail, a disposable image. The ritualised and continuously repeated act of trying to revisit an event in the past becomes more significant than its actual retrieval. This is in effect how knowledge is produced: meaning is to be found more in the rehearsals than in the grand finale. It is this processual act that lies at the heart of the creation and perception of art, wherever it is produced.

1 Ramadan, Dina, "Regional Emissaries: Geographical Platforms and the Challenges of Marginalisation in Contemporary Egyptian Art", *Proceedings of Apexart Conference 3*, Honolulu, 2004, http://apexart.org/conference/ramadan.htm

2 Wilson-Goldie, Kaelen, "Archaeology and the Street: The Imagined City in Contemporary Arab Art", *In the Arab World... Now*, ed. Jérôme Sans, Paris: Galerie Enrico Navarra, 2008, pp. 16–28.

3 The Palestinians refer to the *nakba* ('catastrophe') as the event that marks the creation of the State of Israel in 1948.

4 Wright, Stephen, "Territories of Difference: Excerpts from an E-mail Exchange between Tony Chakar, Bilal Khbeiz and Walid Sadek", *Out of Beirut*, ed. Suzanne Cotter, Oxford: Modern Art Oxford, 2006, pp. 57–64.

5 Quote from artist statement: www.sakakini.org/visualarts/sansour.htm

MINDING THE GAP: MIGRATION, DIASPORA, EXILE AND RETURN IN WOMEN'S VISUAL MEDIA
LINDSEY MOORE

Looking at art produced by female artists with Middle-Eastern affiliations, my focus signals Middle-Eastern connections across time and space, with an emphasis on double and dialogical frames.[1] The artists I discuss are often geographically removed from places construed as points of origin—as migrants, exiles or (sometimes second or third generation) members of diaspora communities—meaning that the Middle-Eastern places they evoke are also partly constructs of memory, narrative, imagination and affect. Those places have also, on the macro-level, historically accrued identities via different, often competing cultural and political processes. The very visibility and legibility of Middle-Eastern contexts, to Western observers, has for centuries been entangled in unequal geopolitical relations of power.

An English-language publication such as this presupposes a cosmopolitan audience. And, seeking to educate that audience in the contemporary art practices of the Middle East, it will inevitably draw upon work by artists who are geographically, culturally and linguistically mobile and attuned to a history of representing the Middle East from the 'outside'. The dialogues excavated in, and entered into via the work can, then, to a substantial extent be defined as cross-cultural. Fran Lloyd, in her introduction to *Contemporary Arab Women's Art: Dialogues of the Present*, exhibited in the UK in 1999, asks:

> Can such a dialogue ever occur or are we always bound by our positioning within a binary system which privileges one set of cultural values over another?… Do we always subtly frame and classify art produced in the diaspora or in non-Western countries as other and create a separate sphere of difference for it? Or, in the postmodern and postcolonial world… do we subsume this difference into a floating sign of sameness which

ignores the ways that we as historical subjects are differently located by gender, race and class within its power structures?[2]

Lloyd reminds us of the need to attend to implicitly hierarchical binaries—here/there, them/us, recognisable/exotic, familiar/dangerous—that burden women's art with the sign of 'difference'. At the same time, she is wary of 'universal' aesthetic categories and posits a multi-axial (gendered, classed, sexual, ethnic, geographical) politics of positionality, as prerequisite to a responsible analysis of processes of cultural production and reception.

This essay similarly emphasises feminist modes of representing Middle-Eastern and diaspora contexts, although my discussion of the work of Franco-Algerian artist Zineb Sedira suggests a recent revisitation to more widely resonant themes of migration, exile and return. I am particularly interested in the historical freighting yet dynamic potential of hyphenated identities. As Jacques Derrida observes, the hyphens articulating his Franco-Maghrebian-Jewish autobiography produce neither a benevolently plural identity nor a neutral supplementarity; rather, they mark historical 'relations of force', if differently for Derrida than for Algerian Arab or Berber subjects.[3] The Moroccan writer and philosopher Abdelkébir Khatibi, underscores an experiential "chiasmus between alienation and inalienation" derived from education in a colonial language (in his case French), and related worldview. Khatibi proposes neither neutrality nor a happy hybridity, but recommends that one "assume[s] this broached identity, in *a lucidity of thought that lives on this chiasmus, on this schism [schize]*".[4] In other words, he suggests that we remain attentive to the gap (schism) between facets of one's inherited identity and considers ways in which that gap (chiasmus) might, always provisionally and partially, be traversed.[5]

The appellation 'Middle-Eastern' is, of course, a construction. The neologism was coined in 1902 by US naval historian Alfred Thayer Mahan as a way of describing the area between India and the 'Near Orient' (North Africa and the Biblical lands). As the term passed into common usage in the early twentieth century, its reach extended to cover the mass of land under waning Ottoman rule. The region subsequently became naturalised in area studies due to its economic—and hence continuing political—significance for Western Europe and the United States. Contemporary usage encompasses the Maghreb (North-African Arab West), Mashriq (Arab East, including Egypt), Turkey, Iran and Afghanistan, a similar landmass to the oldest designation of the Orient: the lands of Islam of the Arabs, Turks and Persians. Because Islam historically constituted the greatest threat to Christian Europe, but also due to the longevity of religious, cultural and intellectual exchange between these neighbouring regions, the Middle East emerged in Western consciousness as an ambivalent border zone, "*of* the West, yet *outside* it, familiar, yet alien".[6] In the postcolonial era, due to different modes of migration, the reach of the global media and the dominant construction of 'terror', the Middle East is sometimes perceived as also *in*—if sometimes radically different *from*—the West.

The recent abstraction of a long history of interchange between two internally diverse regions to a contemporary 'clash of civilisations'—with its Manichean echoes of colonial discourse—is one motivation for creative artists to resist singular, static categories. As Tina Sherwell indicates, putatively Middle-Eastern women hail from "a multitude of different circumstances and their identities [are] tempered by religious beliefs, class backgrounds, the social contexts in which they find themselves, and personal experiences". Refuting essentialism, she reminds us that "such a broad label as Arab women may at times also encompass conflicting and antagonistic identities and experiences".[7] This is particularly the case when histories of migration are at stake, but not only then: wherever one lives, Arab and Muslim are also categories, produced historically, with which one may or may not choose to identify. Despite popular misunderstanding in the West, neither term should be conflated with the multi-ethnic, linguistic and religious territories of the Middle East.[8]

Moreover, as Rebecca Hillauer points out in her *Encyclopedia of Arab Women Filmmakers*, artists seldom provide "an unbroken gaze from within" a given society. For women born into postcolonial geographies, higher education and/or training (if not birth) in the West is common and can indicate a relatively privileged class background as well as a certain amount of distance from the culture of 'origin'.[9] In an era that can be characterised, at least in part, as one of transnational postmodernity, the notion of 'scattered hegemonies', in which gender intersects with other axes of identification to locate individuals in complex power relations with plural others (as Lloyd reminds us above), provides the most apposite critical framework.[10] This, as I have argued at length elsewhere, is why postcolonial women writers and visual artists tend not to simplistically equate acts of speaking, writing or viewing with presence, authority or unmediated truth.[11] Their work involves, instead, a reflexive awareness that gender is mediated in and through other axes of identity, already existing representational paradigms, and framing devices used by the artists and writers themselves.

In related fashion, it is necessary to mark my critical location as a white British non-Arabic speaker, with privileged access to certain archives and audiences, but very limited access to others. Feminist praxis is always a "situated practice within co-implicated and constitutively related histories and communities", so no position can be ideologically innocent.[12] A cross-cultural viewing scenario contains, one would hope, the potential for mutual illumination even if, as Derek Gregory puts it, "vision is always partial and provisional, culturally produced and performed, and it depends on spaces of constructed visibility that—even as they claim to render the opacities of 'other spaces' transparent—are always also spaces of constructed invisibility".[13] Inge Boer helpfully likens critical interpretation to the production of a palimpsest, a "plural text, one that cannot be mapped back onto [binaries such as] self and other, text and context, colonizer and colonized".[14] Accepting that any interpretation is located, contingent and dialogical helps to avoid simplistic claims to 'speak for' others, as well as problematic ascriptions of authentic or representative positions.

SHIRANA SHAHBAZI
From the *Series Farsh/Teppiche*
2004, hand-knotted rug, wool on silk, 70 x 50 cm
Courtesy Bob van Orsouw Gallery, Zürich

The work discussed here is informed by (but never reducible to) a history of representation that has presented Middle-Eastern contexts in troubling ways and continues to do so. Islam in colonialist discourse traditionally "offered an explanatory touchstone for the behaviour of people from otherwise diverse cultures, ethnic groups and social classes", creating the impression of "a timeless social order scarcely subject to the forces of social or economic change".[15] Marnia Lazreg suggests that academic approaches toward Arab and Muslim women still often reify women with reference to a timeless Islam.[16] Sarah Graham-Brown, Malek Alloula and Linda Nochlin have built on Edward Said's colonial discourse analysis in *Orientalism*, 1978, with reference to photography, the colonial postcard and Orientalist painting respectively, in order to show that visual technologies have been centrally implicated in constructions of the Middle East as picturesque, exotic, erotic, despotic, mysterious, empty, veiled, threatening and so on. Other critics emphasise "the multiple crossings and connections knitting an Orientalist intertextuality that surpasses text-image divisions, as well as supposed differences between high and popular art".[17] This, as we shall see, has motivated trans-generic responses by postcolonial Middle-Eastern women.

Graham-Brown suggests that the underpinning structure of feeling or style of thought (*pace* Edward Said) in late-nineteenth and early-twentieth century photography of the Middle East by Europeans was nostalgic. As it developed alongside emergent ethnographic and anthropological disciplines, photography often presented indigenous communities as untouched by history; in the shadow of ancient monuments, this implied cultural decline. The Middle East under the fading Ottoman Empire provided a visual counterpoint to notions of European progress. This was sometimes intended as a critique of—and temporary respite from—the industrialised West, but it also provided a rationale for colonial incursion across the region. Female domestic interiors were subject to a particularly dense collocation of imaginary and political investments, given that visibility was seen as prerequisite for the colonial control of territory, urban space and indigenous populations.[18] The production of the harem brought together two economies, political and psychosexual, around two key

Orientalist topoi: the exotic, perhaps deviant sexuality of the hidden woman and patriarchal, despotic systems of governance.[19] Malek Alloula's *Colonial Harem* provides a critique of this power-knowledge regime with reference to French colonial postcards of the early twentieth century that recycle a dominant trope of mid-nineteenth century painting: the fantasy of accessing the harem. Painting can in part be distinguished from photography due to the imaginative quality of the former genre—European male painters rarely had access to harems—but the highly staged qualities of the photographs in Alloula's book remind us that photography's claim to represent reality is also a tenuous one.[20]

Orientalist imagery produced during the Age of Empire was not, however, monolithic in its signification or devoid of 'countervisions'; neither could it foreclose upon interpretations 'against the grain' by future analysts.[21] Orientalism's citational or reiterative structure, whilst irrefutable in broad terms, can be complicated in several ways. Nineteenth-century European women writers, painters and photographers inflected Orientalism with gendered, classed and other ideological differences, even if they did not fundamentally destabilise it.[22] Reina Lewis shows in *Gendering Orientalism* that while nineteenth-century women writers and painters could claim superior experience—both in terms of assumed empathy with other women and because they could physically access the harem—their visions of the Orient were seen as neither objectively detached nor fully authoritative. Women were also discouraged from excessively identifying with the exotic other in the Romantic tradition of the sublime, something that would be considered a loss of feminine decorum. Lewis concludes that female contributions to Orientalism were "neither more pure (truthful and non-imperialist) than men's, nor… more susceptible to fantasy". Rather, nineteenth-century women travellers should be viewed "as agents whose mixture of observation and fantasy about the East is specifically gendered".[23]

Indigenous photographers were also working across the Middle East by the end of the nineteenth century, although Graham-Brown observes surprisingly little difference in the themes or techniques of their work, apart from an eschewal

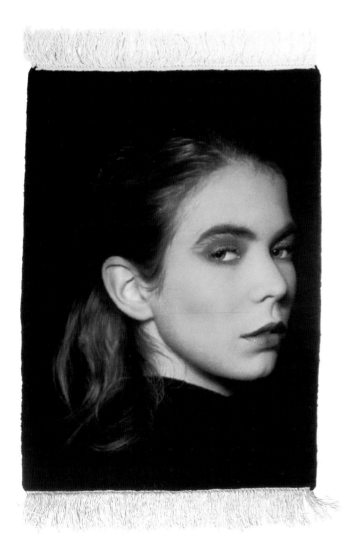

of the erotic female poses encouraged by European photographers.[24] Lewis's *Rethinking Orientalism*, however, provides examples of more dialogical interventions. Focusing on the British author Grace Ellison and a group of upper-class Ottoman Turkish women, Lewis discusses the pressures on the former to include photographs of herself dressed *à la Turque*, in accordance with a recognised Orientalist tradition, in her travel narrative *An Englishwoman in a Turkish Harem*, 1915. Contemporaneously, her Turkish friends were being photographed in hybrid Turkish and European dress for *their* travel narratives—one image, in Zayneb Hanim's *A Turkish Woman's European Impressions*, 1913, shows the author in Edwardian blouse with head-

veil thrown back. As Lewis observes, "when the referent for [the] exotic reappears… clad in Western clothes, the differentiating terms that secure the Western masquerade [of cultural cross-dressing] begin to crumble".[25] Recent images created by two Iranian-born photographers bring this contrast between (neo-)Orientalist expectation and syncretic cultural reality into the early twenty-first century: Shirana Shahbazi uses the traditional art form of the Persian carpet as 'skin' for an ordinary snapshot of a woman and Shadi Ghadirian draws upon the highly stylised conventions of court photography of the Qajar dynasty in her images that combine Iranian Islamic dress and Western consumer items. Ghadirian's photographs, particularly, raise pointed questions about the provenance of commodity culture and the different forms of fetishism that impact upon women *trans*nationally.

Echoes of Orientalist discourse are especially prevalent in recent debates about Muslim veiling in migrant contexts. Muslim women can be burdened not only by historical discourses constructing them as traditional/oppressed: post-9/11 anxieties around multiculturalism construe veiling as a sign of radical resistance to assimilation.[26] As I elaborate elsewhere, women artists do not use veiling motifs in order to pander to a taste for the exotic. Rather, given the loaded signification and simplified understanding of Muslim veiling in the West, they are concerned to re-present and reinvest veils with complex cultural and transcultural meanings and historical narratives.[27] For example, Irish-Iraqi artist Jananne Al Ani's *Untitled*, 1996, consists of two partially mirrored photographs of the artist, her mother and her sisters. The seated women, lined up and facing the camera, are concealed to varying degrees within each image and the mode of self-presentation of each woman changes across the images. This mimics and mocks the use of visual technologies to codify or identify women and related 'civilising' or colonising discourses, as seen for example, in the Algerian War of 1954–1962. Al Ani's earlier *Untitled*, 1989, a reworking of Ingres famous *Le Bain turc/Turkish Bath*, 1862, responds to the other, explicitly eroticising tendency in Orientalist iconography. Ingres painting epitomises what Nochlin has identified as the absent presence of a white male "controlling gaze which brings the Oriental world into being"[28]. Al Ani reproduces

JANANNE AL ANI
Untitled (below)
1996, black and white photographs, 120 x 180 cm
Courtesy the artist

SHADI GHADIRIAN
from *Qajar* series (opposite)
1998–2001, C-print, 60 x 90 cm
Courtesy the artist

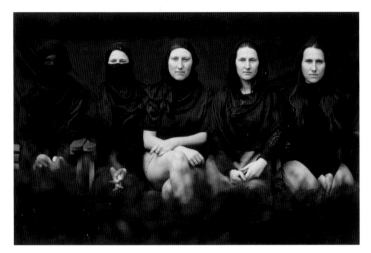
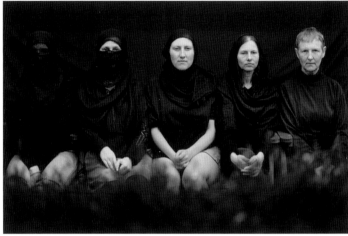

the circular form of the original painting that suggests a stolen view through a keyhole and renders a returned gaze impossible. However, she reframes the optical lens, merging the original image with a photograph of luscious fruit for sale. By foregrounding *trompe l'oeil* techniques, Al Ani reconfigures *The Turkish Bath* as fantasy with ongoing political effects. The women's bodies merge with the fleshy contours of oranges and grapefruit, refiguring the original as 'about' buttocks and breasts, and emphasising the historical and ongoing commodification of women's bodies.[29] The artist has noted other continuities in images of Middle-Eastern contexts from the colonial period to the present. The digital representation of the 1991 Desert Storm campaign, for example, reiterated nineteenth-century notions of the desert as "a place with no history and no population—an empty space, a blank canvas" on which (neo-)imperial desire could be inscribed.[30]

Given the density of the Orientalist visual archive and the persistence of elements of its lexicon in the present era, it is not surprising that Lloyd, cited at the beginning of this piece, assumes the desirability of dialogue and the necessity of revisionist representations of the Middle East. Drawing on the work of 18 visual artists, Lloyd identifies the foregrounding of acts of perception and reception, including "metaphors of absence and presence; veiling and unveiling; nearness and farness [*sic*] [and] the continuous dialogue with different forms of western art". She stresses, above all, "the continuous crossing of territorial boundaries

(both through geographical displacement and through the contrapuntal spaces of memory) and the continuous re-inscribing of identity". Lloyd rightly suggests that the coincidence of these two modalities of mobility—temporal and spatial—is not accidental. She draws on Stuart Hall's elaboration of diaspora identities to suggest that migration encourages artists to engage "not the rediscovery but the *production* of identity. Not an identity grounded in the archaeology, but in the *re-telling* of the past".[31]

Lloyd cites, for example, British-resident Algerian artist Houria Niati's *Ziriab… Another Story*, 1999, a multimedia installation that foregrounds Andalusian and Amazigh aspects of Algerian cultural identity, evoking plural historical sites of colonisation and exile.[32] Another Algerian example is Samta Benyahia's installation *The Architecture of the Veil*, 2007, which overlaid surfaces of buildings such as the Fowler Museum in Los Angeles with adhesive film on which were repeated Arab Andalusian motifs such as the *fatima* (geometic rosace) in Mediterranean blue. Both Niati and Benyahia privilege women's bodies, domestic interiors and oral, often matrilineal traditions.[33] As Lloyd suggests, Arab women's art frequently emphasises "matrilinear connections that include the ancient females of mythology, the threads of storytelling and mother/daughter relationships through the imaginary and the real".[34] In the Algerian context, oral traditions provide an alternative archaeology to the Arabophone cultural dominant in the postcolonial period and to Islamist resurgence from the 1990s that has

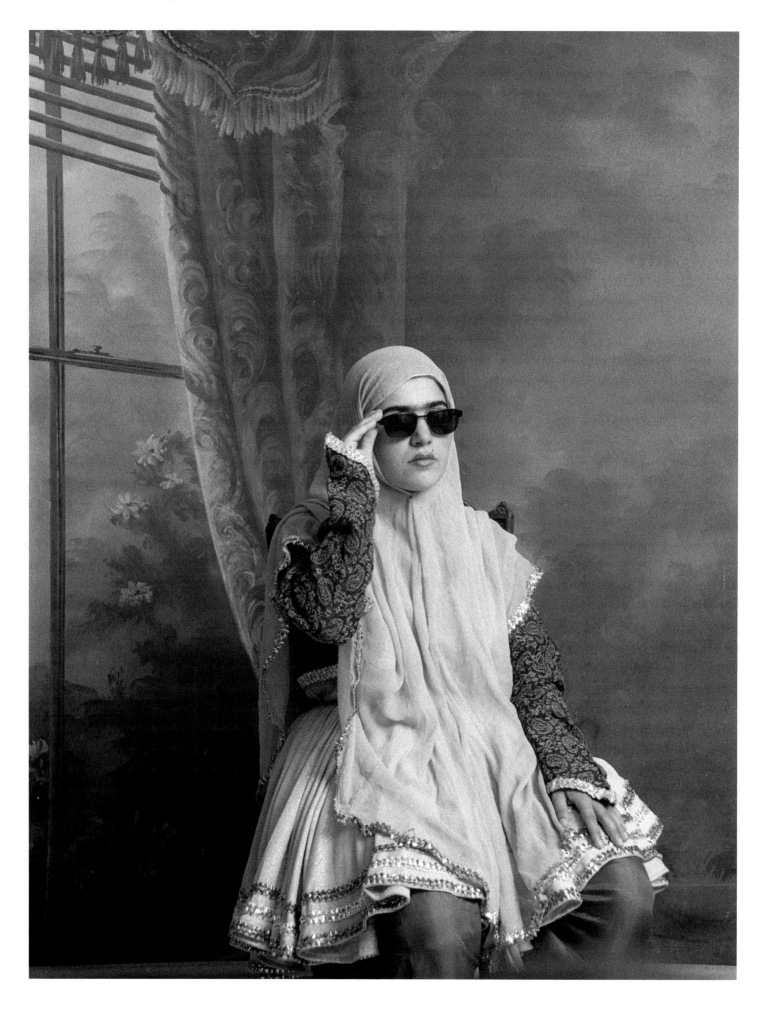

LAILA SHAWA
Letter to a Mother
1992, silkscreen on canvas, 100 x 150 cm
Courtesy the artist

rebounded violently upon intellectuals, artists and women; the latter is the cause, in many cases, of voluntary or forced exile from that country.[35] In similar if more benign terms, it is worth noting the work of Kamala Ibrahim Ishaq, which references oral histories and the hybrid Pharaonic, African, Coptic and Islamic roots of Sudanese culture, and of Leila Kubba Kawash, who draws upon both Islamic and Greek mythology in textured images that "piece together different time periods" in an attempt "to find a place where the past and present overlap, where countries shed their boundaries and distances".[36] Citing the example of the Sumerian goddess Inanna who planted a tree by the Euphrates river, Iraqi-born Kawash describes herself as an "assembler of what is ruined or missing, the unifier of the broken or lost pieces of self" that result both from migration and from monolithic, internally-generated definitions of Middle-Eastern nations.[37]

If women's work archives alternative histories, diaspora identities are also a matter of 'becoming'; they "belong to the future as much as to the past".[38] Lebanese-born Saadeh George's installation *Today I Shed My Skin: Dismembered and Remembered*, 1998, provides a memorable illustration. George, who trained and practised as a doctor in Lebanon in the Civil War period, simultaneously memorialises victims of war and embodies the self-estrangement of exile in this two-part work. In *ID Therefore I Am Not*, casts of parts of the artist's body made of tissue paper, muslin and gauze bring forth the effects of war and signify the fragility of identities defined by national and religious frameworks. The casts function as part-traces of absent bodies, tentatively rehabilitating war victims who have, at best, an ephemeral presence in the international media. In the second part of George's installation, *Surface Tension*, different body parts are assembled and sutured together. The grafted body is symbolically composed, perhaps, of Lebanon's diverse identities and/or of the artist's pluri-local experiences, but while it offers the possibility of regeneration, it also bares the marks of suture.[39]

We see here a shift in perspective away from a purportedly disembodied gaze and toward questions of "what it means to inhabit [a] body" and "from the problem of *looking* (distance) to the problem of embodiment (touch)".[40] As Gannit Ankori

has argued, traumatic rupture from the mother(land) and radical, corporeal self-estrangement are key motifs in the imaging of displacement and exile by Palestinian artists.[41] Laila Shawa, for example, conflates the lost homeland and the mother's body in her silkscreen painting *Letter to a Mother* based on photographs of dialogue recorded on the walls of Gaza during the 1987 Intifada.[42] The fact that Shawa has also superimposed images of the occupied Palestinian territories with x-rays of breast cancer suggests ways in which women's bodies can function as cultural boundary markers: the invading principle in each case is internal to the body (politic), an apt rendering of the Israeli-Palestinian situation.[43]

The entire corpus to date of Mona Hatoum, a Lebanese-born Palestinian and British resident since the mid-1970s, emphasises dislocation and alienation and elicits visceral responses in the viewer.[44] Her short film *Measures of Distance*, 1988, a piece that foregrounds the experience of compounded exile, consists of a double image—the artist's naked mother overlaid by lines of Arabic script—and a double soundtrack. On one track, the narrator/addressee Mona in London reads letters from her mother in Beirut, translating them into English; in the background a conversation in Arabic between the two women can be heard. As the script across the screen takes on the texture of flesh, the mother's body is, conversely, partially inscribed by the text. Hatoum links the absent-presence of the mother's body, her own exile in London during the Lebanese Civil War and her family's evacuation in 1967 from Palestine. The film, with its visual and aural depth of field and its bilingual (Hatoum is, in fact, trilingual) and historical layering depicts exile as "fundamentally a discontinuous state of being" in which "both the new and the old environments are vivid, actual, held together contrapuntally".[45]

Measures of Distance also orients the viewer towards concrete, embodied mother-daughter relations. The letters were written in the aftermath of the artist's trip to Lebanon when she took photographs of her mother in the shower and the two women discussed "women's things". The mother reflects on this experience in her letters frankly and with humour, but reminds "Mona" that her father was dismissive (and jealous) of such "women's nonsense" and

asserted a claim over his wife's body. Although Hatoum's family is Christian, the bar or veil of the Arabic script over the mother's naked body suggests a longstanding tension between the sacred word and iconoclasm in Arabo-Islamic contexts that can render representations of the human form controversial.[46] US-resident Egyptian Ghada Amer's series of delicately embroidered but sexually explicit images of women partially concealed by hanging threads can be construed as particularly transgressive in this respect if viewed within an Arab diaspora context.[47]

The work of Zineb Sedira, in my view, exemplifies the foregoing themes.[48] Sedira was born and raised in Paris to Algerian immigrant parents. Resident in Britain for more than two decades, she has produced a range of theoretically informed visual media that reflects upon her plural and polyglot identity. Earlier work tended to be autobiographically inflected, with the artist using her own body as prop. In the video *Autobiographical Patterns*, 1996, for example, one hand is roughly and hastily written on, over and again. A few words in French can be distinguished —"Je suis née", "immigré", "nationalité", "Algérienne", "ton pays"—before they are overwritten. The hand, which when frozen in a still appears to be decorated in henna, bears a purportedly confessional text that is ultimately an enigma. Sedira's video installation *Don't Do To Her What You Did To Me!*, 1998/2001, also involves the incorporation of writing by the body. Here, the performer enacts a ritual with a talisman—writing worn on the body or swallowed as a form of protection (for example against the evil eye). The paper in this case is inscribed with the words of the title to the piece; although in English, the words start to look

like Arabic as the paper is stirred into an inky glass with several passport photos of the same woman. The agents implied by the piece—the you, me and her of the title—are not identified; nor is it clear what has been done to the performer ("me"?) or could happen to the woman ("her"?) whose image is imbibed. This ambiguity adds to the sense of menace that the slow, calm ritual seems designed to deter.

In her *Self-Portraits of the Virgin Mary* series, 2000, Sedira photographs herself fully concealed in the Algerian *haik* (white body covering and face-veil). She has suggested that the "visible and invisible topology of the veil" is a figure for "the sociality of… [any] subject's construction and the manner of its smooth reproduction".[49] She thus uses it to make her body into a simulacrum of presence. The veil is also glossed as a metaphor for translation. Claiming the identity category *beurette* that signifies a "language of mixing, remixing, translating and transforming [which] helps to articulate the dissonance of a particular time and place: to be Arab and French and Parisian", Sedira describes "a translation of memory that is always of the incomplete, the never fully decipherable", shadowed "by an 'elsewhere', an unconscious, an 'other' text, an 'other' voice, an 'other' place".[50] She here describes a diaspora consciousness with reference to a 'gap' between cultures and languages that cannot be transmitted in words. Nor, she warns, should we seek to reinstate 'truth' through the image that only appears to order and contain experience.

In Sedira's *Mother Tongue*, 2002, three simultaneous video screens present memory dialogues between the artist and her mother (in French and Arabic respectively), the artist and her daughter (in French and English respectively), and the artist's daughter and mother. In the third screen, Sedira's English-born daughter cannot communicate in her '(grand)mother' tongue (Arabic), so her side of the dialogue consists of awkward silences. Cumulative aporia render the transmission of this intergenerational narrative both moving and frustrating. Sedira's interest in matrilineal oral histories interrupted by successive migrations is evident in other work, such as the video *Retelling Histories: My Mother Told Me*, 2003, which focuses on her mother's memories of the Algerian war. In a series of 12 tiled prints entitled *La Maison de ma mère*, 2002, the artist 'wallpapers' images of

her mother's body and house. The mother's presence is partial and displaced on to textiles, ornaments and curtains. The figure of the mother is thus located in relation to a domestic frame, but always only transiently apprehended in her movement within and beyond the borders of that frame. This rather enigmatic status of the mother is also evoked in the short film *Silent Sight*, 2000, which tells of the narrator's experience as a child, struggling to interpret her mother's feelings from beneath her *haik*. The spectator, who only has access to Sedira's voice and eyes, is encouraged to replicate the process of establishing trust within a limited visual field.

Autobiographical threads are woven more tangentially into Sedira's most recent short films *Saphir*, 2006, and *MiddleSea*, 2008, which open beyond female and indigenous Algerian experience. The title of *Saphir* ('sapphire' in French and *safir*, 'ambassador', in Arabic) evokes both the colour of the Mediterranean and themes of travel and cross-cultural contact. The artist has explained that the two films refer to French *pied noir* evacuees during the Algerian war as well as to Algerian Arab and Berber migrants and exiles in the same period and its aftermath.[51] *Saphir*, a split-screen projection, is set in Algiers, although for viewers unfamiliar with that city, this only becomes clear towards the end when we see a hotel sign in Arabic, Algerian flags along the promenade and the name of the arriving *Algérie* ferry. Indeed, historical and urban contexts seem to merge: the protagonists wear contemporary Western dress and the Algiers waterfront features Art Deco façades. The colour palate of the film is predominantly white, grey and blue, giving the film a sculptural quality enhanced by slow tracking and the mirrored semi-circular shapes of balconies, arches and wrought-iron balustrades. The two screens fade in and out, simultaneously or in sequence, at times showing the same scene from different angles and at others revealing differently situated perspectives. The soundtrack orchestrates silence with the subdued sounds of footsteps, swallows that appear at sunset, an ascending and descending lift, and the noises of the port: cars and motorcycles, the hum of machinery and announcement signals.

The film's structural qualities both sustain a binary framework and provide echoes across its two parts,

underpinning the juxtaposition of a woman in a hotel room and a man at the port. At times the stasis of each character is emphasised, with the man's gaze turned outwards to the sea and the incoming ship, and the woman sitting, often with her face concealed or averted from the viewer; a partially open, semi-transparent curtain further divides her experience from the scene outside. The whole film has a meditative, decelerated quality. In a particularly oneiric sequence, the man mounts a seemingly interminable set of stairs towards the hotel while the woman looks out of the balcony and then descends and re-ascends an interior staircase. The two are rarely shown in the same shot, do not appear to see each other, and never meet; toward the end of the film, each exits his/her own frame from opposite

sides. The woman is subsequently seen crossing and exiting the double screen. The ship finally arrives in front of the man and the camera, now in a single frame, pans 360 degrees to reveal the scene that he implicitly is leaving behind.

Saphir undercuts romantic dreams—a potential tryst in a glamorous hotel, a mythic yearning for travel that hearkens back to Homer's *Odyssey*—with the pathos of a separation that seems to precede the man's ensuing departure. If the structure of feeling in that film is a complex of loss and expectation, in the partner film *MiddleSea* the prevailing atmosphere is melancholic.[52] This title echoes and inverts the name of the Mediterranean (derived from *medius*, 'middle', and *terra*, 'land'), a perfect example of a supposed

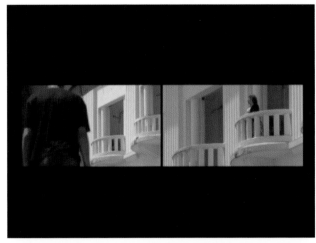

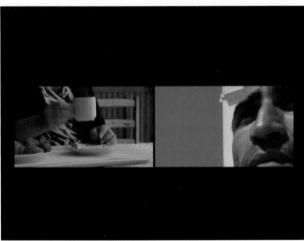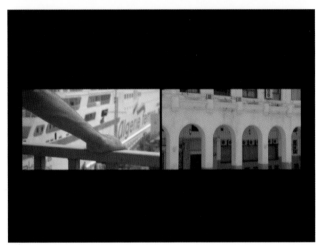

schism—gap—between territories that is, given millennia of traffic and cultural interchange across that sea, also *chiasmatic*, a space of traversals and reversals. Again, the soundtrack precedes the visual image, with a low engine-like sound that later diversifies to include the sound of the sea, birds, radio static, the wind, silent intervals and a haunting, rather dissonant melody composed by Mikhail Karikis.

The opening shot, prior to the film's title, is impressionistic, with slightly blurred or bleeding edges; it shows the same man as in *Saphir*, played by Samir El Hakim, on board the ferry. The title is followed by a slow-motion sequence of a rope being cast off. For the duration of the film, the man alternately stares out to sea, crosses a lower deck, walks down a corridor, or drinks coffee. There is no sign of any other passenger. The monotony of the passenger's routine and the changing light on the horizon give the impression of an epic journey. This is underscored by the intimidating mass of the water in the ship's wake, sometimes shown in slow motion, and by long-distance shots that render the ship small on the sea. The man's expression reveals little, but his tendency to face in the opposite direction to the ship's trajectory suggests nostalgia for what is being left behind or doubt about the voyage being undertaken. Arrival is denoted by the reflection of the name of the ferry, in French and Arabic, in windows and, in an echo of the earlier scene of departure, by a rope released and slowly

pulled out of the frame. While we assume that the arrival is in Marseilles, there are no unequivocal markers of destination; neither are there clear indications of whether the man who releases the rope is French, Algerian or Franco-Maghrebian.

In *MiddleSea*, the interpolation of black and white scenes that imperceptibly accrue colour suggests the ritual enactment of earlier journeys—real, remembered and narrated—across the same ocean that give it historical as well as physical density. If home and homeland represent one set of drives, economic and political imperatives that continue to motivate migration from Algeria to France constitute another. This dualism is reflected in the film through the use of a split screen and in shots emphasising symmetry—of lamps, railings, and staircases, between which the man is positioned, statically and in motion. Both *Saphir* and *MiddleSea* have autobiographical resonance for Sedira, whose family undertook the same journey in the aftermath of the Algerian war to join her father in France, and who returns regularly to France, and more recently Algeria, from the UK. However, the widening of the lens to an anonymous male protagonist suggests an engagement with migration and exile in a more mythic, universal register. The potentially romantic resonance of the theme is then counterbalanced by the installation *Shipwreck: The Death of a Journey*, 2008, which has been exhibited with *MiddleSea*.

The installation comprises photographs, some of which are mounted as structures of light boxes. The images were captured off Nouadhibou in Mauritania, like Algiers a point of North-African mass emigration, and feature rusting and overturned ships abandoned on land or at sea. Some of these are reassembled in hybrid, rather monstrous forms with titles such as *Shattered Carcasses*. Sedira here references the tragic side of mass North-African migration to Europe in the postcolonial period: the ships stand in for those who have failed to depart or who have perished en route.

Just as Sedira evokes a Mediterranean space that is as much a *chiasmus* as a *schism*, tracing routes that link and cut across national borders, Derrida has invoked the entanglement of Algeria and France from 1830 to 1962 —in which Algeria was defined as part of France but Algerian Muslims (and, under the Vichy government, French Algerian Jews such as Derrida) were denied full citizenship—as an exemplary challenge to the notion of (national) frames, boundaries and categories.[53] In a more general sense, he argues that a frame's function is always integral to a work: "A parergon [from *para*, beside or additional, and *ergon*, work] comes against, beside, and in addition to the *ergon*… it does not fall to one side, it touches and co-operates within the operation, from a certain outside. Like an accessory that one is obliged to welcome on the border, on board [*au bord, à bord*]."[54]

While this is a particularly effective way of conceptualising the function of a physical frame around a static image, it also reminds us of the 'cut' that happens in any verbal or visual enunciation. As Ranjana Khanna argues,

> One can never really know the full context of any utterance, whether another person's or one's own. So while a frame determines a meaning, it is also a supplement that throws [that meaning] into undecideability… The supplement can be understood not simply as an interruption by an alternative framework or force field, however. It is also the cut of nonknowledge, of something that opens the possibility of knowledge but is not simply reducible to any currently existing knowledge formation or paradigm. It is a nonknowledge that threatens borders.

Khanna suggests that we think of the figure of the foreigner as a superlative frame-supplement: supposedly outside the frame of a defined community, the foreigner actually defines, so presses on and potentially opens up, identitarian categories.[55] Sedira's work also evokes the double valence of the immigrant and/or ethnic minority subject who bears the trace of colonial histories and haunts the self-styled coherency of European nation-states: witness the photographic series *Jinns*, 2001–2004, in which ghostly silhouettes of women function as inverted shadows of the spectator. In her most recent work, as I have discussed,

dualistic structures of time and space are both mounted and deconstructed. Repeated images, changes in perspective and echoed actions resonate across and sometimes physically traverse the two frames, revealing the arbitrary nature of the *bord* ('border' or 'shore'). Dual-screen film installations lend themselves particularly well to a contrapuntal rendering of the psychological, emotional and physical space and time of migration, not least because they formally combine the static frame of the image with the narrative dynamics of film. In cinematic terms, as Khanna reminds us, "to cut is to splice together two shots from different time and space configurations", with the cut itself forming a border that belongs neither to one frame nor the other.[56] In Emily Jacir's video installation *Ramallah/New York*, 2004–2005, for example, scenes from shops, travel agencies, salons and clubs in both locations of the title are juxtaposed. By privileging quotidian scenes from culturally hybrid and to some extent interchangeable urban landscapes, Jacir challenges the disaster-zone imagery of the Palestinian territories that feature in the international media.

I have focused upon women's visual media because, as Khanna proposes, women's work, in particular, privileges "the inassimilable, the barely incorporated… melancholic traces" of dominant nationalist and metropolitan histories and so 'cuts' through conventional representational frames.[57] While Western Orientalist discourses have tended to produce Middle-Eastern women as exotic, oppressed or inassimilable, nationalist ideology has often involved a retrenchment around the figure of the woman as spatial and cultural boundary marker. Migration, not only in the conventional geographical sense, but also in its psychological, temporal, conceptual and creative modalities, helps to redefine women's relationship to private, public, cultural and national space, in both the Middle East and its diasporas. It is worth remembering, finally, that part of the ethical work of reception is to eschew the will toward transparency and cognition that would attempt to fix and contain others. The women I have discussed here, by "reclaiming and reprocessing of habits, objects, names and histories that have been uprooted—in migration, displacement or colonization", posit *performative* rather than *normative* identities.[58] Autobiography and inherited

context are not definitive and may not even be construed as foundational; rather, they can be seen as retrospective ways of opening beyond present time and space.[59] This is one reason why female artists foreground "cuts through representation, sometimes sewing them together and [at] other times acknowledging the pertinence of the gape" or, in the double sense that I have used 'gap', the schism/chiasmus.[60]

1 I thank Routledge for permission to include revised material from my *Arab, Muslim, Woman: Voice and Vision in Postcolonial Literature and Film*, London: Routledge, 2008. Both the 'Middle East' and 'the West' are historical constructions, as I discuss. I will heretofore leave both terms unmarked.

2 Lloyd, Fran, "Cross-Cultural Dialogues: Identities, Contexts and Meanings", Fran Lloyd, ed, *Contemporary Arab Women's Art: Dialogues of the Present*, London: Women's Art Library, 1999, p. 13.

3 Derrida, Jacques, *Monolingualism of the Other or The Prosthesis of Origin*, trans. Patrick Mensah, Stanford: Stanford University Press, 1998, p. 9.

4 Cited in Derrida, *Monolingualism*, p. 9, original emphasis.

5 A chiasmus is a 'crosswise' binary structure in which the latter part echoes or mirrors the former part; a schism is akin to a cleft or split.

6 Melman, Billie, "The Middle East/Arabia: 'The Cradle of Islam'", Peter Hulme and Tim Young, eds, *The Cambridge Companion to Travel Writing*, Cambridge: Cambridge University Press, 2002, p. 105, original emphasis. See also Said, Edward, *Orientalism*, London: Pantheon, 1978, and Sardar, Ziauddin, *Orientalism*, Buckingham: Open University Press, 1999.

7 Sherwell, Tina, "Bodies in Representation: Contemporary Arab Women's Art", Lloyd, ed, *Contemporary Arab Women's Art*, p. 59–60.

8 The region contains substantial Christian (and, formerly, Jewish) communities and indigenous Berber populations. Turks and Iranians are not ethnically Arab, although aspects of their culture are Arabised; the same argument has been extended, more controversially, to Egyptians. Whilst language is ostensibly a unifying factor, multilingualism and diglossia produce what MH Bakalla, *Arabic Culture through its Language and Literature*, London: Kegan Paul International, 1984, terms spectroglossia. Neither is Islam a homogenous organising framework, politically or otherwise: on the macrocosmic level, compare Turkey (a secular democracy) and Iran (an Islamic Republic), or consider the variety of ways of being Muslim that includes secular modes.

9 Hillauer, Rebecca, *Encyclopedia of Arab Women Filmmakers*, Cairo: American University Press, 2005, p. 4.

10 Grewal, Inderpal and Caren Kaplan, *Scattered Hegemonies: Postmodernity and Transnational Feminist Practices*, Minneapolis: University of Minnesota Press, 1994, p. 7.

11 See Moore, "Introduction", *Arab Muslim Woman*, for an elaboration of this argument and on the politics of positionality.

12 Shohat, Ella, *Taboo Memories, Diasporic Voices*, Durham: Duke University Press, 2006, p. 12.

13 Gregory, Derek, *The Colonial Present: Afghanistan, Palestine, Iraq*, Malden, MA: Blackwell, 2004, p. 12.

14 Boer, Inge, *Disorienting Vision: Rereading Stereotypes in French Orientalist Texts and Images*, Amsterdam: Rodopi, 2004, pp. 18.

15 Graham-Brown, Sarah, *Images of Women: The Portrayal of Women in Photography of the Middle East, 1860–1950*, London: Quartet, 1988, p. 6.

16 Lazreg, Marnia, "Feminism and Difference: The Perils of Writing as a Woman on Women in Algeria", Marianne Hirsch and Evelyn Fox Keller, eds, *Conflicts in Feminism*, NY: Routledge, 1990, p. 338.

17 Boer, *Disorienting Vision*, 20; Moore, *Arab Muslim Woman*; Vogl, Mary, *Picturing the Maghreb: Literature, Photography, (Re)presentation*, Lanham, MD: Rowman and Littlefield, 2003.

18 Fanon, Frantz, "Algeria Unveiled", *A Dying Colonialism*, trans. Haakon Chevalier, London: Writers and Readers Publishing Cooperative, 1980; Grewal, Inderpal, *Home and Harem: Nation, Gender, Empire, and the Cultures of Travel*, London: Leicester University Press, 1996; Yegenoglu, Meyda, *Colonial Fantasies: Towards a Feminist Reading of Orientalism*, Cambridge: Cambridge University Press, 1998.

19 Melman, Billie, *Women's Orients: English Women and the Middle East, 1718–1918: Sexuality, Religion and Work*, Basingstoke: Macmillan, 1992, p. 60. The term 'despotism' comes from the Greek *despotes*, meaning 'master over slaves in a domestic space'.

20 See Moore, *Arab Muslim Woman*, pp. 33–36, for an analysis of Alloula's book.

21 Boer, *Disorienting Vision*, 23; see also Mackenzie, John M, *Orientalism: History, Theory and the Arts*, Manchester: Manchester University Press, 1995.

22 See Melman, *Women's Orients*; Moore, *Arab Muslim Woman*, pp. 29–33; Lewis, Reina, *Gendering Orientalism: Race, Femininity and Representation*, London: Routledge, 1996.

23 Lewis, *Gendering Orientalism*, pp. 178–79, 184.

24 Graham-Brown, *Images of Women*, pp. 55–56.

25 Lewis, Reina, *Rethinking Orientalism: Women, Travel and the Ottoman Harem*, London: IB Tauris, 2004, pp. 229–231.

26 Donnell, Alison, "Visibility, Violence and Voice? Attitudes to Veiling Post-11 September", David A Bailey and Gilane Tawadros, eds, *Veil: Veiling, Representation and Contemporary Art*, London: Institute of International Visual Arts, 2003; see also Fortier, Anne-Marie, *Multicultural Horizons: Diversity and the Limits of the Civil Nation*, London: Routledge, 2008.

27 See Moore, "Introduction", *Arab Muslim Woman*, which argues for the continued interest of veiling motifs in women's creative work, as the recent exhibition *Veil*, 2003, attests. The exhibition was co-curated by Zineb Sedira and Jananne Al Ani, both discussed below, alongside David A Bailey and Gilane Tawadros.

28 Nochlin, Linda, *The Politics of Vision: Essays on Nineteenth-Century Art and Society*, NY: Harpers & Row, 1989, p. 4.

29 Moore, *Arab Muslim Woman*, pp. 30–31.

30 Al Ani, Jananne, "Acting Out", David A Bailey and Gilane Tawadros, eds, *Veil: Veiling, Representation and Contemporary Art*, London: Institute of International Visual Arts, 2003, p. 90. Al Ani has recently produced *The Visit*, 2004, a video installation in two parts. In *Muse*, an anonymous, silent male figure walks restlessly on a strip of desert over the course of a day; in the counterpoint piece *Echo*, separated by a partition wall, four women on separate screens discuss a 'visitor' who never arrives. US-based Iranian artist Shirin Neshat has also used dual screens to contrast male and female experience, in a more explicit commentary on the traditional division of space in Muslim contexts. See Moore, Lindsey, "Frayed Connections, Fraught Projections: The Troubling Work of Shirin Neshat", *Women: A Cultural Review* 13: 1, Spring 2002: pp. 1–17.

31 Lloyd, "Cross-Cultural Dialogues", 41, 31; Hall, Stuart, "Cultural Identity and Diaspora", Jonathan Rutherford, ed, *Identity: Community, Culture, Difference*, London: Laurence and Wishart, 1990, p. 393, original emphasis.

32 Ziriab is a tribute to Ziriab Ibn Nafi, a ninth-century composer forced into exile in Cordoba, whose music was subsequently brought to North Africa in the aftermath of the Spanish Inquisition. Lloyd, "Cross-Cultural Dialogues", pp. 31–32, 208.

33 While Ziriab was a male composer, Niati's work usually foregrounds women's histories, as in her reworking of Delacroix's *Women of Algiers in their Apartment*, 1847–1849, in her *No to Torture* installation, 1982. In the Ziriab installation, the artist performed and sang, thus transmitting a hybrid cultural legacy through her body.

34 Lloyd, "Cross-Cultural Dialogues", 41.

35 The Algerian writer Assia Djebar structures *So Vast the Prison*, 2001, through the same contrast between official, Arabic male discourse and marginal, multilingual and oral female narratives. The Egyptian writer Nawal El Saadawi also critically aligns written Arabic, the father and a punitive God, in contrast with an effaced maternal signature, in the first volume of her autobiography, *Daughter of Isis*, p. 1.

36 Lloyd, "Cross-Cultural Dialogues", p. 32.

37 Cited in Lloyd, "Cross-Cultural Dialogues", pp. 191–92.

38 Lloyd, "Cross-Cultural Dialogues", p. 16; Hall, "Cultural Identity and Diaspora", p. 394.

39 See Lloyd, "Cross-Cultural Dialogues", p. 35 and 173–176.

40 Betterton, Rosemary, *An Intimate Distance: Women, Artists and the Body*, London: Routledge, 1996, p. 7, original emphasis.

41 Ankori, Gannit, "'Dis-Orientalisms': Displaced Bodies/Embodied Displacements in Contemporary Palestinian Art", Sara Ahmed, Claudia Castaneda, Anne-Marie Fortier and Mimi Sheller, eds, *Uprootings/Regroundings: Questions of Home and Migration*, Oxford: Berg, 2003, p. 59.

42 See Lloyd "Cross-Cultural Dialogues", pp. 32–33.

43 See, for example, Yuval-Davis, Nira and Floya Anthias, eds, *Woman-Nation-State*,

44 Basingstoke: Macmillan, 1989. The best-known example is her *Corps étranger* installation, 1994. See Ankori, "Dis-Orientalisms", for a fuller analysis of Hatoum's corpus and Moore, *Arab Muslim Woman*, pp. 140–46, on "Measures of Distance".

45 Said, Edward, "Reflections on Exile", *Reflections on Exile and Other Literary and Cultural Essays*, London: Granta, 2000, pp. 177, 186.

46 See Shohat, *Taboo Memories*, ch. 3.

47 Given that Amer's images have titles such as

Diane's Pink, they may be seen alternatively as commentary on Western voyeuristic and pornographic traditions.

48 For a longer analysis of Sedira's work, up to and including *Jinns*, 2001–2004, see Moore, Arab Muslim Woman, pp. 130–40.

49 Sedira, Zineb, "The Oblique Gaze: Notes of an Artist/Notes of a Spectator", Lloyd, ed, *Contemporary Arab Women's Art*, pp. 217, 216, 217.

50 A feminisation of *Beur*, French back-slang for 'Arab'. Initially a term of abuse, it has, to some extent, been reappropriated by second-generation Franco-Maghrebians.

51 Personal communication with Sedira, February 2009.

52 An analogous term might be nostalgic. Khanna links nostalgia and melancholia and gives them a theoretical edge as 'a wound rather than simply a romanticisation… an encrypted critical relation to that home for which the nostalgic person longs'. Khanna, Ranjana, *Algeria Cuts: Women and Representation, 1830 to the Present*, Stanford: Stanford University Press, 2008, p39. It is beyond the scope of this essay to engage the *nostalgérie* evoked by Derrida and Hélène Cixous, both Algerian-born, as part of the genealogy of deconstructionist thought.

53 Derrida, Jacques, *Of Hospitality*, trans. Rachel Bowlby, Stanford: Stanford University Press, 2000, pp. 142–143. See also Cixous, Hélène, "Albums and Legends", Mireille Calle-Gruber and Hélène Cixous, *Hélène Cixous, Rootprints: Memory and Life Writing*, London: Routledge, 1997, and "My Algeriance", *Stigmata: Escaping Texts*, London: Routledge, 1998.

54 Derrida, Jacques, *The Truth in Painting*, trans. Geoffrey Bennington and Ian McLeod, Chicago: Chicago University Press, 1987, p. 54.

55 Khanna, *Algeria Cuts*, pp. 38, 35. The ambivalence of the French terms *l'hôte*, host

or guest, from *hostis*, which can also mean a sacrificial victim, and *l'étranger* (foreigner/ stranger) underpins these theoretical interventions. See Khanna, *Algeria Cuts*, p. 41.

56 Khanna, *Algeria Cuts*, p. 5, original emphasis.

57 Khanna, *Algeria Cuts*, p. xvii.

58 Ahmed et al, "Introduction", p. 9.

59 See Derrida, *Monolingualism*, on the 'prosthesis of origin', a form of futurity within which the past inscribes itself.

60 Khanna, *Algeria Cuts*, pp. 6–7.

DESIRE IN DIASPORA
TJ DEMOS

"If I could do something for you, anywhere in Palestine, what would it be?" This question was posed to Palestinian exiles in 2003 by Palestinian artist Emily Jacir. Taking advantage of her ability to move about relatively freely in Israel with an American passport, Jacir promised to realise the desires of those forbidden entry into their homeland. A series of texts, black lettering on white panels, describe the various requests. Colour photographs, presented by their side, document Jacir's actualisation of them. The project is titled *Where We Come From*. "Go to my mother's grave in Jerusalem on her birthday and put flowers and pray", reads one plea in Arabic and English. The text tells us that the man who made the request, Munir, lives a few kilometres away in Bethlehem but was denied access to Jerusalem by the Israeli authorities. Consequently, he could not visit his mother's grave on the anniversary of her death. Jacir, on the other hand, could. A photograph shows her shadow floating over the tombstone as she carried out the task. It is a fleeting presence that is rather a painful absence. If it fulfills a desire, it remains phantasmic, vicarious.

As with the work of Ayreen Anastas, Mona Hatoum and Rashid Masharawi—other artists who deal with the Palestinian diaspora—it is perhaps the complexity of exile that drives Jacir to neo-Conceptual strategies: the photo-text presentation, the linguistic dimension, the task-based performance, the statistical survey of responses, the use of the newspaper advertisement, the artist as service-provider. By taking up such models, the condition of exile that is her subject emerges within her work, drifting between mediums, producing material displacements, necessitating physical travel, collaborating with diasporic communities. Moreover, Jacir takes up recent reconfigurations of site specificity, where the once-grounded art object, moored to its geographical site (as in post-Minimalist projects by artists such as Richard Serra), has given way to deterritorialisation in artistic practices of the 1990s. The stress now falls on 'discursive' redefinitions of site, on recognitions of the impossibility of geographical delimitation due to

institutional or capitalist pressures that throw the object —or its uprooted reproductions—into a circulating marketplace, or again, alternately, change the context around the site-specific work.[1] Jacir's project, similarly, is thoroughly defined by the experiential crisis of *displacement*, but is far from the self-assuring phenomenology of site specificity and the open access to location that it took for granted. This turn away from site specificity is due not only to the discursive, legalistic, economic and national conditions of the framework she investigates— the Palestinian diaspora—which obviously resists any reductive geographical delimitation. And it owes not only to the fragmented status of her objects and performances, which stretch across a variety of mediums (sculpture, text, photography, video, and so on), distribution mechanisms (galleries, newspapers, commercial outlets), and geographical sites (Israel/Palestine, Texas, New York City). It is also because there is no such thing as site specificity for exiles.

The *impossibility* of 'sitedness' explains why exile is such a ravaging, even self-mutilating experience, as those who have experienced it testify: exile represents "the unhealable rift between a human being and a native place, between self and its true home", writes the Palestinian exile Edward Said, a rift that separates one from "the nourishment of tradition, family, and geography".[2] Were any site latched onto, it appears, the attachment would too easily be exposed as compensatory or nostalgic, reactionary or escapist. Consequently, *Where We Come From*, like much of Jacir's work, concerns the (im)possibility of movement, rather than the plausibility of sitedness. Its locus—where we come from—can only be imagined, not physically occupied. It is the forbidden centre around which exiles perpetually revolve. Yet movement too, whether in terms of immigration, exchange, travel, or translation, is profoundly troubled in this work, even while often desired. Viewers face a project that is first of all divided between text panels and photographs. But how to get from one to the other?

EMILY JACIR
Where We Come From
2001–2003, detail (Munir)
American passport, 30 texts, 32 C-prints and 1 video
Text: 24 x 29 cm, Photo: 89 x 68.5 cm
Courtesy Alexander and Bonin, New York, photo: Bill Orcutt

Go to my mother's grave in Jerusalem
on her birthday and put flowers and
pray.

I need permission to go to Jerusalem. On the
occasion of my mother's birthday, I was
denied an entry permit.

- Munir
Born in Jerusalem, living in Bethlehem
Palestinian Passport and West Bank I.D.
Father and Mother from Jerusalem
(both exiled in 1948)

Notes: When I reached the grave of his mother, I was surprised
to see a circle of tourists surrounding a grave nearby. It was the
grave of Oskar Schindler...buried next to a woman whose son
living a few kilometers away is forbidden paying his respects
without a permit. There were many graves that had smashed
crosses and sculptures of the Virgin Mary destroyed. The
caretaker of the cemetary told me that Jewish extremists had
raided the cemetary and desecrated many of the graves. He
showed me the ones he fixed.

زوري قبر والدتي يوم عيد ميلادها و ضعي
الورود على قبرها و صلي.

كنت بحاجة إلى تصريح للذهاب إلى القدس في
يوم عيد ميلاد والدتي، و لكن تم رفض منحي
التصريح.

- منير
من مواليد بيت لحم، و يعيش في بيت لحم
جواز سفر فلسطيني/هوية ضفة غربية
الأب و الأم من القدس
(نفيا عام ١٩٤٨)

ملاحظات: عندما وصلت قبر والدته فوجئت برؤية مجموعة من
السياح يحيطون بقبر قريب. كان ذلك قبر أوسكار شندلر، الرجل الذي
يرقد الآن بجوار السيدة التي لا يستطيع ولدها المجيء لزيارتها بدون
الحصول على تصريح، و الذي يقيم بضعة كيلو مترات فقط. لقد وجدت
العديد من الصلبان و تماثيل السيدة مريم العذراء محطمة.
قال لي حارس المقبرة إن مجموعة من اليهود المتعصبين
هاجموا المقبرة والحقوا الدمار بالعديد من القبور. لقد أراني
الحارس الصلبان و التماثيل التي أعادها إلى مواضعها.

EMILY JACIR
Sexy Semite
2000–2002, three issues of *Village Voice*,
Palestinians placed ads seeking Jewish mates in
order to be able to return home utilising Israel's 'Law
of Return'
Courtesy Alexander and Bonin, New York

The visual transition from language to image, from text panel to photograph, seems simple enough; a mere shift of the eyes will do. And the descriptions involve things we often take for granted: visiting one's mother, eating food in a restaurant, playing football. Yet it is just this translation, written out in clear language and then realised photographically, that for many is insurmountable. Getting from written description to photographic actualisation can be easy enough for some, like Jacir, who have American passports.[3] But for those unfortunates caught up in the politics of the Israeli-Palestinian conflict that has been raging since 1948, when so many were exiled from their land, the terrain between text and photograph, description and realisation, represents an unbridgeable chasm, an impossibility on which a complex of desire is built.

The piece operates, it would seem, by fulfilling desire. But whose desire? We learn, first of all, about the desires of exiles from their own requests: they yearn for family (seeing one's mother, visiting a parent's grave); they pine over homesickness (visiting the family home, recalling the old land); they wish to participate in simple everyday activities (playing football, walking in Nazareth); they even hold banal pragmatic concerns (paying bills, watering a tree). These requests can also be intimate. Rami asks to: "Go on a date with a Palestinian girl from East Jerusalem that I have only spoken to on the phone. As a West Banker, I am forbidden entry into Jerusalem." The photograph shows the date that took place at a restaurant. Across the table sits the woman, clearly not thrilled with the situation. The sometimes bureaucratic tone of the descriptions reveals the fact that even diasporic desires can become routine after so long, which is yet another tragic element: the banality of exile.

We also learn about the artist's desires: to somehow provide connections through an artistic mediation that would draw together a diasporic community, shed light on the absurdity of displacement and show the privations exiles suffer, which most of us take for granted. Jacir's wish, it seems, is to reassemble the splinters of diaspora into a single place, to build some form of narrative continuity, to narrate an interconnected history. Yet often Jacir's performance, informed by the 'notes' she appends to the

bottom of the texts, only ends in bathos, or still more confrontations with the degraded status of Palestinian suffering, as when she carried out Munir's request: "When I reached the grave of his mother, I was surprised to see a circle of tourists surrounding a grave nearby. It was the grave of Oskar Schindler… buried next to a woman whose son living a few kilometres away is forbidden [from] paying his respects without a permit." The artist's own identification with the subjects is clear, as she acts out their gestures, becomes an extension of their will, becomes them, pointing the mobility of exile itself as a shifting form of identification. Polymorphous, it drifts from geographical displacements to psychic splits to ethical contradictions, and it is inhabited by the exiled and the empathic, even while the two are far from equal.

'Diaspora': from the Greek, *dia*, 'apart' or 'through', plus *speirein*, 'to scatter'; can its tears be repaired, its pieces recollected? This question informs the viewer's desire too, which soon wells up when viewing the piece. We read the text on the left and then look at the task's completion on the right (normally a one-to-one correspondence, but sometimes there are several photographs, or a video). The resolution, from description to realisation, witnessed over and over again (the series has some 20 pieces) repeats the habitual structures of the act of reading, of narrative denouement, and of the pictorial *connectedness* of the diptych structure. We not only see these connections repeated over and over; we come to desire them ourselves. As we come to pronounce the texts, repeating the first-person accounts that slip from the words of others to those of ourselves, we identify with the position of exile: *I* desire to be able to visit *my* mother, to enjoy everyday life in *my* native land, to see *my* friends, and so on. *We* want to see these things carried out for others, for ourselves. In this regard, the photographs further suture the identification, as Jacir's lens becomes the viewer's eye; that is *my* shadow falling across the grave.

But it is precisely the seeming ease of making this transition for the viewer—from textual description to photographic realisation—that dramatises the tragic impossibility for the exiled to realise their desires themselves. Unlike the fantasy of the genie who emerges from the bottle to grant

three wishes (an Orientalist cliché the piece self-consciously tropes), there is no happy ending here: Jacir's 'service' is to show the pathos of desire and its unlikely satisfaction in the artistic sphere. This division between desire and impossibility is inscribed into the piece's very formal structure. The more we look, the more we become aware of the gaping disjunction between the two panels, between the representational conditions of writing and those of photography, between the artist's camera and the exile's eye. Ultimately, in any given combination, there are two very different pieces: one, an exile's wish; the other, an artist's performance. The wish, further, is split into Arabic and English, designating two separate audiences: one, the exile; the other, the viewer of art—or both together, the bilingually split subject of displacement. More, the enactment is reduced to a glossy photographic finish, which sparkles like the fetishistic cover-up that defines the photograph's compensatory relation to loss.[4] In other words, there is little salve in Jacir's service, little benefit that can be gained from her proxy performance, little life or warmth in the photograph. As a stand-in for the realisation of a yearned-for desire, the photograph is a cold and unsatisfying substitute. But, cruelly, it is the only one to be had.

It is not surprising that exchange frequently turns into a kind of compulsion for Jacir, one that re-enacts in disguised form the movement that in other arenas is foreclosed. In *Change/Exchange (3 Days)*, 1998, Jacir took $100 and exchanged it for French Francs 67 times until the sum, after three days of fees, was gradually reduced to insignificance. The piece displays photographs of currency exchanges paired with receipts of transactions. Border crossings for money, these places are portals for a global economy of

deterritorialisation, of continual transactions. Still, even this exchange is never free, we learn, and its costs vary from place to place. Exchange can gradually wear down even money. Similarly, in *My America (I am still here)*, 2000, Jacir went to various stores in the World Trade Centre mall and bought a variety of goods. She later returned them, completing a circuit of ownership and currency transactions. The circuit is replayed in the documentation, where photographs of the purchases are presented with receipts of the full refund. An infinite back and forth seems possible, the object caught in an eternal return. But if *My America* realises certain privileges of living in America (participating in a consumerist fantasy, even being able to resist that fantasy when one wishes to return goods), then the parenthetical *I am still here* signals the undesirability or impossibility of other returns (since *she* is still *here*).

These pieces re-enact an exchange with veiled content. They stage a perverse inequality between things and people. That inequality is the ability of commodities to move about relatively freely through global markets, across national borders, whereas people (so often the focus in her projects) are restricted physically and geographically. People, not things, are denied entry into certain territories or nations, regimented in ways that are politically instrumental to maintaining political bodies, economic groupings and ethnic identities. Jacir responds again in *Sexy Semite*, a series of mock personal ads she had her friends take out in the *Village Voice* between 2000 and 2002. "You Stole the Land, May as Well Take the Women! Redhead Palestinian ready to be colonized by your army" reads one ad. Another: "Shalom baby! Hot Palestinian Semite gal Hoping to find my perfect Israeli man. Let's

EMILY JACIR
Crossing Surda
(a record of going to and from work) (below and opposite)
2002, two-channel video installation,
dimensions variable
Courtesy Alexander and Bonin, New York

From Texas with Love (opposite right)
2002, Video installation, 60-minute video-DVD, MP3-CD
with 51 songs, commissioned by Marfa Studio of Arts
Courtesy Alexander and Bonin, New York

stroll the beaches of Akka & live and love in Jerusalem. No Fatties."Beyond the funny reversal of the Israeli/ Palestinian conflict into a personals' tryst, the humour of the piece turns on the collapse of Israel's Law of Return (allowing any Jew to emigrate to Israel and obtain citizenship) with the controversial Palestinian right of return (claimed by Palestinian exiles, denied by Israelis).[5] While for some this indicates the direction of future revolutionary energies—to struggle for open borders—for Jacir the task is more modest: to meditate on the ridiculous effects of such barriers on people's lives, to show that ridiculousness by contrasting it with the ease of other forms of exchange, or easy exchanges enjoyed by others.[6]

Jacir also explores the effects of travel restrictions placed on people in *Crossing Surda (A Record of Going to and from Work)* of 2003. The video shows the everyday commute to work that multitudes of Palestinians are forced to walk due to a frustrating travel checkpoint manned by Israeli soldiers. This was the last remaining open road connecting Ramallah with Birzeit University and approximately 30 Palestinian villages, until it was disrupted by the checkpoint in March 2001. Consequently, everyone, including the disabled, elderly and children must now walk as far as two kilometres to traverse a path they could once drive. When the Israeli soldiers periodically decide to shut it down, they fire live ammunition, tear gas, and sound bombs to disperse people from the checkpoint. Shot with Jacir's own hidden camera, the video documents the walk, occasionally showing everyday encounters between ordinary

Palestinians and Israeli military might. Otherwise, the clandestine tape exposes nothing so much as the very interdiction on the representation of such borders as a further act of oppressive control. The frustration caused by endless checkpoints and border controls explains why Jacir once got in a car and drove without stopping in Texas. *From Texas with Love*, 2002, presented the resulting video: one hour showing the road ahead. The piece was no doubt directed towards Palestinians under occupation. In fact Jacir asked them the question: "If you had the freedom to get in a car and drive for one hour without being stopped (imagine no Israeli military occupation; no Israeli soldiers, no Israeli checkpoints and roadblocks, no 'bypass' roads), what song would you listen to?"The responses varied.

For the artist, "The ability to actually experience such a freedom in other countries is a painful marker and reminder of the impossibility of experiencing such a basic human right in Palestine."[7] There is a punishing side-effect to such enjoyment, like driving freely in Texas. When one endlessly repeats the freedom of movement *here*, one also continually reenacts the painful reminder of its impossibility *there*. For Jacir this dialectical reversal is just the point: the piece is less about the utopian escape from the restrictions of occupation, which, never naïve, is continually ironised in Jacir's work; rather, it allows the expression of freedom to dramatise a profound unfreedom.

Sometimes, Jacir turns exchange into a mode of subversion. *O Little Town of Bethlehem* of 1999 is a series of Christmas

cards, Hallmark-style. One shows a colour image of three men on camels riding in the desert toward a radiant manger in the distance, flanked by palm trees. Kitschy cards like this could be found at any convenience store in any town across the United States. Upon opening the card, however, one reads its consciousness-raising message:

> There has not been a "silent night" in Bethlehem in over two months. Homes, churches and mosques have been under constant Israeli bombardment. Innocent civilians have been killed by US-sponsored Israeli bullets and bombs. Olive trees, which Palestinians have tended for centuries, have been razed to the ground by the Israelis.

A website is provided, as are the artist's name and email address. Infiltrating the normalising circuits of everyday exchange, both consumerist and ideological, these 'Christmas cards' were clandestinely placed in stores to await unsuspecting shoppers. Other such cards display an appropriated traditionally religious image of the manger, but now with Israeli Apache helicopters (made in the US) hovering overhead threateningly, like giant mosquitoes. The collage that united the two orders of representation is cartoonish but slick, and aside from its subversive content the representation appears like a typical holiday card, which Jacir had professionally printed once she made her alterations. The commercial-style montage signals the collapse of one-time radical avant-garde strategies (from the work of John Heartfield to that of Martha Rosler) into today's

mass-marketing design (Hallmark cards), revealing the domination of representational space by commercial design. But Jacir's appropriation counter-attacks by reclaiming the commercial image of Bethlehem for her own arsenal. The politics of space, for Jacir, is simultaneously a war of graphic design, a contest of the distribution of propagandistic images, and a conflict over the domination of real territory. But such a representational appropriation can hardly compete with the occupation of geographical space by the formidable Israeli Defense Force. While the tactics of montage once indicated a front for opposition, today such avant-gardist fantasies can only be engaged ironically: Jacir's intervention is miniscule, even laughable, compared to the massive machinery of media and military control brought to bear on Middle-Eastern space, discursive and geographic.[8]

The apparent impossibility of seizing the means of production, of re-engineering revolutionary images that would dismantle the propaganda structure of power and deliver an insurgent political message to the masses —which Heartfield attempted to carry out in the 1930s —informs the resignation and double-edged tone one feels in much of Jacir's work. This is perhaps why her project rarely adopts a reductively critical rhetoric, or an oppositional voice confined by its politically instrumentalised speech. If it does so, it is distant from other models of Conceptualist critique, even if it occasionally comes close to the older accusatory polemics of such work (such as Hans Haacke's systematic subversion of corporations, or certain photomontage strategies of the 1970s and 1980s, such as

Rosler's). Rather, Jacir pursues a meditation on a political conflict and its representational complexities, and she exposes not only the oppressive policies of Israel but also the absurd and inhumane effects of such policies on Palestinian lives, as in *Where We Come From*.

The vicarious, not victorious, realisation of diasporic desires that *Where We Come From* performs, is, in the end, no substitute for the basic, even human rights denied to those in exile. It is exactly that failure that guarantees the success of this piece. Through it we focus on the absences that Jacir's service cannot fill. These instil a yearning in us, its viewers, to see some sort of resolution, to wish for an answer to the inequities of movement outside of the piece. "If I could do something for you, anywhere in Palestine, what would it be?" The desire this question elicits is ultimately very difficult to occupy, at least for us who are not exiles, as we can only understand it—vaguely—on the basis of what we can do. What would it be like *not* to be able to do these things? But neither is it a position that power can occupy, for power produces it in the first place: the structure of exile is already responsive to various occupations. A feeling of sitelessness, of a damaged life, results from the experience of requiring another to carry out the wishes that cannot be performed by oneself. Consequently, one is denied the feeling of being at home in exile due to thoughts of the loss of one's home. But this is a sitelessness that is frequently relished in exile as well, which is perpetuated in Jacir's work: to *refuse* to feel at home while homeless and—perhaps perversely—to enjoy it, for the converse would only be a mark of resignation or of capitulation.[9]

Edward Said points out the troubling uncanniness of the Palestinian diaspora: "to have been exiled by exiles". What results is a mirroring frequently answered with aggression to deny exile even to the exiled. For it produces a double displacement, not only of bodies from territories, but stories from history, nations from narration. But is this not a repression that only continues the mimetic cycle, eliciting aggression in turn? Said notes: "It is as if the reconstructed Jewish collective experience, as represented by Israel and modern Zionism, could not tolerate another story of dispossession and loss to exist alongside it—an intolerance constantly reinforced by the Israeli hostility

to the nationalism of the Palestinians, who for 46 years have been painfully reassembling a national identity in exile."[10] The poignancy of *Where We Come From* is that it begins to tell the story of the Palestinian diaspora in a way both humanising and tragic, where an identification might take place outside of threat, an itinerant desire without hostility.

An earlier version of this essay appeared in the Winter 2003 issue of *Art Journal*, published by the College Art Association. Copyright TJ Demos.

1 On this complicated history, see Miwon Kwon, *One Place after Another: Site-Specific Art and Locational Identity*, Cambridge, MA.: MIT Press, 2002; and George Baker and Christian Philipp Müller, "A Balancing Act", October 82, Fall, 1997.

2 Edward Said, "Reflections on Exile", *Granta* 13, Autumn, 1984, p. 159.

3 Although following subsequent political developments in Israel, including the building of further barriers and the construction of the separation wall dividing Jewish Israel from the Occupied West Bank, Jacir would no longer be able to move around in the West Bank as she once did.

4 Barthes writes about the photograph of his own mother as such a fetishistic stand-in for loss in *Camera Lucida: Reflections on Photography*, trans. Richard Howard, New York: Noonday, 1981. One could also reference Mona Hatoum's *Measures of Distance* of 1988, which explores the renewal of a mother-daughter relationship broken apart in the midst of war-torn Lebanon in 1981. Hatoum's focus, however, is on the material mediations of this relationship through the use of video and overlays of Arabic script that seem both to repair and to rupture.

5 Though many missed the joke. The Anti-Defamation League and the Israeli Consulate took seriously its conspiratorial tone, even imagined terrorist agenda.

6 For Palestinians in particular, but also for leftists in general, as in its most recent expression: Michael Hardt and Antonio Negri, *Empire*, Cambridge: Harvard, 2000.

7 The piece was shown in "One Ground: Four Palestinian and Four Israeli Filmmakers" at the University of California Riverside, California Museum of Photography in 2003. The quote comes from the website: www.cmp.ucr.edu/oneground/emily.jacir.html

8 For further elaboration on the status of irony in contemporary art, see my essay "The Cruel Dialectic: On the Work of Nils Norman", *Grey Room* 13, Fall, 2003.

9 Theodor Adorno, writing in exile from Nazi Germany, reached a similar conclusion: "it is part of morality not to be at home in one's home". *Minima Moralia: Reflections from a Damaged Life*, trans. EFN Jephcott, New York: Verso, 1991, p. 39.

10 Said, p. 164.

THE DOCUMENTARY TURN: SURPASSING TRADITION IN THE WORK OF WALID RAAD AND AKRAM ZAATARI
SUZANNE COTTER

In Lebanon, the very question of how one might engage with the image as a medium of expression drives intellectual and artistic sensibilities. In a country still living the consequences and continuations of a devastating sequence of wars, the very production of image-making, let alone its credibility within the highly contested zones of public discourse, is called into question. For artists working within or in response to this context, we move from the primacy of the visual to the concept of the image as footnote, a malleable point of reference in a stream of contested histories competing for a place to be written.

The work of Walid Raad and Akram Zaatari offers two distinct but equally compelling approaches to visual practice. Each artist has developed new forms of address that express the conditions and consequences of Lebanon's recent history, bound to the period of violent civil war, or wars, between 1975 and 1990, and the contradictions—if not impossibility—of their objective representation. In their respective works, the collected document, be it photographic, textual or aural, is a central premise, as is the writing of history in which tangential events and the subjective eye-witness are privileged players. Both engage in processes of dismantling and attempts at reconstruction of the multiple perspectives of this history. Both articulate narratives of a fragile present still coming to terms with its past and looking to find a language with which to express the future.

Walid Raad's exposés of real and alleged events, presented by way of the power-point lecture, documentary-style video works and photo-textual displays, is pointed in its articulation of mechanisms through which history is constructed. Nimbly blurring facts and fiction within an elaborate exposition of impersonation and parody, he reveals the arbitrary nature of these mechanisms and their laughable inefficacy. Working with the history of

photography and filmmaking genres, Akram Zaatari's layered use of written and recorded testimonies and autobiographical material, addressing themes of resistance and the transmission of experience, propose a new form of individual and social portraiture.

Raad's creation of The Atlas Group, 1989–2004, "a project established in Beirut in 1999 to research and document the contemporary history of Lebanon", has resulted in an impressive body of work that mimics the very structure of the forensic archive. The very idea of a largely unidentified collective of individuals (Raad is the only acknowledged member) is redolent with unease, ideas of covert operations, surveillance and undercover activity. It also raises questions about authorship and the construction and dissemination of history, of whom we can trust, and the validity of information purporting to come from a position of empirical authority.

Complete with numbered files, the archive is organised according to three main categories: Type A (attributed to an identified individual), Type FD (found documents) and Type AGP (attributed to The Atlas Group). The subject of these so-called files relates to the situations and conditions of living through the Civil War, from the experience of being held hostage (The Bachar Tapes) and surveillance (*I only Wish that I Could Weep*, [Operator 17]), to the unsolved disappearance of citizens and family members (*Secrets in the Open Sea*, [Anonymous]) and a taxonomy of the charred remains of car engines found after car bomb attacks (*My Neck is Thinner Than a Hair*). Raad plays on the stereotypes we have come to associate with this period of Lebanon's recent history, filtered through the clichés of East-versus-West and its abiding legacy.

Written and verbal explanations and annotations, generally in Arabic and translated into English, abound

in The Atlas Group archive. Each proposes a subjective interpretation of seemingly objective evidence. In the Fakhouri Files, made up of collected documents from one Beirut-based amateur historian, Doctor Fadl Fakhouri, we find a series of annotated notebooks, photographs and films dating from the early years of the Civil War. *Miraculous Beginnings*, we are told, is the result of Fakhouri exposing a roll of super 8 film, frame by frame, each time he thought the Lebanese wars were going to end. Literal snapshots of façades of buildings, familial interiors and fleeting glimpses of daily life are caught and replayed in stroboscopic rhythm, passing before our eyes at lightning speed; the assault of these flickering moments of hope is devastating in its poignancy.

The subjective act of prediction is also present in another work from the same File A, *The Missing Lebanese Wars*, Notebook Volume 72. Raad draws our attention to interpretations of the event rather than the event itself. We are told that the collection of small black and white photographs attests to a betting circle of historians from Lebanon's then leading political parties—Maronite Nationalists, Socialists, Marxists and Islamists—who would meet regularly at the races. In an absurdist twist, rather than bet on the horses, each member of the group would bet on the distance between the horse and the finishing post at the time at which their win was captured by the course photographer. The photographs themselves reveal the just-before or the just-after, but never the

actual moment of passing the post. Adding to the seemingly evasive tactics of our gamblers, we are witness to Fakhouri's carefully pencilled notes on the length of the race, the critical distance between the horse and finishing post and his observations on the characters of the winning punter: "He was imbued with a patience and otherworldliness ill-suited for politics"; "Uncivil and sullenly rude."

Like some brilliant prodigy let loose in the laboratory, Raad's visible role in the construction of the archive's various files adds a further layer to the idea of subjective histories. There is an elegantly mordant wit to his analyses of the social, economical and ideological systems that underpin war and its representation. His addition of brightly coloured dots on a group of black and white photographs in *Let's be Honest, the Weather Helped*, 1998, which recall John Baldessari's reflexive photomontages from the 1980s, are meant to refer to the different coloured tips of ammunition used by a host of national forces fighting in Lebanon during the Civil War. If certain images showing a dense build up of dots along the façade of a building have some credibility as a record of an identifiable military intervention, Raad's account of this particular form of mapping becomes more patently dubious when it names countries such as Switzerland as part of the elementary table of munitions distribution, with the traces from its white-tipped cartridges delineated as a single, large dot on the trunk of a solitary tree.

THE ATLAS GROUP / WALID RAAD
Let's Be Honest, The Weather Helped
1984–2007, archival colour inkjet print,
17 prints, each 46 x 72 cm
Copyright the artist, courtesy Anthony Reynolds Gallery, London

The aesthetic strategies at play in The Atlas Group archive suggest some explicit references to the language of photojournalism and reportage but also to that of photoconceptualism, "the quintessential anti-object", in which the photographic image never functions alone but always in relation to other objects, forms and narratives.[1] Raad's an-aesthetic approach to his work, its marks of indifference in the presentation of supposedly found images assembled by the persona of an amateur, also echo the deliberate 'deskilling' of the medium that was integral to the anti-aesthetic of Conceptual art (Raad's claim of authorship to certain collections of photographs in The Atlas Group archive are ostensibly dated from the artist's pre-formed adolescence): "In photoconceptualism, photography posits its escape from the criteria of art-photography through the artist's performance as a non-artist who, despite being a non-artist, is nevertheless compelled to make photographs." If Dan Graham's photo-essay *Homes for America*, 1966–1967, or Ed Ruscha's *Every Building on the Sunset Strip*, 1966, serve as prime examples of this approach, Martha Rosler's exposition of the photographic image as necessarily part of a critically discursive space in *The Bowery in Two Inadequate Descriptive Systems*, 1974, offers a particularly pertinent reference for Raad and The Atlas Group archive.

In response to the idea that his work might extend the possibilities of Conceptual art's tenets from the perspective of twenty-first century Lebanon, Raad proposes instead that his work represents its negative. If Raad's work contributes to an expanded terrain for a history of Western experimental culture, he aligns it, more crucially, to an emergent artistic language capable of communicating the complexities of living in a country affected by war. For Raad, it is precisely the impossibility of the conditions that allowed for Conceptual art to flourish in Europe and North America in a context such as that of Lebanon, where the very act of photographing is regarded as a suspicious act and the validity of photographic document itself is regarded with scepticism.[2]

In contradistinction to the operations of Conceptualism, Raad situates his work within the philosophical propositions of the writer Jalal Toufic, whose notion of "the withdrawal of tradition past a surpassing disaster" has proved especially resonant for Raad and his contemporaries in articulating the ghostly presence of established conventions of image-making in the wake of calamitous events, or of their reappearance as an act of haunting or resurrection.[3] A further connection might be made between Raad's enterprise and Aby Warburg's *Mnemosyne Atlas*, conceived in 1927 and continued to his death in 1929. In an unpublished introduction to the Atlas, itself an attempt to construct a collective historical memory of Western European thought, Warburg, in prescient anticipation of the calamitous consequences of Fascism and the Second World War, wrote of the relationship between memory and trauma: "Mnemonic desire… is activated especially in those moments of extreme duress in which the traditional material bonds between subjects and objects, and between objects and their representation appear to be on the verge of displacement, if not outright disappearance."[4]

In the summer of 2008, Raad presented a 'retrospective' exhibition at the Gallery Sfeir-Semler in Beirut. Titled A History of Modern and Contemporary Arab Art Part 1. Chapter 1: Beirut 1992–2005, it was the first of what is intended to develop into a multi-form elaboration of the use of the archive as medium. In the first manifestation of this new body of work, which Raad anticipates will develop over a number of years, he uses the reflexive strategy of the exhibition format itself to explore what he describes as "the emerging infrastructure for the creation, distribution and consumption of Arab art and artists". The six-room installation was organised with Raad's characteristically taxonomic precision:

1. Part I_Chapter 1_Preface: Title 23
2. Part I_Chapter 1_Section 79: Walid Sadek's *Love Is Blind* (Modern Art Oxford, UK, 2006)
3. Part I_Chapter 1_Section 79: Index XXVI: Artists
4. Part 1_Chapter 1_Section 8a: Museums
5. Part I_Chapter 1_Section 139: The Atlas Group (1989–2004)
6. Part I_Chapter 1_Section 271: Appendix XVIII: Plates

The section on The Atlas Group presented a scaled-down model of the almost complete archive. The second section,

WALID RAAD
A History of Modern and Contemporary Arab Art Part
I Chapter 1: Beirut 1992–2005, Section 79: Walid
Sadek's Love Is Blind (Modern Art Oxford, UK, 2006)
2008, paint on wall, 4 x 10.3 m and 4 x 6 m
Courtesy the artist and Gallery Sfeir-Semler, Beirut

Love is Blind, featured a *trompe l'oeil*-painted reproduction of a work by Raad's fellow artist Walid Sadek as it was installed in the exhibition Out of Beirut at Modern Art Oxford in 2006, in which Raad also exhibited. In a further layer of historical reverberation, the work by Sadek references a series of paintings by yet another Lebanese artist from the first half of the twentieth century, Moustafah Farroukh. While Raad's nascent enterprise reveals the systems of constructing an all too consumable contemporary Middle-Eastern art, it also eloquently conveys the condition of the artist who, like history, is reduced to the state of a document, a mere footnote in a sequential telling of events stripped of context and consequence.

In contrast to Raad's discursive use of the archive as format, Akram Zaatari dislikes the use of the term in discussing his work. Instead, he prefers to discuss the multi-faceted approach that defines his practice as "field work".

Zaatari consciously plays on the genres of photographic practice and film, from the studio portrait to documentary filmmaking. Reinventing these traditions in an attempt to adequately reflect the dynamics of image-making arising out of conditions of war, he has developed an extensive practice in which he assumes the role of collector, researcher, and curator. He considers his different photographic and film portraits as "objects of study", collected for the purposes of specific phenomena, whether it is the practice of photography in Lebanon or the broader Middle East, or communicating the experience of imprisonment and acts of resistance.[5]

Zaatari's "habits of recording" are related to his adolescent years in Lebanon during the Civil War. Growing up in the southern town of Saida in a relatively protected environment, and with few opportunities to leave his parent's apartment, he developed the habit of taking notes, and making photographs and recordings of the things going on around

him. That these things proved to be Israeli planes being shot down overhead by Syrian fighter pilots and news of the bombing of Beirut, or propaganda broadcasts by Lebanese resistance groups, was simply part of the daily reality that merged with his interest in the Cannes Film Festival or the latest pop release by singer Sami Clark.

The sense, prevalent in Zaatari's work, of a quotidian that contains within it extraordinary events, is particularly apparent in his exploration of resistance. His early documentary-styled *All is Well on the Border*, 1997, was shot largely in the southern suburbs of Beirut as he was unable to cross into southern Lebanon, which, since its invasion by Israel in 1978, has been at the heart of the country's resistance activities. While these activities, intended to protect the southern part of the Lebanon under the banner of the 'National Resistance', were initially led by a coalition of largely secular, left-of-centre parties, they were subsequently assumed under the leadership of the radical Islamicist movement Hezbollah as the dominant force defying Israeli occupation. Writing of the work in the context of the 'uncritical consensus' which has prevailed in Lebanon since the end the Civil War in 1991, Lebanese writer Rasha Salti has observed: "It defends a forgotten cause, speaks for the silenced, and exposes a reality occluded from representation."[6]

Zaatari's film, a deliberately self-conscious montage of still images, current and archival footage from news broadcasts and propaganda films, and recorded interviews with former resistant fighters and prisoners, bears witness to multiple perspectives on the nature of resistance. Both in terms of visual style and in the title itself, Zaatari is explicit in his references to Jean-Luc Godard's forays into *cinema vérité* in the late 1960s and early 1970s with his films *All Is Well*, produced with Jean-Luc Gorin and *Here and Elsewhere*, which he produced with Anne-Marie Miéville. True to his interest in the unmaking of existing film or documentary traditions, Zaatari engages with the very failure of Godard's ambitions for an activist cinema in order to portray a continuing and evolving narrative of conflict, imprisonment and displacement that is marginalised from mainstream visual consciousness.

The collected document as evidence in the excavation of stories that have either become obscured over time, or that simply cannot be told, is a central element of Zaatari's project of individual and collective portraiture. His film *In This House*, 2005, records the search in the garden of a house in southern Lebanon for a letter encased and buried there by a former National Front resistance fighter who had occupied the house in the early 1980s. The split-screen format presents, on one side, the resistance member—now a respected photojournalist—telling the story of his experience in the house and on the other side, the digging up of the garden and the eventual discovery of the canister containing the letter. The running table of text that accompanies the unfolding narrative identifies the owners of the house and a host of security agents who oversee the operation and whose faces, we are told, are not to be filmed. The anxiety about who or what is allowed to be caught on film together with their growing excitement as the letter is unearthed connotes the poignant tension of a country in a constant state of deferral; the dilemma of whether it is better to unpack the still unresolved consequences of events from the past or to simply carry on, and leave them buried.

Zaatari's description of works such as *In This House* as interventions is telling. Drawing on documentary methods, he produces a physical but also psychological impact on the people and places involved. For the present owners of the house where the buried letter was found, their perception has been changed by this freshly uncovered knowledge. More recently, Zaatari's style has moved on from the more straight, if not slightly reflexive, reportage of *All is Well* and of *In This House* to that of constructing a scenario to which real-life characters respond. His film *Nature Morte*, 2008, is an *intimiste* portrait of two men intent on the task of making a bomb. Filmed in a cabin interior, its painterly *chiaroscuro* is lent by the burning gas lamp which provides the principle light source, the only sounds accompanying their task those of a call to prayer from a distant mosque. It is into the crisp air of a rugged hillside that the two men part company at the end of the film, one equipped with a backpack presumably carrying the explosive device.

AKRAM ZAATARI
Neruda's Flowers
2009, set with three prints, C-prints, each 80 x 62.5 cm
Courtesy of the artist and Gallery Sfeir-Semler, Hamburg/Beirut

Revisiting his collected material over time is also a feature of Zaatari's project. For *Letter to Samir*, 2008, Zaatari filmed Nabih Awada—nicknamed Neruda—who had been imprisoned in Israel for ten years from the age of 16. Awada's poetic letters to his mother during the years of his imprisonment formed part of the content in *All is Well on The Border*. Awada's letters are also the subject of a recent series of still photographic portraits, in which the writing is erased, leaving only the author's touching embellishments of drawn, coloured flowers. Zaatari has said of his act of erasure: "What is or was significant cannot be said. The content is irrelevant; it is enough to see the drawings."[7]

Responding to a news photograph of Samir al-Qintar, Israel's longest-held Lebanese prisoner released in summer

of 2006, Zaatari asked Nabih Awada to write to the former member of the PLO to ask him why, in his first public appearance after his release, he was photographed with Hezbollah's party leaders and dressed in their Islamic party's uniform. Recorded in real time, Awada begins by stating al-Quintar's first name before writing a letter, the content of which remains unknown to us. The second half of the 30 minute film witnesses Awada folding the letter into a small capsule before encasing it in successive layers of plastic, a method that suggests the communication might be swallowed or inserted into a bodily cavity, a common means of smuggling communications from one cell or one prison to another. That the histories of Awada and his imagined correspondent are ones of shared national struggle and imprisonment is the pivotal link

around which the two narratives revolve is central to the film's unspoken narrative. We can only imagine what Awada might have written to his compatriot, empathy with his years of incarceration, the cause for which they had been fighting, confusion from the apparent shift in ideological allegiances.

The mountains and valleys of the Shebaa farms are the focus of a new but related area of Zaatari's ongoing photographic research. It is in this rugged and bitterly fought-for landscape on the border of Lebanon with Israel and Syria that he filmed *Nature Morte*. Zaatari's large-scale photographs of this same area continue his fascination with this eerily unpopulated, high-surveillance terrain. It is when talking about these photographs that Zaatari allows himself to use the term "archive", for it is here in these mountains and this earth that one might trace its cartography of clandestine resistance. Although the image suggests only what cannot be revealed or spoken, the tension of its secrets is palpable. In the impossibility of viewing these images as pure landscape, we are witness to the overshadowing of one tradition, its withdrawal if it ever existed, and the production of an entirely new way of seeing, one that seems to respond to the question of the image as a credible producer of content in a way that might allow for what might be a new tradition to begin.

1 Jeff Wall, "'Marks of Indifference', Aspects of Photography in, or as, Conceptual Art", 1995, originally published in Ann Godlstein and Anne Rorimer, *Reconsidering the Object of Art, 1965–1975*, Los Angeles: Los Angeles Museum of Contemporary Art, 1995, reprinted in Douglas Fogle, *The Last Picture Show: Artists Using Photography 1960–1982*, Minneapolis: Walker Art Center, 2003, pp. 32–44.

2 Conversation with the artist, Dubai, March 2009.

3 Jalal Toufic, *Two or Three Things I'm Dying to Tell You*, Sausalito: The Post-Apollo Press, California, 2005.

4 Benjamin HD Buchloh, "Gerhard Richter's *Atlas*: The Anomic Archive", *Gerhard Richter: Atlas. The Reader*, London: Whitechapel, p. 109.

5 Conversation with the artist, Munich, March 2009.

6 Rasha Salti, "The Unbearable Weightlessness of Indifference", *Akram Zaatari: The Earth of Endless Secrets*, Portikus, Frankfurt, Galerie Sfeir-Semler, Beirut, forthcoming, in which Rasha Salti provides an excellent exposition of the history of armed resistance in southern Lebanon.

7 Conversation with the artist, Munich, March 2009.

ARTISTS

In keeping with the diverse nature of cultural output in the region, this selection of artists eschews fixed categories in favour of a loose structure that suggests associations in a multi-layered arrangement of shifting styles and artistic practices. The section moves through photography, painting, sculpture, textiles, installation, video and performance, all knitted together according to common thematic preoccupations. The associations are implied but not enforced, creating an open-ended interaction between style and theme that provides a subtle navigation for an often contradictory, challenging collection that offers a voice for a diversity of approaches, practices and ideas.

Miss Hybrid I (right)
2006, Lamda print, 149 x 118 cm
Courtesy Galerie Kashya Hildebrand, Zürich

Miss Hybrid III (opposite)
2006, Lamda print, 149 x 118 cm
Courtesy Galerie Kashya Hildebrand, Zürich

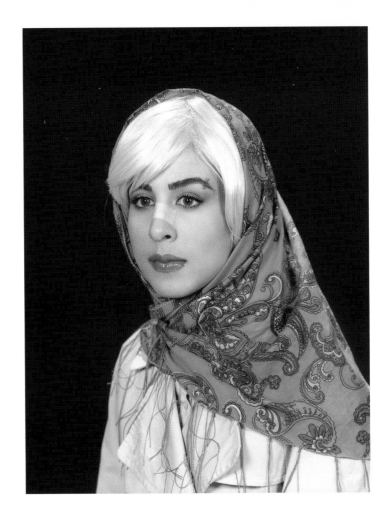

SHIRIN ALIABADI

Photography in Iran has increasingly become one of the key media for representing the present dynamic times, articulating issues of fraught geopolitics, questions of identity and cultural, sexual and social differences. Tehran-based Shirin Aliabadi's *Miss Hybrid* series, portraying young Iranian women in somewhat unconventional ways, is a perfect example. Bleached hair, azure contact lenses, immaculate makeup and colourful scarves all seem to be quite incongruous with the commonly projected image of Muslim women. The photographs are staged as studio portraits; the sitters portrayed from the mid-torso and up, against a dark backdrop. A single strip of surgical tape is applied to their noses, a curious fashion statement amongst Iranian youth connoting the increasingly common practice of plastic surgery.

In *Miss Hybrid III*, 2006, the young platinum blonde is blowing bubblegum, the pink bubble covers her mouth and her blue eyes remain fixed on the viewer. The image functions as a comment on the idea of beauty and its significance in contemporary society but can also be seen as subversive, disrupting the conventions of female dress in Iran.

Miss Hybrid I, 2006, has adopted a more conventional studio portrait pose. She is seen slightly from the side, her gaze straight-on but still slightly averted from the camera's eye. Her plump, glossed lips are firmly shut, their colour bringing out the shades of red in her headscarf. One of her eyebrows is pierced; it is a subtle detail further accentuating the adoption of a modern fashion convention familiar in the West.

The posed portraits, potentially troubling as they may be, are also striking in their colour and composition and while constructing these hybrids—crossovers between traditional attire and trends that influence 'the new Iranian girl'—Aliabadi achieves a compelling comment on artificial beauty as well as the sartorial confines of certain Muslim women. There is also a humorous aspect to the photographs as the bubblegum, piercings and surgical tape make for unexpected twists, satirising contemporary stereotypes. Here, the use of the veil is not antithetical to rhinoplasty, makeup, hair dye and the seemingly perpetual standard of blonde hair and blue eyes. Perhaps it is finally an illustration of the emancipation from one constraint only to rush into the arms of another.

Shirin Aliabadi has also collaborated with Farhad Moshiri on the project *Operation Supermarket,* shown at the Singapore Biennale in 2008. The series comprises packages and advertising manipulated so that the labels read as loaded phrases, a comment on commodification and the (failed) promise of capitalism.

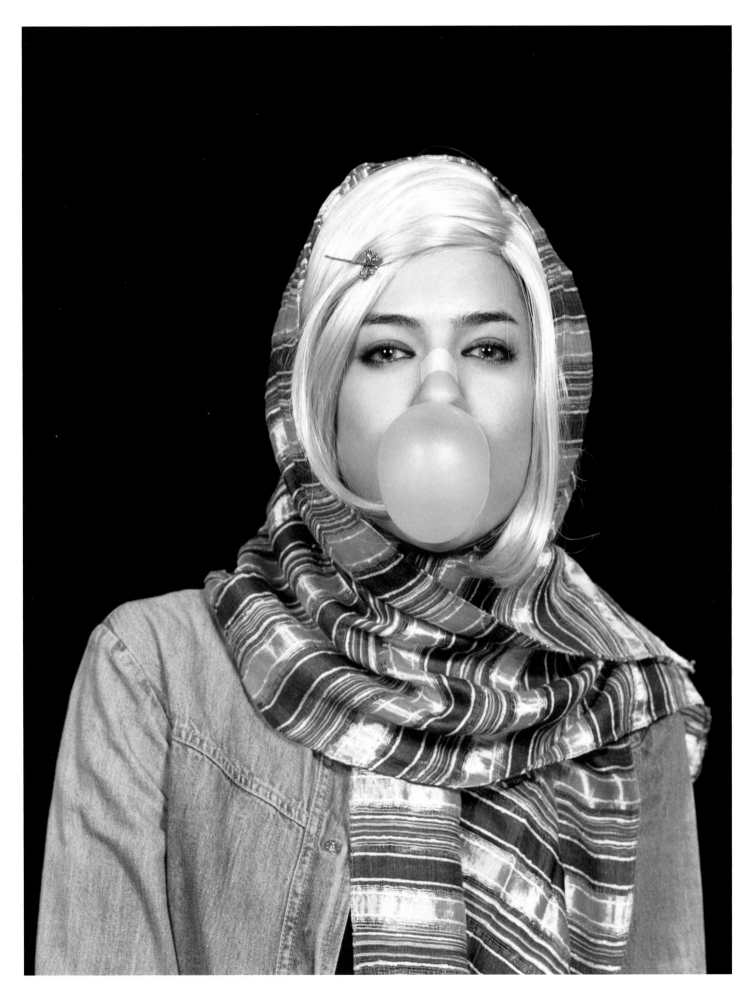

YOUSSEF NABIL
Tracey Emin (below)
2006, hand-coloured silver gelatin print
Courtesy the artist

Self-Portrait with Roots (opposite)
2008, hand-coloured silver gelatin print
Courtesy the artist

Shirin Neshat (overleaf)
2004, hand-coloured silver gelatin print
Courtesy the artist

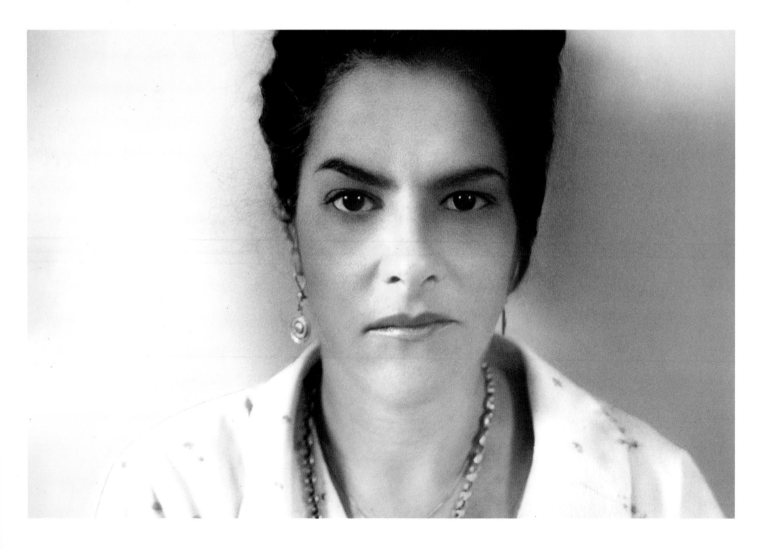

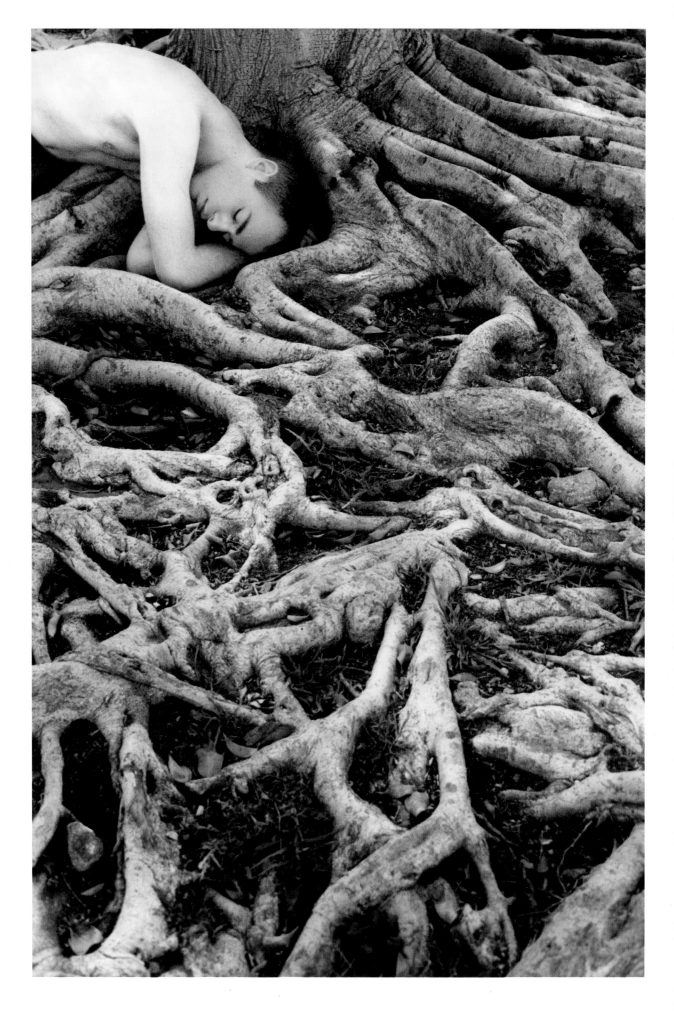

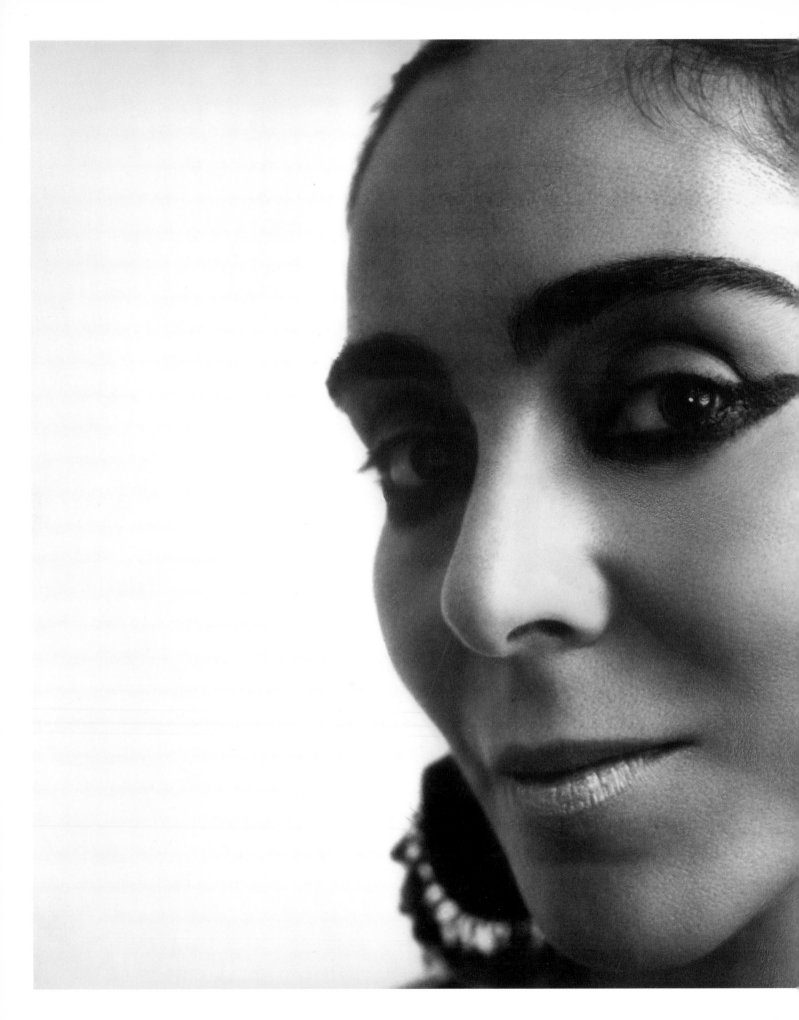

Saleh
2001, painted photograph
Courtesy the artist

OSAMA ESID

Syrian-born Osama Esid remembers looking at black and white photographs as a child and thinking that the people in the images lived in a world that had lost its colour. Feeling that colour photography embodied happiness, Esid began hand-colouring his own black and white photographs. *Saleh* from his series *Orientalism* shows a young man sitting in an interior setting. His head is slightly tilted as he gazes up at the viewer. The studio-like setting suggests a hidden, enclosed space. The man's shirt is open, revealing a bare torso; his legs are spread and his arms rest comfortably on his thighs.

Esid's oeuvre is based primarily on early 1900s portrait photography as well as representational clichés alluding to historical stereotypes of the Middle East.

The photographs from the *Orientalism* series are quite startling in this way, referencing familiar renderings of 'the East' in an uncanny manner. The concept of 'Orientalism' as discussed by Edward Said has opened up methods of thinking critically about the way in which 'the East' has been historically viewed and represented by the Euro-American world.

Saleh evokes photographs and paintings of harem scenes from the 1800s and postcards from the early 1900s where female sitters were portrayed in studio settings. The sitters were seldom identified by name; if they were labelled at all it was often with captions such as 'Woman from Algiers' or 'Women of Maghreb'. Conversely, Esid gives his subjects names, thus infusing the portrait with agency. The man in the portrait does

not appear to be in any way subservient or made to be simply a souvenir from 'a land far-far away'; rather, he appears to be challenging the viewer with his candid gaze.

However, for Osama Esid the notion of the 'Oriental' stereotype is not necessarily negative, or positive, but offers possibilities for investigation, creating new perspectives and interpretations, without the need, in his own words, "to pigeonhole a culture". Esid not only deploys common orientalist tropes but also does this consciously, thus re-appropriating negative traditions of representation. In playing with Orientalist stereotypes he creates a potentially new outlook on Middle-Eastern culture, or at least an alternative to the routine images that focus on war and fundamentalism, a common way in which the 'Occident' views the 'Orient'.

LAILA MURAYWID

La Césure des Heures (below)
2008, diptych, painted photographs on canvas,
33 x 82 cm
Courtesy the artist

A Travers les Décombres (opposite)
2001, painted photograph
Courtesy the artist and Waterhouse & Dodd

KHOSROW HASSANZADEH
Javad (right)
2008, from *Ready to Order*
Courtesy the artist and B21 Gallery

Googoush (opposite)
2008, from *Ready to Order*
Courtesy the artist and B21 Gallery

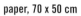

AFSHAN KETABCHI
Harem, Citrus (below)
2006, digital print on canvas
Courtesy the artist and B21 Gallery

Safavid, Miniature Wine Bibber (opposite)
2007, digital print with hand-coloured painting on
paper, 70 x 50 cm
Courtesy the artist and B21 Gallery

Speechless (opposite)
1996, RC-print and ink, 119 x 89 cm
Copyright Shirin Neshat, courtesy Gladstone Gallery

Identified (overleaf left)
1995, black and white RC-print and ink, 36 x 28 cm
Copyright Shirin Neshat, courtesy Gladstone Gallery

Zahra (overleaf right)
2008, C-print and ink, 152 x 102 cm
Copyright Shirin Neshat, courtesy Gladstone Gallery

SHIRIN NESHAT

The well-known photographic collection *Women of Allah*, produced over the period 1993–1997, very much epitomises the practice of Iranian-born artist Shirin Neshat. The series of images of Iranian women, the artist often using herself as a subject, addresses the issue of women in relation to the Islamic state and martyrdom, mobilising tropes traditionally associated with the Middle East. The veiled female body here becomes a locus for everyday life in the Islamic Republic of Iran and simultaneously a canvas, as elegant calligraphy is superimposed on the skin. The highly stylised images conform to ideas of conventional and formal beauty, but also contain troubling and poignant details.

Rebellious Silence, 1994, is a black and white photograph of Neshat dressed in a black chador, holding the barrel of a rifle in front of her—the cold steel bisecting her face as she stares directly at the viewer, her gaze unyielding. Similarly, in *Speechless*, 1996, half of a woman's face is shown up close, her right eye looking sternly at the viewer, the barrel of a gun pointing straight at us, peeping out from the black cloth covering her hair like a piece of jewellery. The Farsi script written directly onto the photographs is predominantly from contemporary poetry by writers like Forough Farokhzad and Tahereh Saffarazdeh, who have often written about female sexuality and desire. The works address historical issues of women in Iran while also confronting the contemporary concerns of an Islamic state.

Working in photography and video, Neshat relies heavily on traditional Islamic motifs such as calligraphy and the veil. Her work is also deeply influenced by her life. She travelled to California at the age of 17 to study fine art and as the revolution broke out in Iran she ended up staying in the United States. Returning to her home country several years later she was struck by how it had changed under the new Islamic regime and began to explore this in her work. Deploying such recurring symbols as the veil and Farsi script may seem precarious as such practice risks reinforcing stereotypes, yet to invoke clichés in such a highly aestheticised manner also serves to highlight the status of the themes as artificial constructions.

The work of Shirin Neshat has attained an international reputation and is now featured in the permanent collections of major museums such as the Whitney, the Guggenheim and the British Museum.

Les Femmes du Maroc no. 10
2005, chromogenic C-print mounted on aluminium,
102 x 76 cm
Courtesy the artist and Waterhouse & Dodd

LALLA ESSAYDI

Lalla Essaydi's use of text is closely related to her practice as a painter. In the series of photographs seen here, the preparative work is a vital component of the final piece. The application of henna is a painstaking process that can take up to six months to fully prepare and execute; moreover, once the henna dries it flakes off easily and often needs to be reapplied during the photo shoot. Essaydi always rehearses with her models one day in advance and the shoot itself becomes a social process.

The *Les Femmes du Maroc* series is set in Essaydi's studio in Boston. As in *Converging Territories*, the photographs show women draped and veiled in cloth, against a backdrop of the same inscribed textiles. This creates an effect of merging, as the woman becomes inseparable from the interior. By staging the photographs in Boston, Essaydi engages with the idea

of the diaspora, and issues of distance and difference.

The heavy focus on Orientalist subject matter such as calligraphy and veiled women in Essaydi's work constitutes an engagement not only with Arab culture, but the Western fascination with it. The artist has stated: "I want the viewer to become aware of Orientalism as a projection of the sexual fantasies of Western male artists, in other words, as a voyeuristic tradition, which involves peering into, and distorting private space." This statement alludes to the tradition of females often being confined to interior, private settings, while public places have typically been defined as male; countless examples of Orientalist paintings meanwhile have mobilised the odalisque and the harem (the epitome of females in restricted, interior spaces) as central tropes.

The *Converging Territories* series was taken in Morocco in a large, unoccupied house owned by the artist's family. During Essaydi's childhood this was where young women were sent as a punishment for their supposed transgressions. They would spend a month here in total silence, surrounded only by servants. The site becomes a locus for personal memory, but also acts as a poignant illustration of the confinement of women to domestic spaces.

Furthermore, Essaydi addresses the male/female dichotomy through the use of calligraphy as a medium. Calligraphy is an art form traditionally practised by men, while henna is associated with major celebrations for Moroccan women such as puberty, marriage and childbirth. Essaydi's oeuvre intersects several key issues, all inextricably linked to her cultural heritage as well as personal experiences.

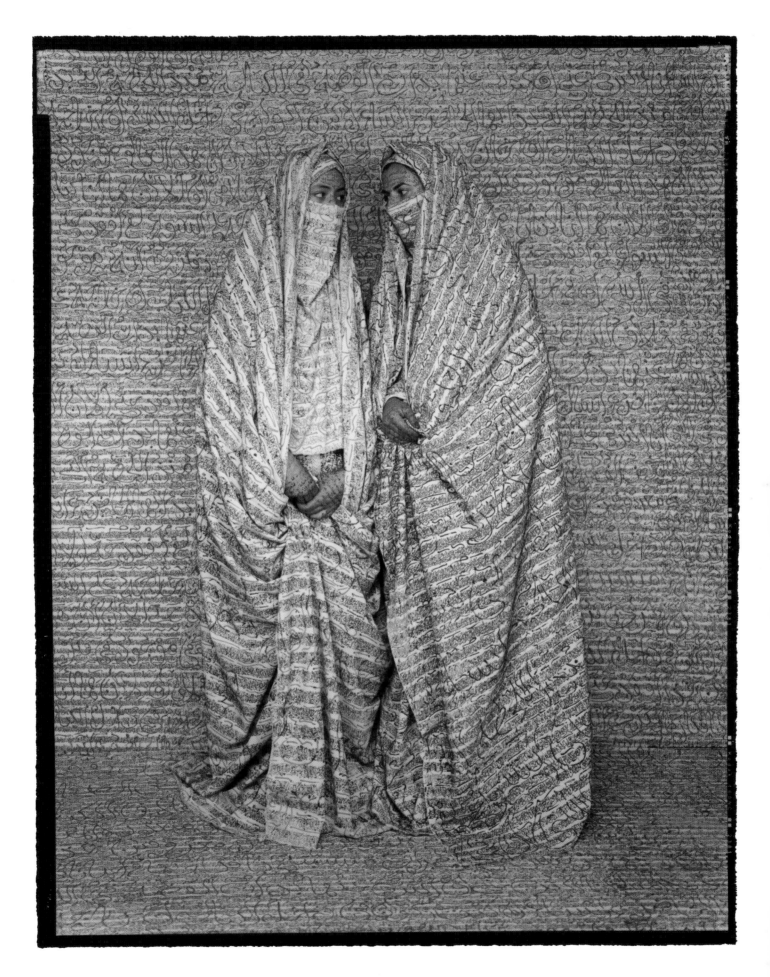

ANNABEL DAOU

Lebanese artist Annabel Daou's large-scale installation can be read as a portrait of America: a makeshift map or landscape, a verbal rendition of a history and a country, or as an abstract meditation of a contemporary society. Consisting of excerpts from well-known literary works, political speeches and lyrics from songs, the work is a compilation of American texts, forming figures that echo the imagery her borrowed words describe.

Here it is seen installed at the Park Avenue Armory in New York City, where it formed part of the Creative Time project Democracy in America from September 21 to 27, 2008. Democracy in America: Convergence Centre was the culmination of a national travelling arts project, examining the American democratic tradition and encouraging

discussion and participation during the 2008 election season. The final exhibition in New York featured over 40 artists and was conceived of as a "participatory project space and meeting hall", pairing the art works with an extensive program of events and performances.

America was conceived during the brief but violent Lebanese–Israeli war in the summer of 2006. Daou immersed herself in literature as a strategy for making sense of the violent conflict, and this exploration has been translated into the final work. Perhaps a sense of urgency can be perceived in the pencil's scrawling on the paper—a repetitive quality reinforcing the need for contemplation and conversely a manifestation of determinacy and clarity. The representation of America rather than

the Middle-Eastern centre of the conflict may seem an odd focus, but the evocations of American texts can be traced back to the artist's childhood. Daou was born in Beirut in 1967 and lived there throughout the Civil War before moving to New York City at the age of 18. Her parents owned an English-language bookstore in the Lebanese capital, which they were forced to close, and subsequently stored the stock in their home, giving Daou access to a wide range of English literature. Thus the artist, in a way, returns to the shattered city of her past by portraying the country of her present.

Daou now lives in New York and has taken her interest in language further, her most recent work focusing on Arabic and English translation and transliteration.

Calligramm on Parchment (below)
2002–2007, 80 x 80 cm, Indian ink and acrylic
painting on parchment
Courtesy the artist

Calligramm on Papyrus (opposite)
2004, 260 x 60 cm, Indian ink and acrylic painting
on papyrus
Courtesy the artist

NJA MAHDAOUI

Nja Mahdaoui emphasises the visual impact of his work, which he refers to as "calligrams" ("beautiful writing"). The meticulous paintings *Calligram on Parchment* and *Calligram on Papyrus* are typical of Mahdaoui's style, inspired by Kufic script, Arabic letter forms and Tunisian heritage. His scriptures have no literal meaning as his focus is on the formal, visual aspects of painting as opposed to the art of writing itself. Thus his employment of text functions twofold: the elegantly scrawled text evokes language, but also operates as mere visual form. Tunisian aesthetics professor Rachida Triki writes: "The gaze is constantly deprived of its ability to read and is brought back to pure pictorial seeing."

The way in which Mahdaoui uses writing blurs the distinctions between genres and styles. The calligrams combine a precise employment of calligraphy with beautiful abstract patterns, echoing Tunisian cultural traditions such as textile designs. His highly advanced work is painted on parchment and papyrus is used for its connotations of tradition and heritage. He has also recently began using linen as a surface material, which has allowed his compositions and mazes of colour to evolve in different ways.

Mahdaoui came to prominence in the 1960s as part of a generation of North-African artists who reinvented calligraphy as a vital element in their art. Calligraphy had traditionally been associated with the Qur'an, but with anti-colonial struggles and increased globalisation came opportunities for a more liberal employment of scripture as an art form.

Nja Mahdaoui's work is not only limited to calligrams; he also takes in painting, tapestry, print and even performance art, and he also works as an illustrator and book designer.

MONIR SHAHROUDY FARMANFARMAIAN

Cubes Within Cubes (below)
2008, mirror and reverse glass painting on plaster,
60 x 60 cm
Courtesy the artist and The Third Line

Variations on Hexagon (opposite)
2008, mirror and reverse glass painting on plaster,
170 x 171 cm
Courtesy the artist and The Third Line

The Wall and the Tree
2007, unique bronze, 80 x 45 x 25 cm
Private collection, courtesy the artist and Waterhouse & Dodd

PARVIZ TANAVOLI

Parviz Tanavoli is a highly influential and significant figure in the Middle-Eastern art world. In the late 1950s and early 1960s Tanavoli was one of the founders of the Saqqakhaneh School, a neo-traditional movement that drew inspiration from the cultural heritage of Iran, to mobilise traditions such as calligraphy and classical poetry. Tanavoli was also once the cultural advisor to Farah Pahlavi, the Queen of Iran.

As a sculptor he has worked with various materials, including bronze, copper, brass, and scrap metal. A central motif in Tanavoli's work is the *heech*, a figure put together from three Persian letters to form the word 'nothingness'. This can be interpreted as a commentary on the desolation of modern culture or, conversely, the nothingness can stand for a space of opportunity, a void to be filled with creativity. Tanavoli made his

first heech sculpture in the mid-1960s and has since continued to employ the symbol in his practice. One of the more recent examples is *Caged Heech*, 2005, a comment on the prisoners held at the infamous Guantanamo Bay detainment camp. The curving shape of the *heech* alongside its engagement with language and poetics marries Tanavoli's interests in traditional mysticism and calligraphy.

In keeping with his commitment to Persian traditions, Tanavoli has always had an avid interest in locks and locksmithing and its rich history in the region. After the *Heech* series he began producing a series of lock-inspired sculptures. *The Wall and the Tree*, 2007, is part of a more recent collection of works on the theme of walls, inspired by the pre-Islamic sculptor Farhad the mountain carver.

Born in Tehran 1937, Parviz Tanavoli is widely recognised for his contributions to the development of modern Iranian sculpture. He is also a writer, collector and art historian and has written extensively about Iranian art, specifically Persian rugs and textiles. After completing his BA at Tehran School of Arts, Tanavoli went on to study at the Brera Academy of Milan, Italy. Following his graduation in 1959 Tanavoli moved to the United States to teach sculpture at the Minneapolis College of Art and Design. He remained there for three years before returning to Tehran to assume the directorship of the Department of Sculpture at the University of Tehran, a position he held until 1979. In 2003 his work was shown in a major retrospective exhibition at the Tehran Museum of Contemporary Art, his first exhibition in the country for over 25 years.

Veiled Testament
2007, mixed media, ink and gauze on paper, 83 x 113 cm
Courtesy the artist and Waterhouse & Dodd

MALIHEH AFNAN

Maliheh Afnan describes her work as "rooted in memory, both my own and a more distant, perhaps collective one". The theme of memory is evoked primarily through the use of calligraphy, both as a central subject matter in her work and as a way of suggesting hidden meanings.

In *Veiled Testament*, 2007, she has written with black ink on paper and then covered the surface with a thin gauze. The title of the work refers to the textile as a veil, covering—yet not completely concealing—the text. The script itself mimics letters but is in fact only her own scribbles; "invented artistic vocabulary inspired by ancient Middle-Eastern scripts". The images suggest writing but evade literal meaning. Thus

Afnan can evoke language and all that it entails, without actually dictating meaning.

The title of this work, *Veiled Testament,* suggests documents of some sort, further enhancing the emphasis on text as well as memory and history. Shrouded in gauze, Afnan's works evoke archaeology: unearthed manuscripts echoing ancient times. The veiling can be interpreted as literal—as covering and protecting the script—but also as an emblem of mystery or hidden meaning.

The title of a similar work, *Veiled Agenda,* also has a sinister connotation, perhaps suggesting a covert agenda: a scheme that cannot be exposed. The use of veiling

also strongly suggests a link to the veiling of women in many Islamic countries throughout the Middle East. Thereby the works take on a quite literal, material meaning, commenting on the garb, and thus often position, of women in Middle-Eastern societies, as well as the more suggestive implication of the veil as hiding knowledge or, potentially, threats.

By alluding to ancient scripture, her works demonstrate a commitment to Middle-Eastern heritage. Like many of her peers, Afnan is influenced by Middle-Eastern culture and art history as well as Euro-American aesthetic traditions. Among her Western influences she cites Pollock, Rothko, Dubuffet and Klee.

Untitled
2008, acrylic and pen on canvas, 120 x 120 cm
Courtesy The Third Line

GOLNAZ FATHI

The work of Golnaz Fathi recalls movements such as American colour field painting and minimalism, but her oeuvre is firmly rooted in Iranian calligraphy.

Fathi was trained as a traditional calligrapher, but like many of her contemporaries, she uses script for its formal qualities rather than to convey literal meaning. She first became interested in calligraphy while studying graphic design and later spent six years at the Calligraphy Association of Iran. Calligraphy is a painstaking craft and Fathi has said of it: "I would travel with my kit wherever I would go. If you went a couple of days without practice, on the third day, you would find it incredibly difficult to get back."

Fathi cites Abstract Expressionism and artists such as Jackson Pollock and Cy Twombly as important influences. Echoes of the abstract, scribbled calligraphic style of Twombly are visible in some of Fathi's earlier work, but in works such as *Untitled*, 2008, she takes a step closer to abstraction, the use of vertical colour fields and lines more evocative of Barnett Newman. Yet here the band on the left evokes the animation of a power field or transmission; it is almost as if the black contours are receiving a broadcast from the denser field of paint on the left. This renders the centre of the picture white—but not blank. A tension is created between the two segments, leaving the midpoint of the image charged and generating meaning in the empty space.

Untitled, diptych, 2008, presents us with two picture planes, the black mass on the left contrasting with the quivering lines on the right. Again, the aesthetic here recalls Newman and perhaps also the refined minimalism of Agnes Martin. Fathi never titles her work, allowing the viewer to experience the paintings without being conditioned by words. Building upon her early calligraphic training, Fathi has developed a unique style that is neither pure calligraphy nor simple abstraction. Executed in acrylic and pen on canvas, Fathi's work is intrinsically concerned with painting, yet not in the manner of impasto or action painting. She manages to combine the qualities and concerns of Abstract Expressionists with the flatness of Pop Art, while at the same time her output is firmly rooted in the cultural traditions of her native Iran. As such, her work refers widely to her cultural heritage as well as contemporary art without evoking oversimplifications of calligraphy or other Orientalist tropes.

For Fathi, script becomes a point of departure for further excursion: the habit of delicate lettering finally erupts into colour fields, lending the works a truly painterly quality. Thus Fathi never deals with merely 'written paintings', demonstrating instead a genuine engagement with form and the picture plane.

GOLNAZ FATHI
Untitled
2006, acrylic on canvas, 143 x 118 cm
Courtesy The Third Line

NEDA DANA HAERI
Sole/Soul (below)
2007, oil on wood, 30 x 30 cm
Courtesy the artist and Janet Rady Fine Art

Chain of Purpose II (opposite)
2008, acrylic on canvas, 76 x 76 cm
Courtesy the artist and Janet Rady Fine Art

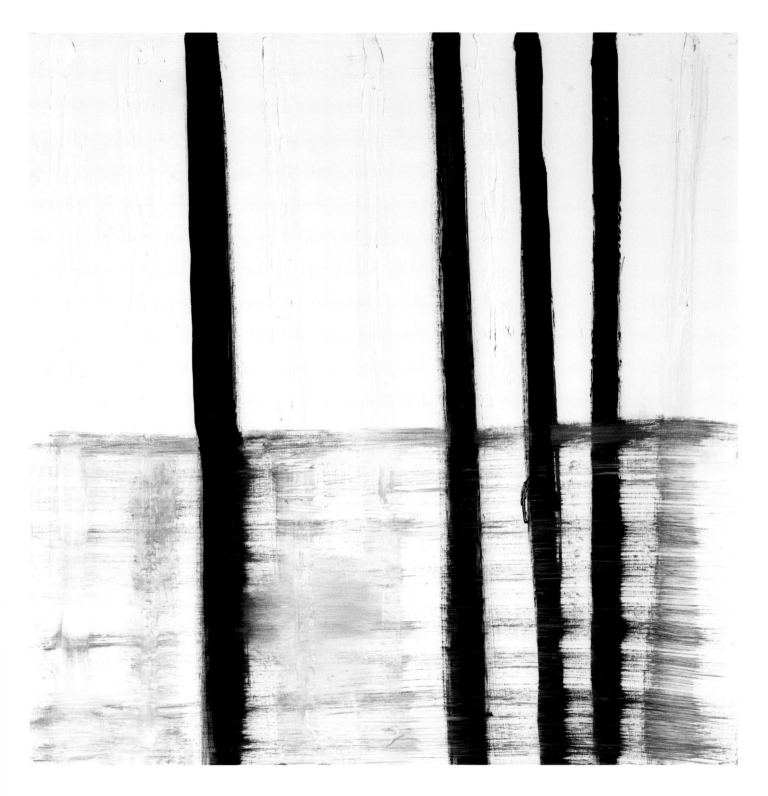

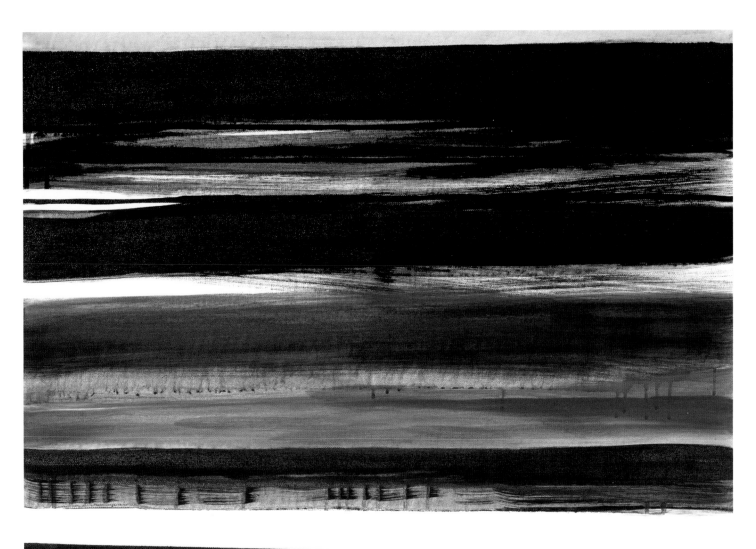

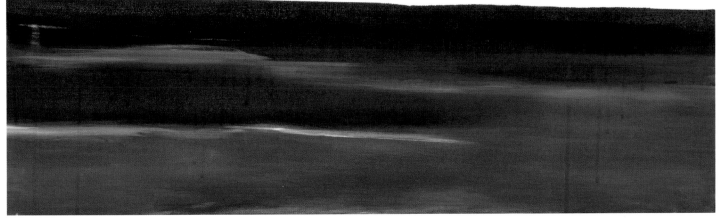

AHLAM LEMSEFFER
Untitled (below)
2008, oil on canvas, 120 x 120 cm
Courtesy the artist

Untitled (opposite)
2007, acrylic on canvas, 120 x 120 cm
Courtesy the artist

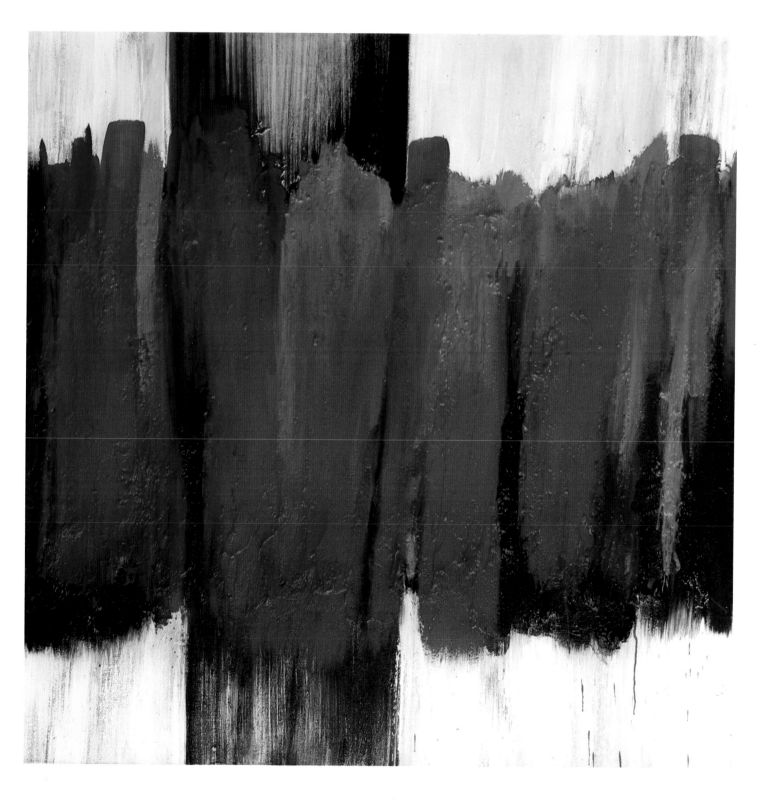

Rashm I
2003, watercolour, china inks and liquid gold on paper,
145 x 74 cm

WIJDAN ALI

Wijdan's *Rashm I*, 2003, is composed of watercolour on strips of paper. While the use of watercolour on paper occasionally renders an image flat and somewhat brittle, here the strips superimposed on each other create a tangible three-dimensional, vibrant effect. On the strips to the left is inscribed a poem by the Lebanese poet Charbel Daghir, parts of which are in French and English and the rest of which are in Arabic. Wijdan was not trained as a calligrapher, but uses script asa structural element in her work, experimenting with letters, and in particular with Kufic script. She describes her work as "calligraffiti", a free style not belonging to any particular school of calligraphy, and more contingent upon individual handwriting.

The poetry in *Rashm I* is written on pale yellow paper, interspersed with patches of fading red. Balancing the text are other strips in colours ranging from deep red to seaweed blue and pink and splashed with liquid gold. A strip on the far right is white with spots of black: perhaps vestiges of writing, but from a distance the narrow belt of paper is more reminiscent of the trunk of a young birch tree. This lends the work a suggestive quality, as it oscillates from poetry to ornamental colour fields to evocative abstraction.

The artist began her career as a diplomat but later turned to painting and trained with Jordanian painter Muhanna Durra who influenced her early abstract work. Her oeuvre also includes landscape oil paintings and in the late 1970s she turned to calligraphy. Major events in the political history of the Middle East have shaped her artistic development. After the 1967 war against Israel she began painting her first calligraphic works, in black in white, perhaps finding colours too vibrant or joyful to illustrate the zeitgeist of the time. Decades later Wijdan abandoned all figurative representations as a reaction to the onset of the Gulf War in 1991.

Wijdan Ali's commitment to Middle-Eastern art extends far beyond her own practice as a painter: she is also an art historian, a writer, a curator and the founder of Jordan's National Gallery of Fine Arts. She is also a member of the Jordanian royal family.

GHADA AMER
Anne (below)
2004, acrylic, embroidery and gel medium
on canvas, 168 x 201 cm
Courtesy Gagosian Gallery

Red Diagonales (opposite)
2000, acrylic, embroidery and gel medium
on canvas, 183 x 183 cm
Courtesy Gagosian Gallery

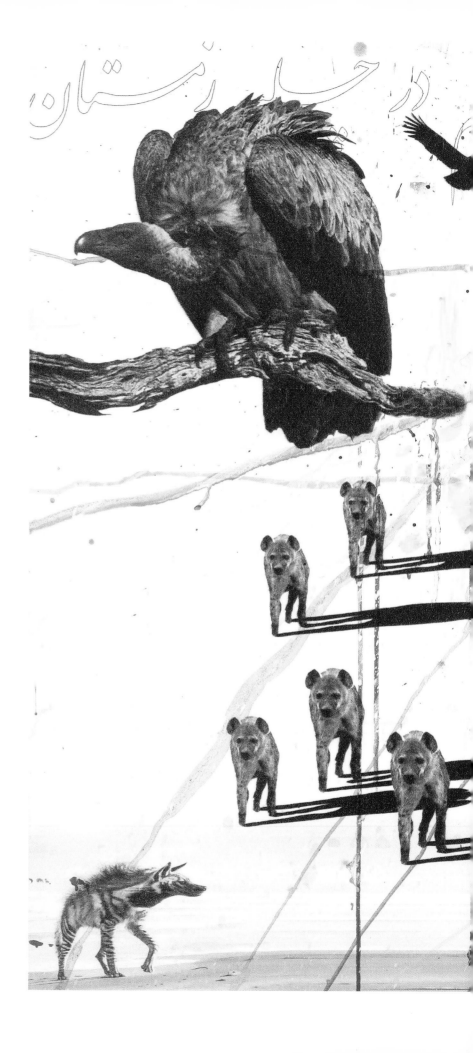

FEREYDOUN AVE
Rostam in the Dead of Winter
2009, mixed media and digital print on paper, 75 x 110 cm
Copyright the artist, courtesy Janet Rady Fine Art

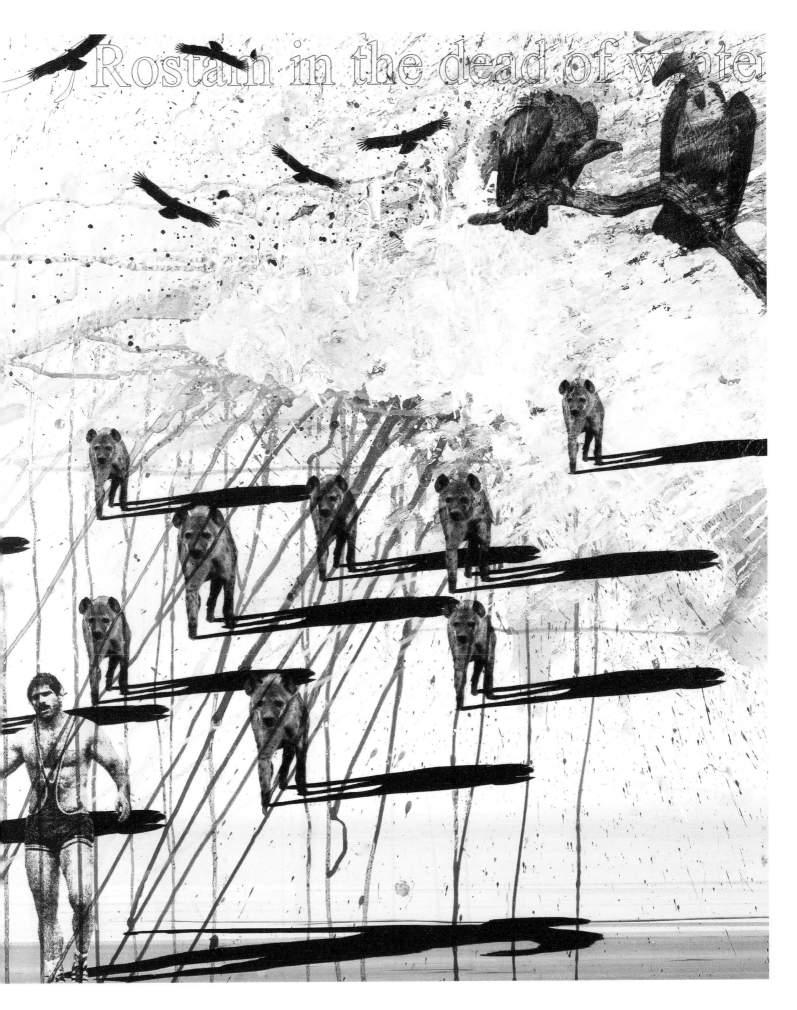

Rostam in the dead of winter

AYAD ALKADHI
I am Baghdad III (below)
2008, charcoal and acrylic on Arabic newspaper
and canvas, 122 x 122 cm
Courtesy the artist

I am Baghdad V (opposite)
2008, charcoal and acrylic on Arabic newspaper
and canvas, 122 x 122 cm
Courtesy the artist

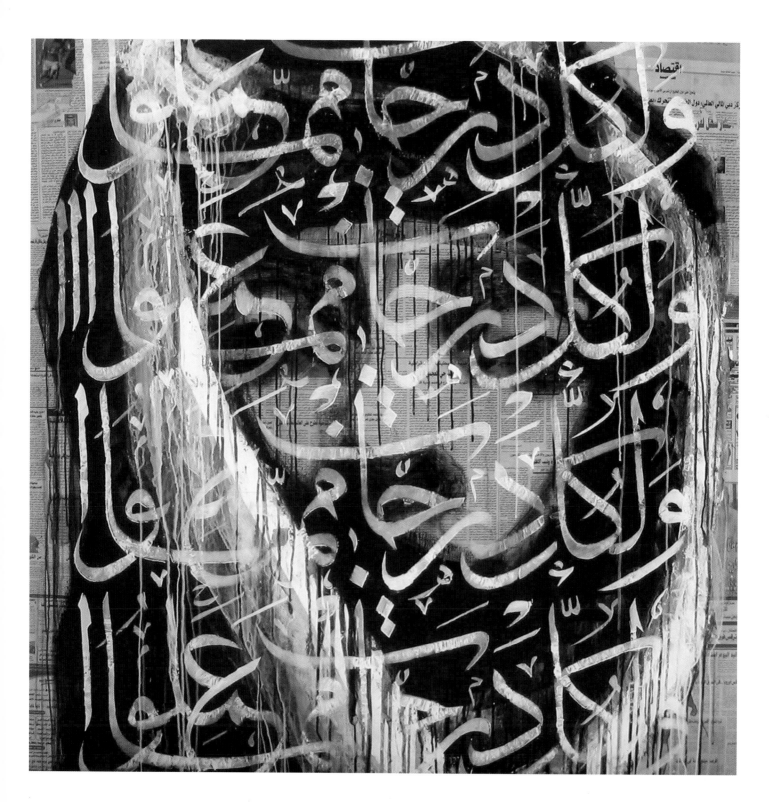

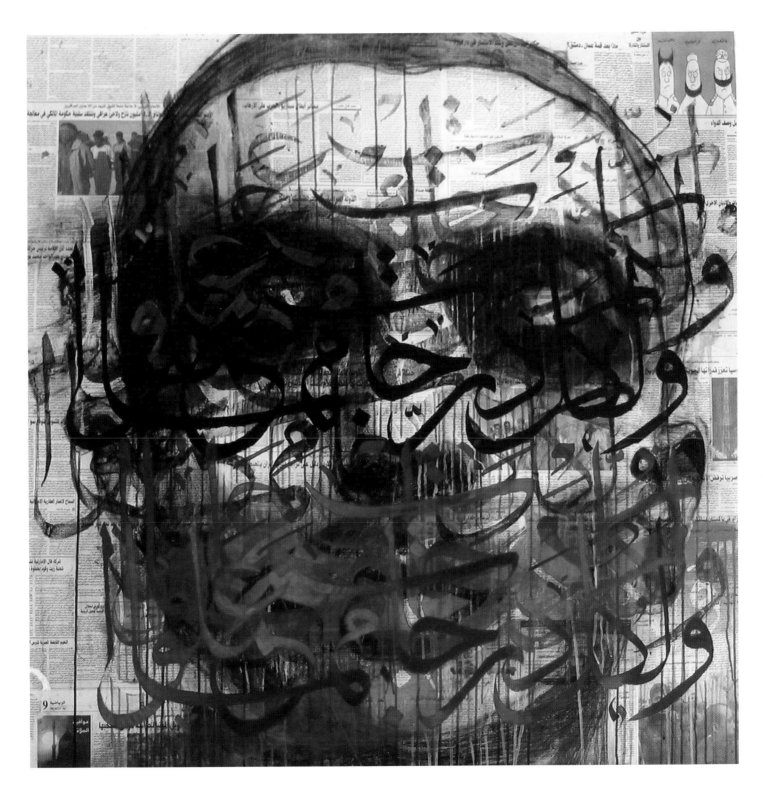

Flag 19 from *Memories without Recollection*
2008, mixed media textile, 203.2 x 116.8 cm
Courtesy the artist

SARA RAHBAR

The unmistakable stars and unambiguous stripes of the Star-Spangled Banner immediately enmesh Iranian-American artist Sara Rahbar's *Flag 19* from *Memories without Recollection* in a series of connotations. Strips of textile are superimposed onto an American flag hanging from the wall. The materiality of the flag, on which strips of textile are superimposed, carries undertones of Persian rugs and wall tapestries. By bringing together the foremost symbol of America with material suggesting the cultural heritage of Persia, Rahbar attempts to fuse the two together, thereby obliterating the ideas of nationalism and borders that the flag symbolises.

The American flag features in much of Rahbar's work. In 2008 she completed several new flag pieces on the subject of tolerance, commissioned by the Queens Museum of Art. In one piece, *Prayer Mat*, the artist has shredded American and Iranian flags and woven them together.

As a ubiquitous feature of North-American culture, the flag also holds a special significance for Rahbar as an Iranian-American. The artist's family owns a restaurant and after 9/11 they were coerced into put the flags up: "If we didn't, people were saying, 'You're not with us. You're against us'. We were getting death threats, people throwing things at the windows."

There is also an element of theatricality in Rahbar's work. In *After You*, 2007, a series of 24 photographs, the artist depicts the protagonists in different staged poses, ostensibly telling a story of loss and belonging, using costumes and textiles that allude to Iran, America (the flag appears again, this time wrapped around a woman's waist like a skirt and then a belt), and military agency. Pomegranates also feature in several of the images; the significance of the fruit crosses geographical, political and religious boundaries.

Rahbar has said in a statement about her work: "I don't believe in borders created by devotion towards a flag, a country, or a religion; the only thing I want to do with these titles, which have created so much separation between us, is shed them." Her oeuvre encompasses a vast array of techniques and symbols, all of which in some way serve to further the idea of a common ground, shunning symbols of nationalism and power in favour of intertwining and connection, emphasising similarities rather than highlighting difference.

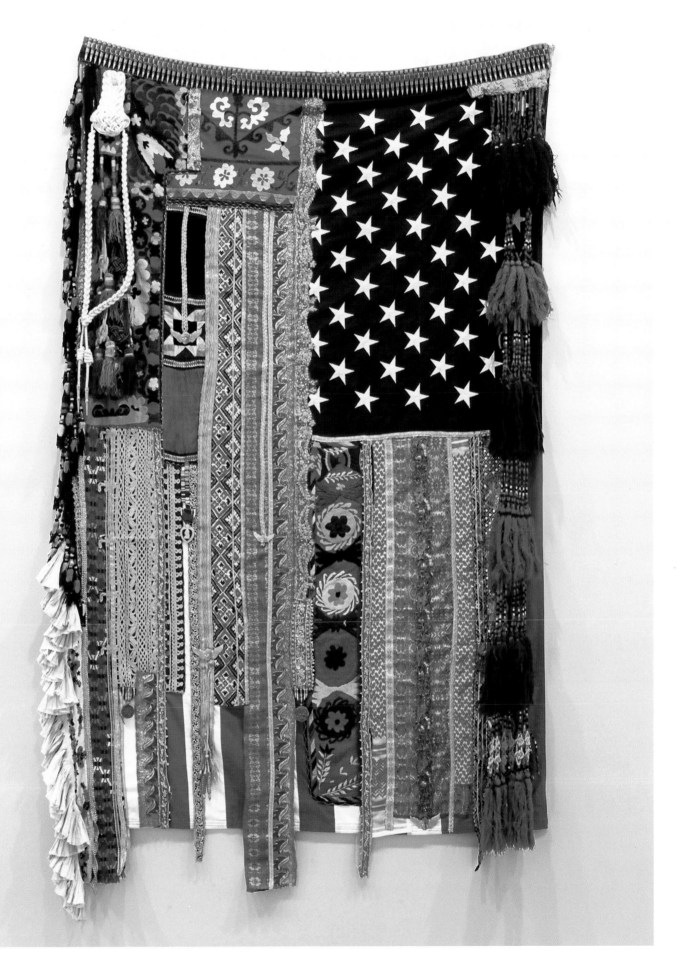

LAILA SHAWA
20 Targets from *Walls of Gaza Series II*
1994, photo lithograph on paper, 38 x 58 cm
Courtesy the artist and October Gallery

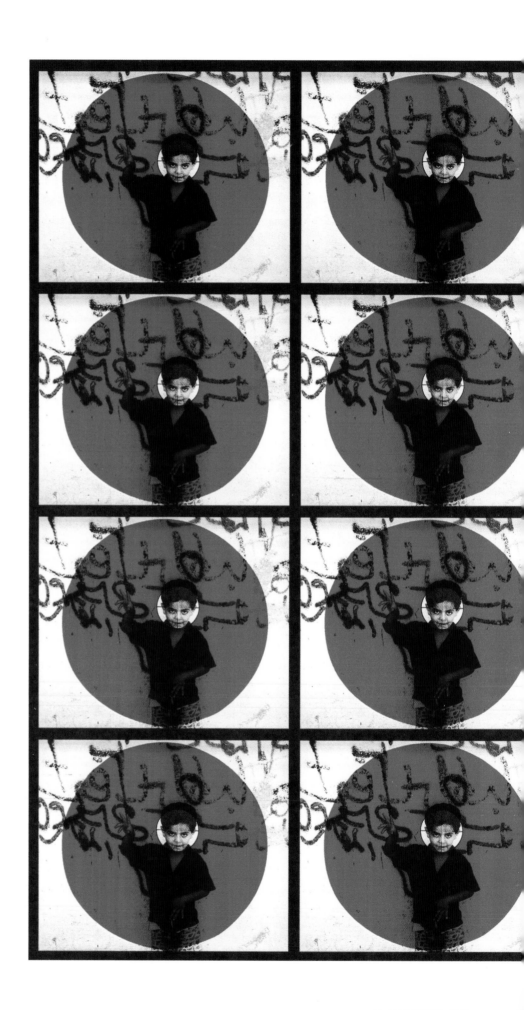

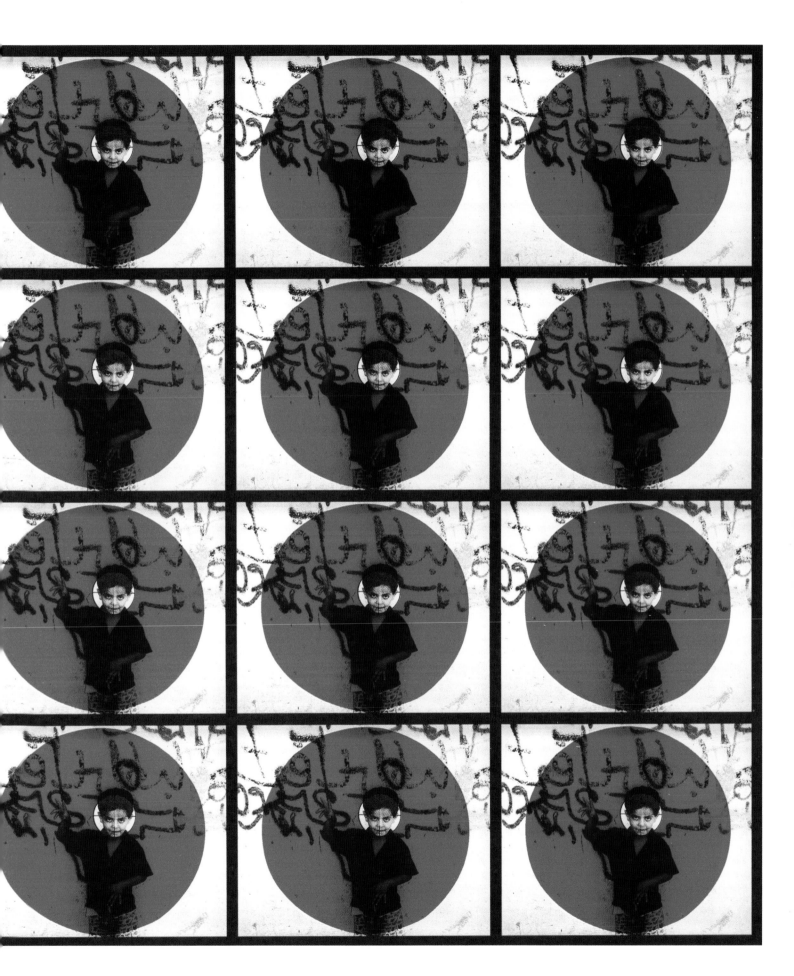

Mobile Talker
2007, oil acrylic glitter on canvas, 170 x 140 cm
Courtesy the artist and The Third Line

FARHAD MOSHIRI

Colourful kitsch in the style of Jeff Koons, traditional Persian calligraphy and ceramics —as well as a dedicated engagement with different artistic media—all somehow come together in the practice of Farhad Moshiri.

Moshiri's *King Bed*, 2004, is a life-size installation of a gilded double bed with stereo speakers replacing the pillows, part of the installation *Living Room Ultra Mega X*, which comprised a bed, four armchairs, a sofa, two chandeliers, a vitrine and side tables, all in the same golden colour.

This work is an example of Moshiri's practice of operating in the realms between traditional form and contemporary culture. The ornamental details on the faux Louis XV style furniture and the lavish gold paint invoke a kitschy *nouveau riche* feel and the work borders more on humorous commentary than overt critique.

Moshiri is comfortable working in a range of different media. *I Give You My Tears*, 2006, is an image of a cracked urn decorated with Farsi script painted on white canvas, part of his series of jar paintings. The three-dimensional rendering of the vase and the relatively large scale of the painting lend a sculptural quality to the work. The artist builds up layers of paint, then subsequently folds and crushes the surface, creating a crackling of the picture plane, before sealing the painting with glue to prevent further damage. The distressed surface is evocative of archaeological findings or fading histories, but also makes for an elegant image and further enhances the three-dimensional effect.

Mobile Talker, 2007, is another example of Moshiri's multi-faceted practice in terms of material. He addresses similar themes of consumer culture and kitsch aesthetics as

those explored in *Living Room Ultra X*, yet here with the more obvious connotations of modern day life, such as the mobile phone and the application of bright coloured paint on the canvas using a cake-icing dispenser. The impastoed acrylic paint in small dabs on the hyperrealist image of a wedding-cake and a bouquet of red roses adds a distinct spatial feature to a work which manages to combine minimalism, in the simplicity of its execution, with over-the-top aesthetics.

In *Operation Supermarket*, 2008, Moshiri collaborated with fellow Iranian artist Shirin Aliabadi in producing a series of photographs showing commodities such as breakfast cereal or detergent with humorously manipulated labels. A chocolate bar reads "Intolerance", while a dishwashing detergent is renamed "Shoot First".

FARHAD MOSHIRI
King Bed
2004, lifesize mixed materials installation
Courtesy the artist and Daneyal Mahmood Gallery

From *Be Colourful* series
2006, C-print, 60 x 90 cm
Courtesy the artist

SHADI GHADIRIAN

Iranian artist Shadi Ghadirian is known for her dynamic use of photography to subvert common expectations. Her *Nil Nil* series, 2008, sees military objects enter into the domestic sphere, juxtaposing symbols of potential violence with everyday, anodyne items. The door of a white washing machine is depicted head-on, the white surface of the machine dominating the picture plane, compelling the viewer to focus on the window of the drum. On closer inspection it appears to be some sort of army attire. The simplicity of the composition recalls Duchamp's ready-mades or a postmodern still life, yet seen as part of the collection of photographs the uncanny juxtaposition of quotidian culture and war paraphernalia becomes apparent.

Other examples of photographs from the series include a pair of blood stained soldier's boots on the floor beside shiny red pumps, a hand grenade in a fruit bowl, and an army helmet hanging next to an elegant silk scarf.

The gas mask depicted in the *White Square* series of 2008 has a red ribbon tied around its base, adding an uncomfortably delicate dimension to the otherwise severe austerity of the subject and composition. The decoration simultaneously introduces a soft, elegant element to this military object, while perhaps also suggesting streaks of blood, the inevitable product of war. The series comprises ten images of military objects, similar to the ones used in the *Nil Nil* series, photographed against a white background and all bearing a silk red band, tied in a neat bow.

The *Qajar* series, 1998–2001, brought Ghadirian to wider public attention in 2001. The collection of images relies heavily on the tradition of studio portraiture, first introduced in the late nineteenth century during the Qajar dynasty of 1794–1925. The sepia-toned photographs are staged against painted backgrounds and the models are dressed in vintage clothing. A modern

detail is added to each composition; here the woman is wearing a pair of sunglasses, holding them by the rim so as to accentuate her pose. The other photographs include a boom-box stereo, a vacuum cleaner, a newspaper and a Pepsi can.

The *Be Colourful* series of 2004 has an entirely different feel, depicting models behind a painted glass pane in a composition that consists of three layers —the chador, the glass and finally the paint—that separate the subject and the viewer. All these portraits are executed in a studio; thus they are not documentary, yet nonetheless achieve a compelling commentary on contemporary society, and the situation of women in particular. All images of women in Iran must be shown in hijab and instead of trying to escape this or seeing it as a constraint, Shadi Ghadirian has made it her theme as she continues to investigate the condition of women in her home country.

SHADI GHADIRIAN
From *Nil Nil* series (below)
2008, C-print, 75 x 75 cm
Courtesy the artist

From *White Square* series (opposite)
2008, C-print, 75 x 75 cm
Courtesy the artist

MONA HATOUM

Dangerous domesticity is a theme that runs through much of Palestinian artist Mona Hatoum's work: common household objects are taken out of context, modified or somehow rendered precarious. In Hatoum's installation piece *Grater Divide*, 2002, a cheese grater has been reproduced in the size and shape of a room divider. Its reference to and function as a folding screen is palpable and the combination of sharp metal surface alongside the work's formal presence in the room creates an effect of potential hazard while the unexpected scale invokes Surrealism, and the word play of the title adds a humorous aspect to the uncanny figure of sharp steel. In a similar way, *Electrified*, 2002, combines a potentially harmful aspect with everyday objects as kitchen utensils hang together on an electric wire connected to a light bulb.

Drowning Sorrows, 2001, is an installation of glass liquor bottles arranged in a neat circle on the floor. The cut flasks appear to be sinking—bottom or top up—and struggle to remain above the surface. Similar to *Grater Divide*, the title here conjures a witty duality: the repositories of escapism are themselves drowning.

Hatoum's engagement with scale and her commitment to installation can be felt throughout her work. In the 1980s she focused primarily on video and performance art, dealing with issues of gender and the body as well as violence and oppression. As her style matured her work became subtler and more poetic, often meticulously dealing with themes of identity, family and geography in installation pieces. Hatoum often invokes the idea of the body in her art by using it as a reference for scale or by working with related materials, such as human hair.

In her more recent work she often uses maps as motifs. *Present Tense*, 1996, is a map made of small red beads embedded in some 2,000 bars of olive oil soap from Nablus. The map delineates the outline of the map of the Oslo Accords between Israel and the Palestinian authorities in 1993. By engaging with local products and pairing that with larger geopolitical issues, Hatoum accentuates the very real existence that sits behind the abstract and arbitrary nature of borders and maps. The ephemeral nature of the soap further underlines that effect.

The phrase 'double exile' is often invoked in relation to Hatoum. Her parents fled Haifa in 1948 and settled in Beirut, where she was born in 1952. Hatoum was visiting London when the Civil War broke out in Lebanon in 1975 and she was forced into exile. Interpretations of her work often address the issue of displacement and identity, as well as issues of sexual difference and the body. She now lives and works in London and Berlin.

MONA HATOUM
Drowning Sorrows (below)
2001–2002, glass bottles 10 x 250 cm
Copyright the artist, courtesy Jay Jopling/ White Cube, London,
photo: Carlos Germán Rojas

Grater Divide (opposite)
2002, mild steel 204 x 3.5 cm, variable width
Copyright the artist, courtesy Jay Jopling/ White Cube, London,
photo: Iain Dickens

Conceptual Art
2008, black and white transfer on paperback,
190 pages, 95 plates, 17 X 11 cm
Courtesy the artist

BABAK RADBOY

There is a touch of austere minimalism in the artistic work of Babak Radboy, which is fuelled by an inextricable combination of commitment to documents, archival modes and collecting, and an avid dedication to the images themselves.

Conceptual Art is a 190-page paperback book. Aside from its title—which appears on the front, back, spine and title page—it features only images, the text having been erased. Page after page of black and white photographs of Conceptual art installations make for a suggestive, serene reading. Among the works are also a small number of photographs that do not specifically depict Conceptual art but bear a resemblance; as such, without textual context the two cannot be distinguished from each other.

In *Showing*, Radboy has collected 40 exhibition advertisements from the late 1960s to the early 1980s, reproducing everything as it was originally printed with the exception of the gallery information, which has been carefully omitted. Detached from clear temporal and spatial signifiers (in some cases dates are shown, but never years), the ensuing works act as fleeting historical documents that are impossible to file away. The stark remnants of typography hint at the artistic practice of the names they spell out, but the content has gone. The words read like forgotten monuments to past events.

On one panel, the name of Japanese artist On Kawara is stamped in white block capitals on a black background. Under the name is written simply "June". The lettering gives no indication of meaning and the composition and the curious, austere composition attains the status of a found object. On another, Robert Rauschenberg is scribbled on a yellow background in the artist's characteristic handwriting. Here the bright colour relieves the minimalism, but yet again the contextual void leaves the work suspended in memory, with only subtle hints of cultural location.

Radboy's *Uninstallation* takes the confusion of the boundary between the depicted space and the real to its limit, reprinting images of installations and arranging the images themselves in an installation setting. The result is that the work appears in an exhibition as an image, but in its catalogue as an installation.

Creative Director of *Bidoun*, Radboy's collections have become an integral feature of the magazine. Radboy's practice of appropriation can be likened to an art-historical archive—much like the actual archive of books and magazines he keeps as the basis for his artistic practice. This process of collecting began as research and later developed into a compilation of printed objects intended for use as "raw material in a manner more associated with sculpture and painting".

BABAK RADBOY
All from *Showing* (below)
2008, silk screen on balsa wood, dimensions variable
Courtesy the artist

Untitled Uninstallation 2 (opposite)
2008, inkjet print on 28 x 22 cm paper
Courtesy the artist

A 1

AL 2

ALL 3

ALLA 4

ALLAH 5

1HALLA 6

A99LLAH 7

ALHAMDUL 8

ALHAMDULI 9

ALHAMDULIL 10

ALHAMDULILAH 11

ARWA ABOUON
Allah Eye Doctor Chart
2007, digital print on duratrans and light box
80 x 120 cm
Courtesy the artist and The Third Line

ARWA ABOUON

Black letters floating on a white light box allude to an optometrist's chart; the title *Allah Eye Doctor Chart*, 2007, tells us that it is one. Libyan/Canadian artist Arwa Abouon's works primarily, sometimes consciously, utilise immediately familiar Middle-Eastern imagery such as the veil, within an often colourful palette to express her investigations of culture and heritage.

Allah Eye Doctor Chart is at once simple and complex. The letters spell out 'Allah' and 'Alhamdulilah' (all praise to Allah), alongside a series of numbers. Initially, it may perhaps evoke the office of the school nurse: representing some kind of conflation of medicine and education. As a graphic object it initially functions as a stark, apparently random typographic treatment; on closer inspection the words begin to materialise. Gradually the work starts to deal with issues of seeing and believing: the idea of trying to read/see God, and

ultimately the implication that the ability to see God suggests a positive bill of health. There could also be an alternative aspect to this work: that the viewer is 'seeing' God in all places—even an eye chart, which should operate as a random arrangement of letters—in much the same way that images are seen emerging from a Rorschach blot.

Allah Eye Doctor Chart is visually unlike much of Abouon's work, which often features a bright spectrum of colour. *Al Matra Rahma*, 2007, encompasses all the colours of the rainbow as 16 women stand in a row against a white background, some bending forward, forming a multi-coloured arch. The sheer number of protagonists suggests a warm notion of collectivity and confirmation, whereas the solid shades of their garb and consistency of pose transforms the human figures into mere blocks of colour.

Similar imagery is revisited in Abouon's provocatively titled photographic work *Weapons of Mass Discussion*, 2008, which shows the artist alongside her mother, both of whom are putting on a pink headscarf. Solid blocks of pink on top and the colour dissolving into white at the bottom frame the portraits. The playful title suggests the contentious subject of the veil, as well as pointing to a more conscientious approach, perhaps to the geopolitics of the Middle East region that has regrettably become synonymous with the subject of the image as well as the title.

Abouon's varied production also includes graphic prints, video, illustrations and site-specific installations. The way in which Abouon works with image, colour and language creates new points of entry into thinking about issues of Western culture and Muslim heritage, often with a touch of humour and audacity.

BARBAD GOLSHIRI
Hand Job (right)
2008, 230 x 74 cm
Courtesy the artist

Where Spirit and Semen Met (opposite)
2008, 230 x 74 cm
Courtesy the artist

```
You write what you hear. You hear what you write.
The diminishing act of creation begins:
                You write ceaselessly:
                I will not express again I will express again

In 1913, Malevich presented to the Moscow public "the dead square"
penciled on "the void beyond".

Two years later the Supreme Being wrote:
For inability is not art.

Your handwriting is terrible for inability is not art.
You scribble until your right hand falls off.
You cannot go on with your left hand as you usually do,
like when you jack off.

                You stop.

You copy the paper with your fax machine and scrunch
the-to-be-vanished-writing.

You can't even crumple your paper into a ball like Martin Creed.
But since inability is not art, so be it.

Then you pinch paper creases between your forefinger and thumbnail
and move along the edges. Please make them take these as sharp clean
fabric creases of Jan Van Eyck's grisailles.

                It won't stop.
```

The Monuments (opposite above)
2008, helmets, 150 x 150 x 100 cm
Courtesy the artist and Conrads Galerie, Düsseldorf,
photo: Mounir Fatmi

Skyline (opposite below)
2007–2008, VHS tape, 820 x 360 cm
Courtesy the artist and Lombard-Freid Projects, New York,
photo: Mounir Fatmi

Save Manhattan 03 (overleaf)
2007, sound architecture, speakers, sound system,
sounds (real and fictional), light, shadow,
400 cm x 100 x 120 cm
Courtesy the artist

MOUNIR FATMI

A number of artists have articulated the events of 11 September 2001 and its implications, both locally and globally. Mounir Fatmi deals with the issue in quite a literal way, portraying the pre-9/11 cityscape in three different versions. *Save Manhattan 03*, 2007, is the final piece in the series. It comprises a number of stereo speakers, arranged in a manner mimicking the grid of a modern city. The speakers rise up from the floor as skyscrapers, and the two largest loudspeakers in the centre of the installation are unequivocally stand-ins for the twin towers of the World Trade Center. Exhibited against a white wall, the shadows of the city skyline add an eerie element to the composition.

The first in the series, *Save Manhattan 01*, 2003–2004, was constructed from a number of books, all written after 9/11, except for two copies of the Qur'an that stood in the middle as the twin towers. The second work, *Save Manhattan 02*, 2005, uses empty VHS tapes. Black videotapes are also used for

Fatmi's most recent installation at the 2009 Sharjah Biennial. VHS tapes are a material connoting both the preservation of memory—through captured moving images—but also the fading of memory, VHS being an obsolete medium.

Save Manhattan 03 differs from the two earlier versions in the series in that it mobilises sound as a vital component in the work. The loudspeakers play a grumble of city sounds: noises from traffic and the subway, interspersed with sounds of explosions extracted from Hollywood movies. Here it is as if life has been breathed into the city, only to be disrupted by sounds of violence.

Fatmi's *Save Manhattan* project deals with the idea of the city as an entity. Always recognisable, always important, the city becomes the locus for memory and trauma, as well as a familiar image of an old friend that can perhaps be seen as a comfort. In this way, Fatmi's work is almost sentimental;

the high-rises are reconstructed again and again with respect and fondness. Fatmi writes that "we are all the heirs of a post-September 11 world", thereby stressing that date as a formative event, a lens that is forever placed in our line of sight. He addresses the issue quite unambiguously by rebuilding the actual site of the attack, yet *Save Manhattan* also resonates as a catalyst for thinking about urban environments as signifiers for temporality, while the formal qualities of the work and the play of shadows lends it a poignant presence.

Fuck Architects is the somewhat dramatic title of one of Mounir Fatmi's ongoing projects. *The Monuments* is part of *Fuck Architects: Chapter III*, shown at the Brussels Biennale, 2008. This installation comprises a number of white hardhats with printed names on them: A Ginsberg, Gandhi, W Benjamin, M Heidegger in simple black lettering. Here the architects are the builders of society, the philosophical founders of modern life.

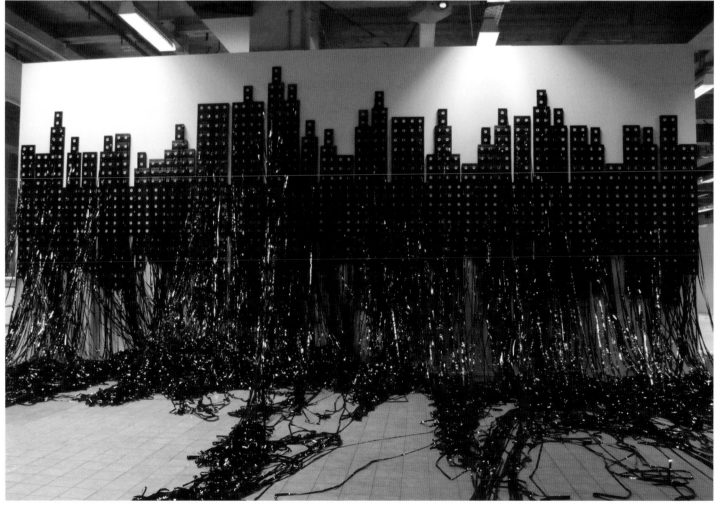

MARWAN RECHMAOUI
Spectre (The Yacoubian Building, Beirut)
2006–2008, non-shrinking grout, aluminium, glass,
fabric, 225 x 420 x 80 cm, as installed at Saatchi
Gallery, London
Courtesy the artist, photo: Matthew Pull/
Black Dog Publishing Ltd.

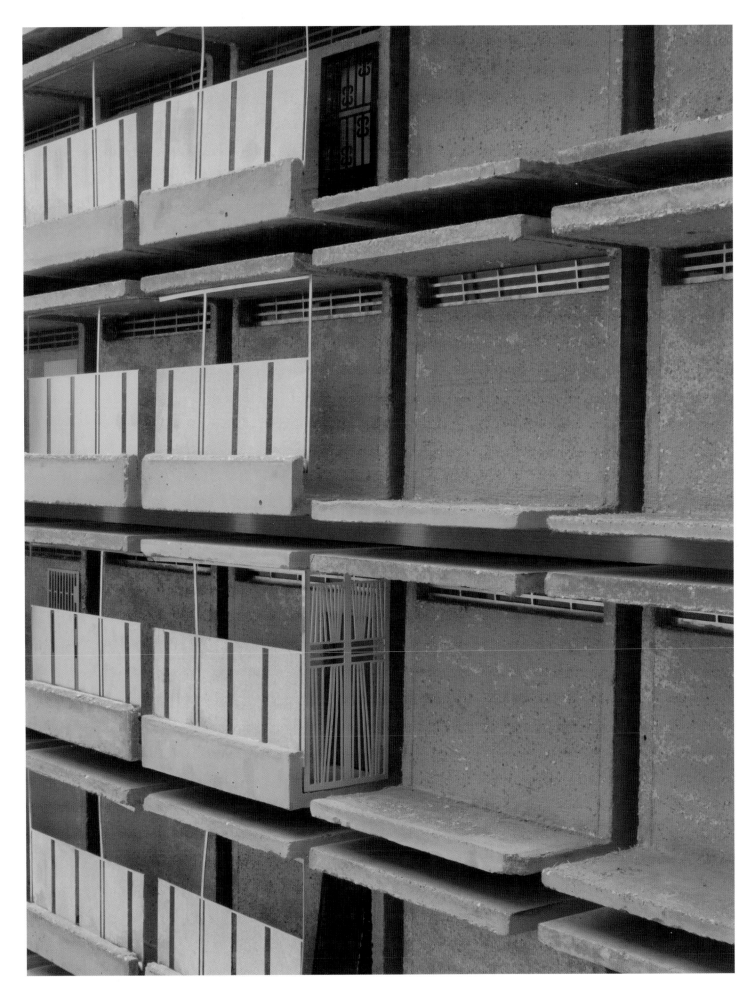

Rue de la Liberté
from *A Life Full of Holes: The Strait Project*
2000, Tangier, C-print mounted on aluminium,
125 x 125 cm
Copyright the artist, courtesy Galerie Polaris, Paris

YTO BARRADA

Due to its location between Africa and Europe, the Strait of Gibraltar has become a contentious body of water and it can be seen as a locus for issues of migration, exile and borders. Yto Barrada borrowed the name of the narrow canal for her series *A Life Full of Holes: The Strait Project*, 1998 –2004. Following the signing of the Schengen agreement in 1991 by Spain and several other countries, the EU closed their borders and since then Africans have required a visa to cross the strait, making it effectively a one-way passage. Morocco is a prime tourist attraction for Europeans, yet Moroccans do not enjoy the same freedoms of movement.

Barrada's project explores the role that the Strait of Gibraltar plays for the city of Tangier. The glistening water lies there as a temptation of freedom and possibilities. Barrada says of the project: "I'm looking to capture the basis of this mindset, of those who are permanently on the verge of leaving." The series also addresses the disparity between the promised life on the other side of the water as opposed to the reality of life in exile.

Barrada's series ranges from video, installation and text to beautifully composed photographs, building on an established documentary tradition that evokes Henri Cartier-Bresson's "decisive moment", to more traditionally photojournalistic images or suggestive still lives. *The Strait Project* comprises a number of photos of Tangier and the people of the city. Seemingly incongruous are the images of walls and wallpapers, such as *Wallpaper*, Tangier, 2001. The fading alpine scene, peeling at the corners, becomes a stand-in for an unattainable reality as well as a reminder of transience: as time goes by, images and dreams fade. Another image from *The Strait Series* is a satellite rendering of the two coastlines framing the canal. *The Strait of Gibraltar*, Tangier, 2002 offers a plain, zoomed out view of the protagonist, the strait itself. Except for some variations in the coastal outlines, there is no way to distinguish the two bodies of land from each other. This view from above demonstrates the arbitrary nature of borders, so painfully apparent in this region.

YTO BARRADA
Wallpaper (below)
From *A Life Full of Holes: The Strait Project*
2001, Tangier, 60 x 60 cm
Courtesy Galerie Polaris, Paris

Strait of Gibraltar (opposite)
From *A Life Full of Holes: The Strait Project*
2003, Tangier, 60 x 60 cm
Courtesy Galerie Polaris, Paris

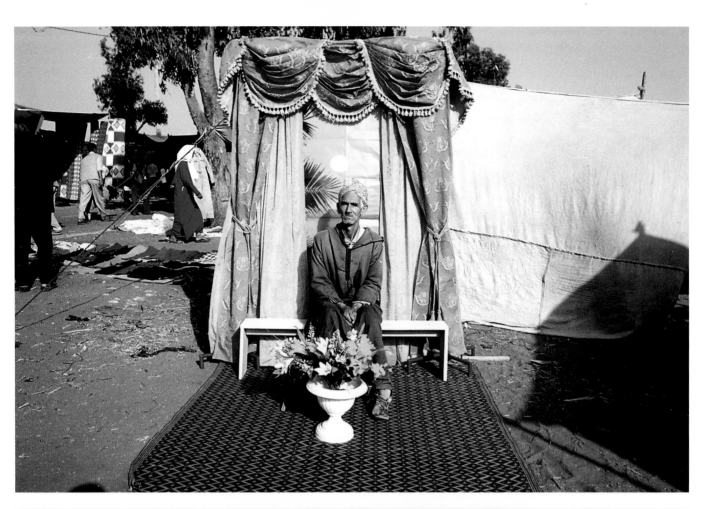

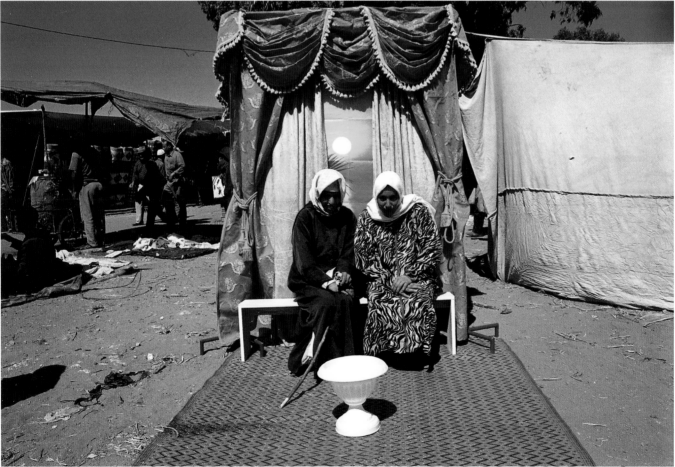

From *Portraits of Families* series
2001, photographic prints, dimensions variable
Courtesy the artist

HASSAN DARSI

Hassan Darsi, much like Shadi Ghadirian and Osama Esid, uses the practices of traditional studio photography as his point of departure. Darsi is less concerned with the art of photography than the acts of photography; when he began working on the *Family Portraits* project in 2001 it was with the intention of investigating the social encounters more than the actual photographic practice itself. Visiting neighbourhoods in several different countries, he set up studio set pieces on-site, with the aim of capturing the essence of these meetings between the artist and the families. Throughout the series the backdrops remain essentially the same as the surroundings and the subjects change, reflecting similarity and difference in Darsi's journey through Morocco, Holland, France and the United States.

These two photographs were taken in 2005 at a marketplace in Morocco. The handsome stage has been set up in the crowded setting of the Souk and the camera zooms out so as to capture this incongruous juxtaposition. This is where Darsi's practice differs most obviously from that of other artists inspired by traditional studio photography. In offering the viewer a broader view Darsi highlights quotidian scenes and exchanges. Thus the rendering of a day at the marketplace, the hustle and bustle of commerce and social encounters, comes together with an evocation of portrait photography and the stage set becomes almost a centrepiece rather than a sombre studio backdrop.

The evocation of studio photography recalls certain nostalgia for times passed, yet in revisiting these traditions with an agenda that is more social activist than pictorially precise, Darsi creates his own version of the once-popular portrait. These photographs reinvest the process of photography with social significance and simultaneously pay homage to past practices. The resulting images are both static and dynamic, tranquil and vivacious.

Hassan Darsi was born in Casablanca and often engages with his Moroccan cultural heritage, specifically addressing social concerns. He has been very active in Casablanca and in 1995 was one of the founders of the artist's group La Source du Lion. The group has initiated several interesting, proactive projects including one of Darsi's more well-known works, a 'rehabilitation concept' for the Hermitage Park in Casablanca. In 2006 he covered a wall in the park with 78 photographs of people he had seen there during the course of a single day. Darsi has also been involved in a summer art school for children and workshops in the park, situated in a low-income area of Casablanca formerly used as a garbage dump. He is also a member of *L'appartement 22*, an artist collective and collaborative art space located in Rabat.

AFSHIN DEHKORDI
Untitled from *Iran* series
2007, digital print
Courtesy the artist

AFSHIN DEHKORDI
Untitled from *Iran* series (below)
2007, digital print
Courtesy the artist

Untitled from *Iran* series (opposite)
2007, digital print
Courtesy the artist

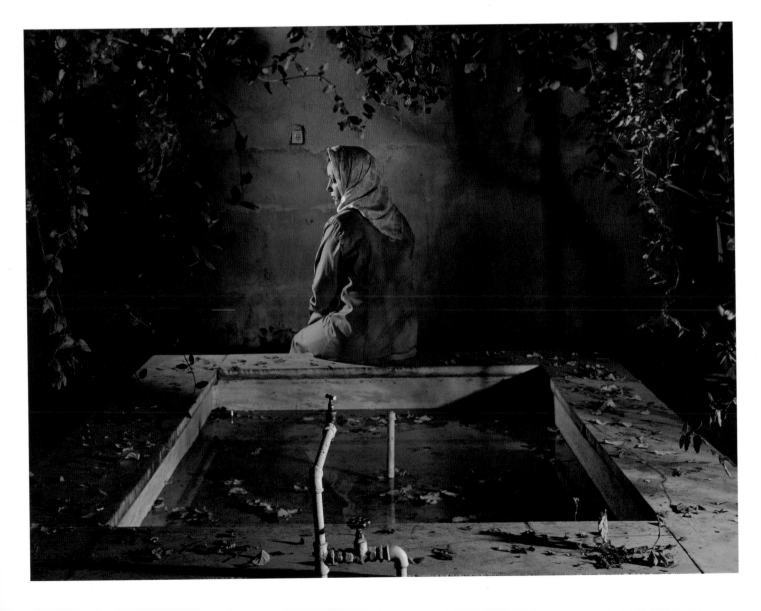

Untitled from *Unfinished* series (opposite above)
2007, C-print, 100 x 150 cm
Courtesy Kalfayan Galleries, Athens

Untitled from *Unfinished* series (opposite below)
2007, C-print, 100 x 150 cm
Courtesy Kalfayan Galleries, Athens

HRAIR SARKISSIAN

The photographic series *Unfinished* by Hrair Sarkissian focuses on minimal compositions of stark, urban structures. Through the abstraction of these empty, often man-made spaces, Sarkissian explores the potential of light and form to affect perception and encourage a new way of thinking about the implications of the urban landscapes that surround us, and their relation to personal identity.

Human presence has left marks on the urban landscape; in capturing them Sarkissian creates a refuge for the displaced self within the objects of its own creation. The photographs feature Damascus, where Sarkissian was born, and Amman in Jordan. The abandoned structures operate as monuments to human construction and subsequent withdrawal. Dark rooms are touched by filtered daylight; scorching red light enflames concrete walls: through this haunting play of light and shadow, the visual effect becomes almost cinematographic. According to Sarkissian, the perspective in his *Unfinished* series "is altogether different as it departs from traditional forms and structures, shunning any kind of Orientalism… Buildings under construction are shown as uncompleted monuments, often unnoticed, which only become briefly present while they appear on the landscape and the image." Thus Sarkissian sees his practice as a conscious departure from 'Oriental' themes, forms and stereotypes, stressing instead the development of cityscapes and the formal details hidden within urban settings.

Sarkissian's wider fascination with the process of urban decay and subsequent redevelopment resonates in a project he put together for a photographer's workshop at the Mustafa Ali Art Gallery and Foundation in Damascus in 2007. The artist took photographs of the nine doors that lead into the Old City of Damascus, digitally altering the images in order to close each door with a curtain of the kind used on construction sites in the city. By obscuring the doorways Sarkissian highlights them as urban scenes as well as places affected by relentless construction. The city has grown around the sites, engulfing them in development and rendering them hard to find within the complex, shifting maze of the capital.

Sarkissian's documentary practice and site-specific work often engages with spaces and architectural structures, seldom capturing human figures within the frame but frequently emphasising the theatrical, uncanny nature of the abandoned sites. The works do not necessarily deal with issues of place in relation to memory, but more the urban landscape as stage or form, and the process of change and how it affects the city.

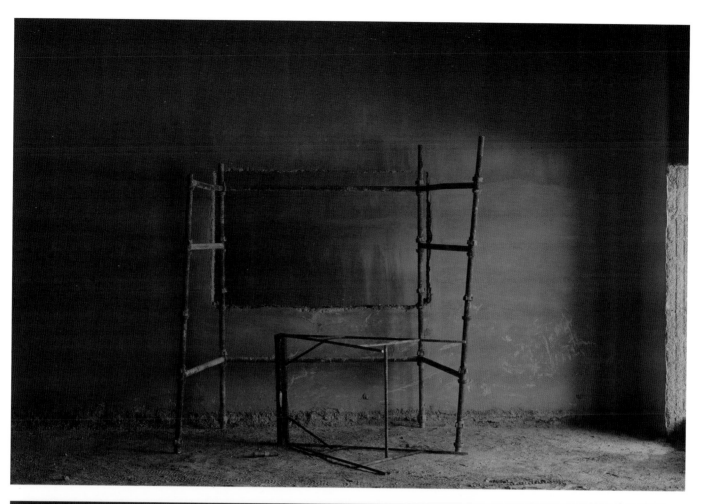

HRAIR SARKISSIAN
Untitled from *Unfinished* series
2007, C-print, 100 x 150 cm
Courtesy Kalfayan Galleries, Athens

YEHUDIT SASPORTAS

Corefire and laughter (below)
2008, three engravings in circles, ink on compressed
paper, laminated on MDF, 200 x 300 cm
Private Collection, courtesy Sommer Contemporary Art, Tel Aviv
and Galerie EIGEN + ART Leipzig/Berlin, photo: Uwe Walter

Thomas (opposite)
2005, ink on paper 200 x 150 cm
Courtesy Sommer Contemporary Art, Tel Aviv and Galerie
EIGEN + ART Leipzig/Berlin, photo: Uwe Walter

The Guardians of the Threshold (overleaf)
2007, installation View, 52nd Venice Biennale,
Israeli Pavilion, mixed media
Courtesy Sommer Contemporary Art, Tel Aviv and Galerie
EIGEN + ART Leipzig/Berlin, photo: Uwe Walter

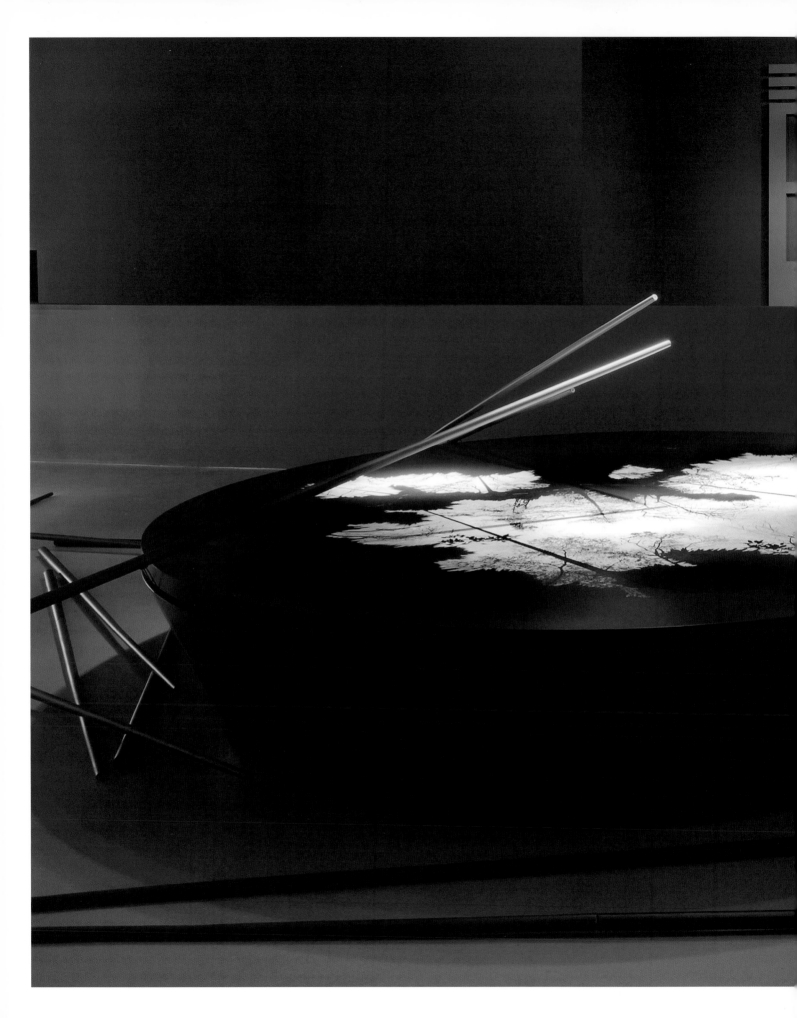

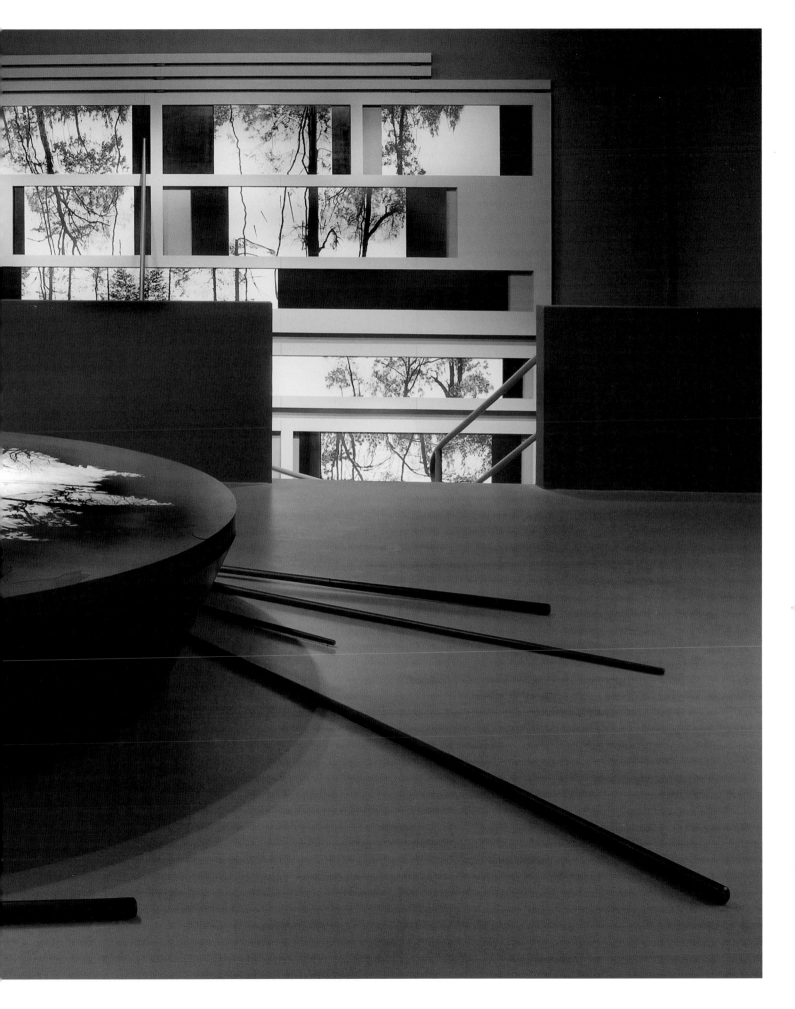

Way of Peace
1976, elevated view
Courtesy the artist, photo: Rina Castelnuovo

Negev Monument
1963–1968, aerial view
Courtesy the artist, photo: David Rubinger

DANI KARAVAN

Through sculpture, monuments and site-specific installations, Tel Aviv-born Dani Karavan often addresses issues of Israel's political situation, frequently emphasising peace and contemplation as a main theme.

In 1976 Karavan created *Environment for Peace* for the Israeli Pavilion at the Venice Biennale in 1976. The site-specific installation outside and inside the pavilion featured two olive trees flanking the entrance, paired with the text: "olive trees should be our borders". Inside the pavilion was written on the wall "… I dedicate this pavilion to peace. To peace between the Israelis and the Arabs. In order that peace should come to reign on the white dunes where we grew up together and which ought never again blackened with our blood." Visitors walked barefoot on the white concrete installation, interspersed with a line of water, a sundial, and sounds of organs recorded at Karavan's *Negev Monument*. Here, as in many of the

artist's works, human scale and the sense of interacting in a space becomes a vital component of the work.

The *Negev Monument*, 1963–1968, was designed in memory of the members of the Negev Brigade who fell in the 1948 Arab–Israeli war. The monument covers 10,000 square metres of desert plain, with a 20-metre high tower. The tower is pierced by holes creating musical tones as strong winds blow through them. The site was conceived as a meeting place: a space to engage with the landscape and the artwork. Karavan has said of the monument: "I wanted to create a sculpture to be climbed on, stepped on, touched, listened to, smelled, and seen." This work was in a way an inception of the artist's sculptural language, and several of its elements, such as the focus on human scale as a point of reference, are employed in his later works.

One such example, *Way of Peace*, 1996–2000, is composed of 108 columns of artificial yellow sandstone, lined up at 30-metre intervals to form a three-kilometre "environmental border sculpture" in Nitzana, Israel, near the Egyptian border. After the peace treaty between Israel and Egypt in 1979, Lova Eilav, a former member of parliament and secretary of the Labour party, asked Karavan to create a border sculpture. The word "peace" is inscribed on 100 of the columns and each end is flanked by four more columns engraved with the words "North", "West", "East" and "South" in Hebrew and Arabic.

The *Negev Monument* and the *Way of Peace* are both reflective of Karavan's broad approach to large-scale public works, all of which are designed to relate to the surrounding landscape, elements and climate while simultaneously inviting social interaction and engagement.

White House
2005, 4 minutes 58 seconds
16mm film transferred to DVD
Courtesy Giorgio Persano Gallery

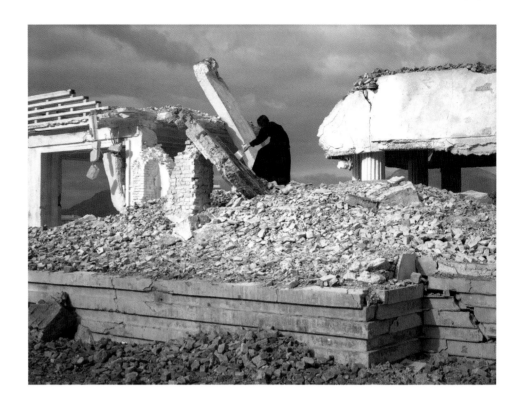

LIDA ABDUL

The notion of place and landscape is a primary concern for Afghan artist Lida Abdul. Her nomadic existence—Abdul was born in Kabul but was forced to leave after the former-Soviet invasion; she lived in India and Germany as a refugee and later studied in the United States—influences her practice in terms of issues of place and memory.

In her video/performance piece *White House*, 2005, the artist travelled to Kabul and executed the work close to a military base in the city. The video follows Abdul as she moves around the ruins of buildings in an arid landscape. She carries a pot of paint and a brush, painting the rubble and still standing pillars white. By whitewashing the products of destruction, marking them and in a sense putting them on a stage,

Abdul reinvests the ruins with meaning and preserves the site for the future. *White House* produces a different knowledge of architecture and space by suggesting new perspectives on construction and destruction.

In Afghanistan the idea of place, landscape and memory are closely—and often painfully—intertwined. In 2001 the Taliban, to dismay around the world, destroyed two ancient, colossal Buddha statues carved in the sandstone cliffs of Bamyan. The Buddhas were built in the sixth century and had thus been standing for over 1,500 years when they were demolished. Abdul's video *Clapping Stones*, 2005, shows a group of 20 young men dressed in black standing in front of the gaping holes in the mountain wall. The men hold two stones—remnants of the grand statues—gently hitting

them together, and creating monotonous clapping sounds.

Growing up in exile often entails a frayed memory: nostalgia, mixed with stories and imagination creates a disjunct recollection of a place no longer present in everyday life. When Abdul revisits her birthplace she engages with that memory, paying homage to the process of loss and remembering. Yet it is more than a contemplative musing of things lost. Her works also reclaim the sites and situates them in the present, thereby calling for change and recognition of past traumas.

Lida Abdul works primarily with video and performance art, and in 2005, she was the first-ever official representative for Afghanistan in the Venice Biennale.

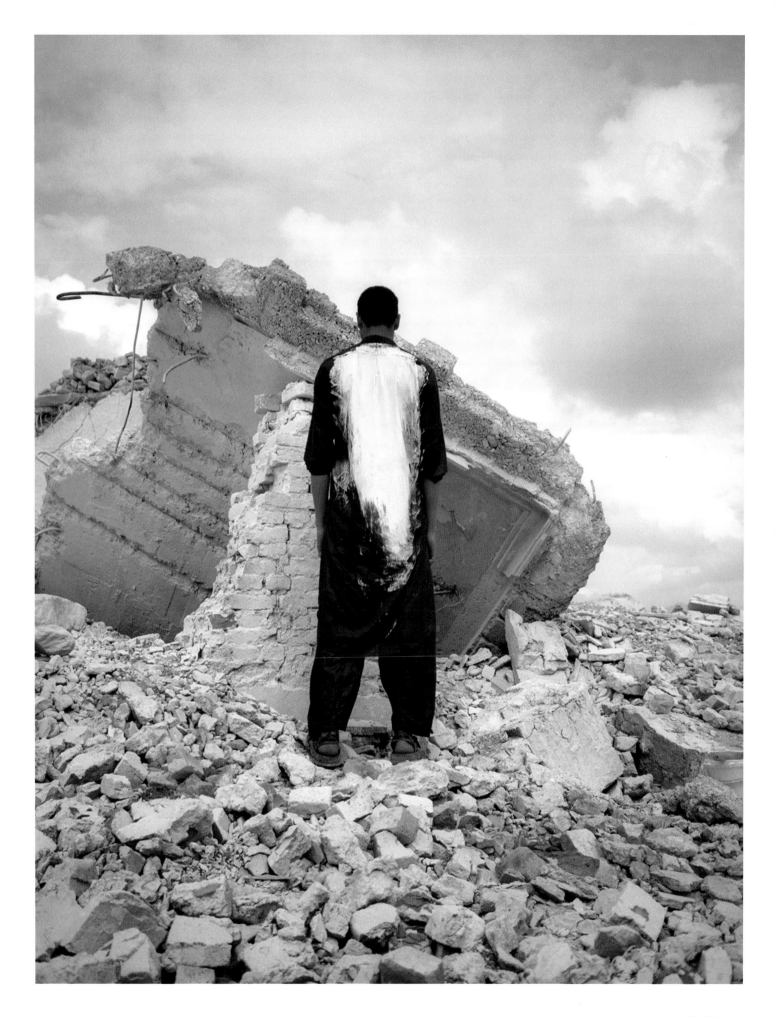

HILDA HIARY
Tarabish
2006, installation, 700 x 700 x 700 cm
Courtesy the artist

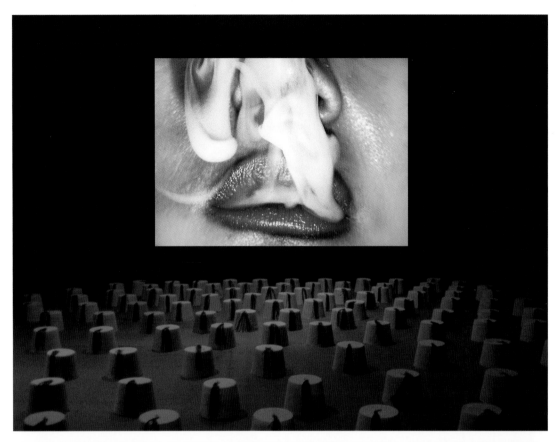

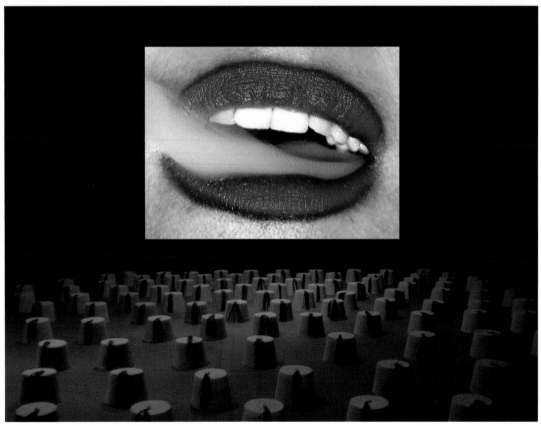

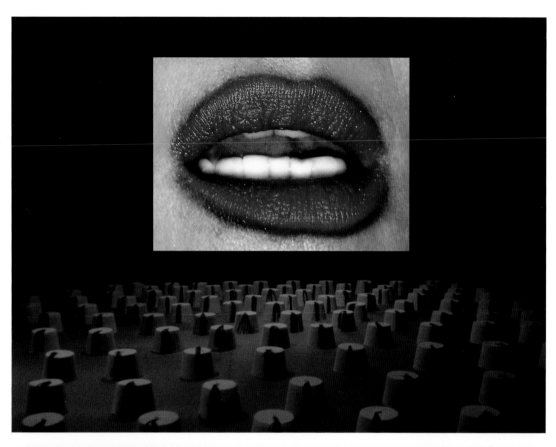

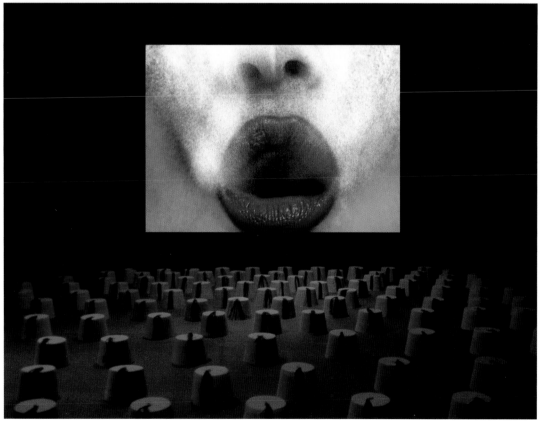

AMAL KENAWAY
The Journey
2004, video installation
Courtesy the artist

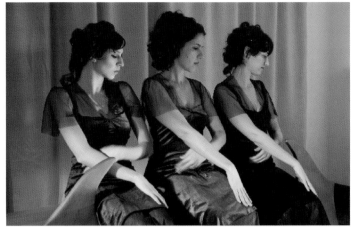

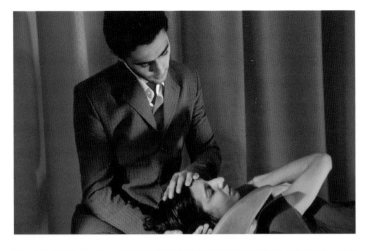

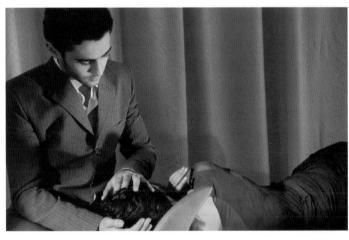

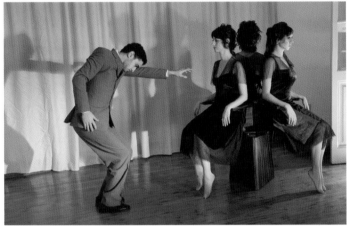

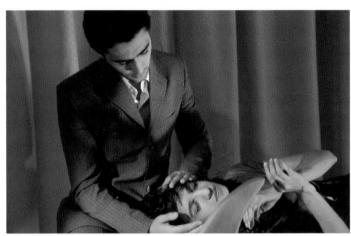

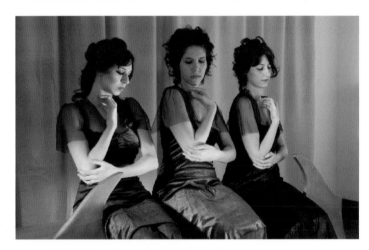

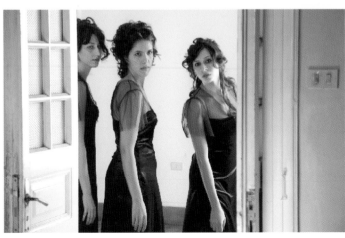

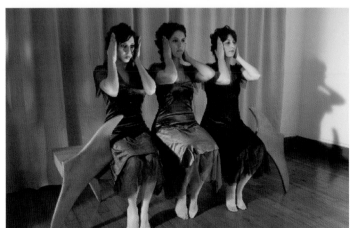

A Tress of Hair
2008, single-channel video installation
Courtesy the artist

DOA ALY

Doa Aly's *A Tress of Hair*, 2008, is a 12-minute long video work based on two short stories by Guy de Maupassant. In de Maupassant's *La Chevelure*, a young man falls in love with a tress of hair that he finds in an old cabinet, while *Berthe* (*Bertha*) tells the story of a girl with learning difficulties who is trained to recognise meal times by the clock. Aly tells these stories of fixation and waste through a cast of four performers, including herself, using a combination of choreography, plot and cinematography.

Aly's interest in body image and movements informs much of her work. In her video *48 Ballet Lessons*, 2005, the artist documented herself training as a classical ballet dancer. The viewer sees the protagonist progressing

and developing new mental and bodily skills. By documenting the painful and rigorous process of learning classical dance at a later age (Aly was 27 years old at the time and had never undertaken any form of dance training), the artist articulates questions of the objectified female body, the ideal athletic body, the body as a machine to discipline and contain, and the body as pure, abstract form. Similarly, Aly's performance highlights the concept of ideal bodies while also alluding to practices of performance and body art. More generally, her focus reflects a preoccupation with the idea of identity and 'becoming'.

Not confined to video, Aly address analogous concerns in her drawings that

often use the contours of the human body as points of departure, which then expand into looming Rorschach blots that frame and disrupt the images. Other works in her diverse practice use glossy, clean paintwork to create similar effects.

A Tress of Hair formed a part of PhotoCairo 4: The Long Shortcut, organised by the Contemporary Image Collective in Cairo under the curatorial direction of Aleya Hamza and Edit Molnar. PhotoCairo 4, an international visual arts festival that explored subversive strategies of existence within large urban environments, is a demonstration of the important role that the collective plays in the city's contemporary art world.

Chess (right)
2007, digital film
Courtesy the artist

Civil Wars (opposite)
2007, digital film
Courtesy the artist

MOHAMMED AL SHAMMAREY

Mohammed al Shammarey's video work draws on his personal experience of living in Iraq through repeated wars. Shammarey, who spent seven years involved in conflict, sees the wars that have been inflicted upon his country as actions that are result of a politics driven by misguided narratives. His cynicism towards conspiracy theory and dislike of narrative fiction interestingly feeds into his work, as he subverts devices of cinema. In the video installation *Chess*, 2007, he references what he sees as a common sense amongst the Iraqi population of being trapped in a game managed by the recently deposed regime and the American forces.

The monochromatic film begins with the camera panning over the chess pieces, their black and white differentiation muted. A fire breaks out on the board. Flames engulf the pawns and the soundtrack slows down; the suggestive music is reminiscent of a horror film. Eventually the fire dies out and leaves the ashes—the ruins of the game. A gust of wind breaks in and carries away the ashes across the board; here the image becomes more and more evocative of a storm across a barren landscape. At the end the rhythmic music returns, suggestive of the cyclical, seemingly never-ending nature of the event that is being played out. What appears at first as a game of chess ends in chaos; in place of calculated moves, the unstructured reality of war has been realised.

In his second film, *Civil Wars*, 2007, the artist views war through the filter of childhood and memory. Again, the soundtrack is reminiscent of narrative cinema, but it is in fact a popular Iraqi religious chant played in reverse. Spinning tops revolve rapidly and aimlessly around each other. The artist has said that he found the civil war in Iraq "to be visually equivalent to the mechanics of rotational motion and the random frictions generated by the rotation itself." At the end of the film the real words of the chant are played as the pieces collide and come to a halt. One of the tops continues to spin, momentarily victorious until it also slows down and joins the rest in stasis.

Having left Iraq and used art to rebuild his sense of self, Shammarey's work also reflects his identity as a fugitive from a troubled land where he feels he still belongs. Finding his refuge in simple, everyday objects such as boxes, drawings in newspapers and handwritten notes, he has fed this into his paintings, which often resemble documents that have been deliberately stripped of a point of view.

FAISAL SAMRA
Performance 19 from *Distorted Reality* series
2007, triptych, lambda prints, 40 x 52 cm each
Courtesy the artist

SHIRANA SHAHBAZI
The Curve, Barbican Art Gallery
4 October 2007–20 January 2008
Courtesy Barbican Art Gallery, photo: Eliot Wyman

HALEH ANVARI
On the Road from *Chadornama* (below)
2005, print
Courtesy the artist

London Piccadilly from *Chado-dadar* (opposite)
2006, print
Courtesy the artist

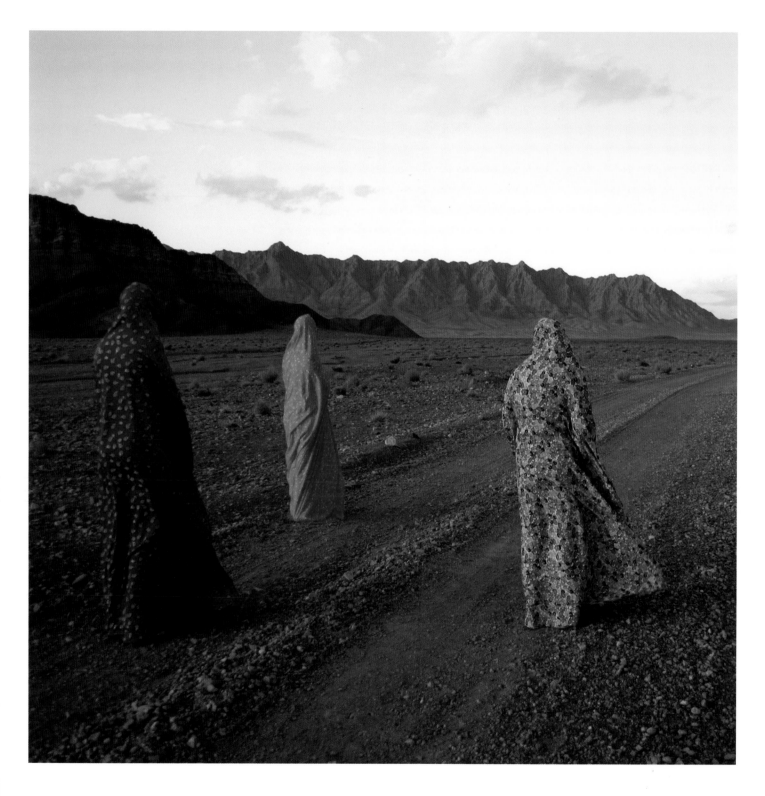

TAREK AL GHOUSSEIN
Untitled 3 from *Self-Portrait* series
2002–2003, C-print, 60 x 80 cm
Courtesy The Third Line

APPENDIX

AN INTRODUCTION TO ORIENTALISM

Few books have had such a seminal impact on a wide array of academic disciplines as Edward Said's *Orientalism*. First published in 1978, it has been translated into 26 languages and continues to influence scholars worldwide. Within his tightly argued text, Said describes the ways in which the West has come to produce knowledge of the 'Orient' as Other, and embarks on an in-depth critique of Western Orientalist scholarship. Although the debate has now run for three decades, Said continues to be a fundamental source for thinking about how the West looks at the East and the effect it has on representation.

In the preface to the 2003 edition Said writes: "there is a difference between knowledge of other peoples and other times that is the result of understanding, compassion, careful study and analysis for their own sakes, and on the other hand knowledge—if that is what it is—that is part of an overall campaign of self-affirmation, belligerency and outright war". Said's fundamentally humanist approach runs throughout much of his scholarship, which also draws on his own experiences as an exiled Palestinian.

Orientalism is not a book about art; however, art is not conceived in a vacuum and many artists in this book either consciously mobilise Oriental stereotypes or deliberately reject them, using Said's vocabulary to conceptualise their work. It seems almost impossible to separate Said's critique of Western knowledge of the Orient with concerns of representation and visual culture.

The relationship between scholarship and politics has always been contentious and in many ways Edward Said in *Orientalism* disrupted the idea that academia was somehow autonomous, a move that naturally attracted a lot of criticism. Numerous voices have discussed and criticised Said's book since it was first published in the late 1970s. His theories have been tested within the fields of art history, philosophy, comparative literature, Middle-Eastern studies and political science. Here, Zachary Lockman, professor of Middle-Eastern and Islamic studies at Harvard University, charts the responses that immediately arose following its publication, some of which were distinctly less considered than others, but all of which provide an indicator of the temper of the discussion at the time. Though they represent only the first moments of a dialogue that continues to this day, Lockman's analysis— alongside the extract of Said's text reprinted here—provides a point of departure for those new to the Orientalist debate.

IMAGINATIVE GEOGRAPHY AND ITS REPRESENTATIONS: ORIENTALIZING THE ORIENTAL
EDWARD W SAID

Excerpt from *Orientalism* by Edward W Said.

Strictly speaking, Orientalism is a field of learned study. In the Christian West, Orientalism is considered to have commenced its formal existence with the decision of the Church Council of Vienne in 1312 to establish a series of chairs in "Arabic, Greek, Hebrew, and Syriac at Paris, Oxford, Bologna, Avignon, and Salamanca."[1] Yet any account of Orientalism would have to consider not only the professional Orientalist and his work but also the very notion of a field of study based on a geographical, cultural, linguistic, and ethnic unit called the Orient. Fields, of course, are made. They acquire coherence and integrity in time because scholars devote themselves in different ways to what seems to be a commonly agreed-upon subject matter. Yet it goes without saying that a field of study is rarely as simply defined as even its most committed partisans—usually scholars, professors, experts, and the like—claim it is. Besides, a field can change so entirely, in even the most traditional disciplines like philology, history, or theology, as to make an all-purpose definition of subject matter almost impossible. This is certainly true of Orientalism, for some interesting reasons.

To speak of scholarly specialization as a geographical 'field' is, in the case of Orientalism, fairly revealing since no one is likely to imagine a field symmetrical to it called Occidentalism. Already the special, perhaps even eccentric attitude of Orientalism becomes apparent. For although many learned disciplines imply a position taken towards, say, human material (a historian deals with the human past from a special vantage point in the present), there is no real analogy for taking a fixed, more or less total geographical position towards a wide variety of social, linguistic, political, and historical realities. A classicist, a Romance specialist, even an Americanist focuses on a relatively modest portion of the world, not on a full half of it. But Orientalism is a field with considerable geographical ambition. And since Orientalists have traditionally occupied themselves with things Oriental (a specialist in Islamic law, no less than an expert in Chinese dialects or in Indian religions, is considered an Orientalist by people who call themselves Orientalists), we must learn to accept enormous, indiscriminate size plus an almost infinite capacity for subdivision as one of the chief characteristics of Orientalism—one that is evidenced in its confusing amalgam of imperial vagueness and precise detail.

All of this describes Orientalism as an academic discipline. The 'ism' in Orientalism serves to insist on the distinction of this discipline from every other kind. The rule in its historical development as an academic discipline has been its increasing scope, not its greater selectiveness. Renaissance Orientalists like Erpenius and Guillaume Postel were primarily specialists in the languages of the Biblical provinces, although Postel boasted that he could get across Asia as far as China without needing an interpreter. By and large, until the mid-eighteenth century Orientalists were Biblical scholars, students of the Semitic languages, Islamic specialists, or, because the Jesuits had opened up the new study of China, Sinologists. The whole middle expanse of Asia was not academically conquered for Orientalism until, during the later eighteenth century, Anquetil-Duperron and Sir William Jones were able intelligibly to reveal the extraordinary riches of Avestan and Sanskrit. By the middle of the nineteenth century Orientalism was as vast a treasure-house of learning as one could imagine. There are two excellent indices of this new, triumphant eclecticism. One is the encyclopedic description of Orientalism roughly from 1765 to 1850 given by Raymond Schwab in his *La Renaissance orientale*.[2] Quite aside from the scientific discoveries of things Oriental made by learned professionals during this period in Europe, there was the virtual epidemic of Orientalia affecting every major poet, essayist, and philosopher of the period. Schwab's notion is that 'Oriental' identifies an amateur or professional enthusiasm for everything Asiatic, which was wonderfully synonymous with the exotic, the mysterious, the profound, the seminal; this is a later transposition eastwards of a similar enthusiasm in Europe for Greek and Latin antiquity during the High Renaissance. In 1829 Victor Hugo put this change in directions as follows: "Au siècle de Louis XIV on était helléniste, maintenant on est orientaliste."[3] A nineteenth-century Orientalist was therefore either a scholar (a Sinologist, an Islamicist, an Indo-Europeanist) or a gifted enthusiast (Hugo in Les Orientales, Goethe in the Westöstlicher Diwan), or both (Richard Burton, Edward Lane, Friedrich Schlegel).

The second index of how inclusive Orientalism had become since the Council of Vienne is to be found in nineteenth-century chronicles of the field itself. The most thorough of its kind is Jules Mohl's *Vingt-sept Ans d'histoire des études orientales*, a two-volume logbook of everything of note that took place in Orientalism between 1840 and 1867.[4] Mohl was the secretary of the Société asiatique in Paris, and for something more than the first half of the nineteenth century Paris was the capital of the Orientalist world (and, according to Walter Benjamin, of the nineteenth century). Mohl's position in the Société could not have been more central to the field of Orientalism. There is scarcely anything done by a European scholar touching Asia during those 27 years that Mohl does not enter under "études orientales". His entries of course concern publications, but the range of published material of interest to Orientalist scholars is awesome. Arabic, innumerable Indian dialects, Hebrew, Pehlevi, Assyrian, Babylonian, Mongolian, Chinese, Burmese, Mesopotamian, Javanese: the list of philological works considered Orientalist is almost uncountable. Moreover, Orientalist studies apparently cover everything from the editing and translation of texts to numismatic, anthropological, archaeological, sociological, economic, historical, literary, and cultural studies in every known Asiatic and North African civilization, ancient and modern. Gustave Dugat's *Histoire des orientalistes de l'Europe du XIIe au XIXe siècle* (1868–1870)[5] is a selective history of major figures, but the range represented is no less immense than Mohl's.

Such eclecticism as this had its blind spots, nevertheless. Academic Orientalists for the most part were interested in the classical period of

whatever language or society it was that they studied. Not until quite late in the century, with the single major exception of Napoleon's Institut d'Égypte, was much attention given to the academic study of the modern, or actual, Orient. Moreover, the Orient studied was a textual universe by and large; the impact of the Orient was made through books and manuscripts, not, as in the impress of Greece on the Renaissance, through mimetic artifacts like sculpture and pottery. Even the rapport between an Orientalist and the Orient was textual, so much so that it is reported of some of the early-nineteenth century German Orientalists that their first view of an eight-armed Indian statue cured them completely of their Orientalist taste.[6] When a learned Orientalist traveled in the country of his specialization, it was always with unshakable abstract maxims about the 'civilization' he had studied; rarely were Orientalists interested in anything except proving the validity of these musty 'truths' by applying them, without great success, to uncomprehending, hence degenerate, natives. Finally, the very power and scope of Orientalism produced not only a fair amount of exact positive knowledge about the Orient but also a kind of second-order knowledge—lurking in such places as the 'Oriental' tale, the mythology of the mysterious East, notions of Asian inscrutability—with a life of its own, what VG Kiernan has aptly called "Europe's collective day-dream of the Orient".[7] One happy result of this is that an estimable number of important writers during the nineteenth century were Oriental enthusiasts: it is perfectly correct, I think, to speak of a genre of Orientalist writing as exemplified in the works of Hugo, Goethe, Nerval, Flaubert, Fitzgerald, and the like. What inevitably goes with such work, however, is a kind of free-floating mythology of the Orient, an Orient that derives not only from contemporary attitudes and popular prejudices but also from what Vico called the conceit of nations and of scholars.

Today an Orientalist is less likely to call himself an Orientalist than he was almost any time up to World War II. Yet the designation is still useful, as when universities maintain programs or departments in Oriental languages or Oriental civilizations. There is an Oriental 'faculty' at Oxford, and a department of Oriental studies at Princeton. As recently as 1959, the British government empowered a commission "to review developments in the Universities in the fields of Oriental, Slavonic, East European and African studies… and to consider, and advise on, proposals for future development."[8] The Hayter Report, as it was called when it appeared in 1961, seemed untroubled by the broad designation of the word *Oriental*, which it found serviceably employed in American Universities as well. For even the greatest name in modern Anglo-American Islamic studies, HAR Gibb, preferred to call himself an Orientalist rather than an Arabist. Gibb himself, classicist that he was, could use the ugly neologism 'area study' for Orientalism as a way of showing that area studies and Orientalism after all were interchangeable geographical titles.[9] But this, I think, ingenuously belies a much more interesting relationship between knowledge and geography. I should like to consider that relationship briefly.

Despite the distraction of a great many vague desires, impulses, and images, the mind seems persistently to formulate what Claude Lévi-Strauss has called a science of the concrete.[10] A primitive tribe, for example, assigns a definite place, function, and significance to every leafy species in its immediate environment. Many of these grasses and flowers have no practical use; but the point Lévi-Strauss makes is that mind requires order, and order is achieved by discriminating and taking note of everything, placing everything of which the mind is aware in a secure, refindable place, therefore giving things some role to play in the economy of objects and identities that make up an environment. This kind of rudimentary classification has a logic to it, but the rules of the logic by which a green fern in one society is a symbol of grace and in another is considered maleficent are neither predictably rational nor universal. There is always a measure of the purely arbitrary in the way the distinctions between things are seen. And with these distinctions go values whose history, if one could

unearth it completely, would probably show the same measure of arbitrariness. This is evident enough in the case of fashion. Why do wigs, lace collars, and high buckled shoes appear, then disappear, over a period of decades? Some of the answer has to do with utility and some with the inherent beauty of the fashion. But if we agree that all things in history, like history itself, are made by men, then we will appreciate how possible it is for many objects or places or times to be assigned roles and given meanings that acquire objective validity only *after* the assignments are made. This is especially true of relatively uncommon things, like foreigners, mutants, or 'abnormal' behavior.

It is perfectly possible to argue that some distinctive objects are made by the mind, and that these objects, while appearing to exist objectively, have only a fictional reality. A group of people living on a few acres of land will set up boundaries between their land and its immediate surroundings and the territory beyond, which they call 'the land of the barbarians'. In other words, this universal practice of designating in one's mind a familiar space which is 'ours' and an unfamiliar space beyond 'ours' which is 'theirs' is a way of making geographical distinctions that *can* be entirely arbitrary. I use the word 'arbitrary' here because imaginative geography of the 'our land–barbarian land' variety does not require that the barbarians acknowledge the distinction. It is enough for 'us' to set up these boundaries in our own minds; 'they' become 'they' accordingly, and both their territory and their mentality are designated as different from 'ours'. To a certain extent modern and primitive societies seem thus to derive a sense of their identities negatively. A fifth-century Athenian was very likely to feel himself to be non-barbarian as much as he positively felt himself to be Athenian. The geographic boundaries accompany the social, ethnic, and cultural ones in expected ways. Yet often the sense in which someone feels himself to be not-foreign is based on a very unrigorous idea of what is 'out there,' beyond one's own territory. All kinds of suppositions, associations, and

fictions appear to crowd the unfamiliar space outside one's own.

The French philosopher Gaston Bachelard once wrote an analysis of what he called the poetics of space.[11] The inside of a house, he said, acquires a sense of intimacy, secrecy, security, real or imagined, because of the experiences that come to seem appropriate for it. The objective space of a house—its corners, corridors, cellar, rooms —is far less important than what poetically it is endowed with, which is usually a quality with an imaginative or figurative value we can name and feel: thus a house may be haunted, or home-like, or prison-like, or magical. So space acquires emotional and even rational sense by a kind of poetic process, whereby the vacant or anonymous reaches of distance are converted into meaning for us here. The same process occurs when we deal with time. Much of what we associate with or even know about such periods as 'long ago' or 'the beginning' or 'at the end of time' is poetic— made up. For a historian of Middle Kingdom Egypt, 'long ago' will have a very clear sort of meaning, but even this meaning does not totally dissipate the imaginative, quasi-fictional quality one senses lurking in a time very different and distant from our own. For there is no doubt that imaginative geography and history help the mind to intensify its own sense of itself by dramatizing the distance and difference between what is close to it and what is far away. This is no less true of the feelings we often have that we would have been more 'at home' in the sixteenth century or in Tahiti.

Yet there is no use in pretending that all we know about time and space, or rather history and geography, is more than anything else imaginative. There are such things as positive history and positive geography which in Europe and the United States have impressive achievements to point to. Scholars now do know more about the world, its past and present, than they did, for example, in Gibbon's time. Yet this is not to say that they know all there is to know, nor, more important, is it to say that what they know has effectively dispelled the imaginative geographical and historical knowledge I have been considering.

We need not decide here whether this kind of imaginative knowledge infuses history and geography, or whether in some way it overrides them. Let us just say for the time being that it is there as something more than what appears to be merely positive knowledge.

Almost from earliest times in Europe the Orient was something more than what was empirically known about it. At least until the early eighteenth century, as RW Southern has so elegantly shown, European understanding of one kind of Oriental culture, the Islamic, was ignorant but complex.[12] For certain associations with the East—not quite ignorant, not quite informed—always seem to have gathered around the notion of an Orient. Consider first the demarcation between Orient and West. It already seems bold by the time of the *Illiad*. Two of the most profoundly influential qualities associated with the East appear in Aeschylus's *The Persians*, the earliest Athenian play extant, and in *The Bacchae* of Euripides, the very last one extant. Aeschylus portrays the sense of disaster overcoming the Persians when they learn that their armies, led by King Xerxes, have been destroyed by the Greeks. The chorus sings the following ode:

> Now all Asia's land
> Moans in emptiness.
> Xerxes led forth, oh oh!
> Xerxes destroyed, woe woe!
> Xerxes' plans have all miscarried
> In ships of the sea.
> Why did Darius then
> Bring no harm to his men
> When he led them into battle,
> That beloved leader of men from Susa?[13]

What matters here is that Asia speaks through and by virtue of the European imagination, which is depicted as victorious over Asia, that hostile 'other' world beyond the seas. To Asia are given the feelings of emptiness, loss, and disaster that seem thereafter to reward Oriental challenges to the West; and also, the lament that in some glorious past Asia fared better, was itself victorious over Europe.

In *The Bacchae*, perhaps the most Asiatic of all the Attic dramas, Dionysus is explicitly connected with his Asian origins and with the strangely threatening excesses of Oriental mysteries. Pentheus, king of Thebes, is destroyed by his mother, Agave, and her fellow bacchantes. Having defied Dionysus by not recognizing either his power or his divinity, Pentheus is thus horribly punished, and the play ends with a general recognition of the eccentric god's terrible power. Modern commentators on *The Bacchae* have not failed to note the play's extraordinary range of intellectual and aesthetic effects; but there has been no escaping the additional historical detail that Euripides "was surely affected by the new aspect that the Dionysiac cults must have assumed in the light of the foreign ecstatic religions of Bendis, Cybele, Sabazius, Adonis, and Isis, which were introduced from Asia Minor and the Levant and swept through Piraeus and Athens during the frustrating and increasingly irrational years of the Peloponnesian War."[14]

The two aspects of the Orient that set it off from the West in this pair of plays will remain essential motifs of European imaginative geography. A line is drawn between two continents. Europe is powerful and articulate; Asia is defeated and distant. Aeschylus *represents* Asia, makes her speak in the person of the aged Persian queen, Xerxes' mother. It is Europe that articulates the Orient; this articulation is the prerogative, not of a puppet master, but of a genuine creator, whose life-giving power represents, animates, constitutes the otherwise silent and dangerous space beyond familiar boundaries. There is an analogy between Aeschylus's orchestra, which contains the Asiatic world as the playwright conceives it, and the learned envelope of Orientalist scholarship, which also will hold in the vast, amorphous Asiatic sprawl for sometimes sympathetic but always dominating scrutiny. Secondly, there is the motif of the Orient as insinuating danger. Rationality is undermined by Eastern excesses, those mysteriously attractive opposites to what seem to be normal values. The difference separating East from West is symbolized by the sternness with which, at first, Pentheus rejects the hysterical

bacchantes. When later he himself becomes a bacchant, he is destroyed not so much for having given in to Dionysus as for having incorrectly assessed Dionysus's menace in the first place. The lesson that Euripides intends is dramatized by the presence in the play of Cadmus and Tiresias, knowledgeable older men who realize that 'sovereignty' alone does not rule men;[15] there is such a thing as judgment, they say, which means sizing up correctly the force of alien powers and expertly coming to terms with them. Hereafter Oriental mysteries will be taken seriously, not least because they challenge the rational Western mind to new exercises of its enduring ambition and power.

But one big division, as between West and Orient, leads to other smaller ones, especially as the normal enterprises of civilization provoke such outgoing activities as travel, conquest, new experiences. In classical Greece and Rome geographers, historians, public figures like Caesar, orators, and poets added to the fund of taxonomic lore separating races, regions, nations, and minds from each other; much of that was self-serving, and existed to prove that Romans and Greeks were superior to other kinds of people. But concern with the Orient had its own tradition of classification and hierarchy. From at least the second century BC on, it was lost on no traveller or eastward-looking and ambitious Western potentate that Herodotus—Historian, traveler, inexhaustibly curious chronicler—and Alexander—king warrior, scientific conqueror— had been in the Orient before. The Orient was therefore subdivided into realms previously known, visited, conquered, by Herodotus and Alexander as well as their epigones, and those realms not previously known, visited, conquered. Christianity completed the setting up of main intra-Oriental spheres: there was a Near Orient and a Far Orient, a familiar Orient, which Rene Grousset calls "l'empire du Levant",[16] and a novel Orient. The Orient therefore alternated in the mind's geography between being an Old World to which one returned, as to Eden or Paradise, there to set up a new version of the old, and being a wholly new place to which one

came as Columbus came to America, in order to set up a New World (although, ironically, Columbus himself thought that he discovered a new part of the Old World). Certainly neither of these Orients was purely one thing or the other: it is their vacillations, their tempting suggestiveness, their capacity for entertaining and confusing the mind, that are interesting.

Consider how the Orient, and in particular the Near Orient, became known in the West as its great complementary opposite since antiquity. There were the Bible and the rise of Christianity; there were travelers like Marco Polo who charted the trade routes and patterned a regulated system of commercial exchange, and after him Lodovico di Varthema and Pietro della Valle; there were fabulists like Mandeville; there were the redoubtable conquering Eastern movements, principally Islam, of course; there were the militant pilgrims, chiefly the Crusaders. Altogether an internally structured archive is built up from the literature that belongs to these experiences. Out of this comes a restricted number of typical encapsulations: the journey, the history, the fable, the stereotype, the polemical confrontation. These are the lenses through which the Orient is experienced, and they shape the language, perception, and form of the encounter between East and West. What gives the immense number of encounters some unity, however, is the vacillation I was speaking about earlier. Something patently foreign and distant acquires, for one reason or another, a status more rather than less familiar. One tends to stop judging things either as completely novel or as completely well known; a new median category emerges, a category that allows one to see new things, things seen for the first time, as versions of a previously known thing. In essence such a category is not so much a way of receiving new information as it is a method of controlling what seems to be a threat to some established view of things. If the mind must suddenly deal with what it takes to be a radically new form of life—as Islam appeared to Europe in the early Middle Ages—the response on the whole is conservative and defensive. Islam is judged to

be a fraudulent new version of some previous experience, in this case Christianity. The threat is muted, familiar values impose themselves, and in the end the mind reduces the pressure upon it by accommodating things to itself as either 'original' or 'repetitious'. Islam thereafter is 'handled': its novelty and its suggestiveness are brought under control so that relatively nuanced discriminations are now made that would have been impossible had the raw novelty of Islam been left unattended. The Orient at large, therefore, vacillates between the West's contempt for what is familiar and its shivers of delight in—or fear of—novelty.

Yet where Islam was concerned, European fear, if not always respect, was in order. After Mohammed's death in 632, the military and later the cultural and religious hegemony of Islam grew enormously. First Persia, Syria, and Egypt, then Turkey, then North Africa fell to the Muslim armies; in the eighth and ninth centuries Spain, Sicily, and parts of France were conquered. By the thirteenth and fourteenth centuries Islam ruled as far east as India, Indonesia, and China. And to this extraordinary assault Europe could respond with very little except fear and a kind of awe. Christian authors witnessing the Islamic conquests had scant interest in the learning, high culture, and frequent magnificence of the Muslims, who were, as Gibbon said, "coeval with the darkest and most slothful period of European annals". (But with some satisfaction he added, "since the sum of science has risen in the West, it should seem that the Oriental studies have languished and declined".[17]) What Christians typically felt about the Eastern armies was that they had "all the appearance of a swarm of bees, but with a heavy hand... they devastated everything": so wrote Erchembert, a cleric in Monte Cassino in the eleventh century.[18]

Not for nothing did Islam come to symbolize terror, devastation, the demonic, hordes of hated barbarians. For Europe, Islam was a lasting trauma. Until the end of the seventeenth century the "Ottoman peril" lurked alongside

Europe to represent for the whole of Christian civilization a constant danger, and in time European civilization incorporated that peril and its lore, its great events, figures, virtues, and vices, as something woven into the fabric of life. In Renaissance England alone, as Samuel Chew recounts in his classic study *The Crescent and the Rose*,"a man of average education and intelligence" had at his fingertips, and could watch on the London stage, a relatively large number of detailed events in the history of Ottoman Islam and its encroachments upon Christian Europe.[19] The point is that what remained current about Islam was some necessarily diminished version of those great dangerous forces that it symbolized for Europe. Like Walter Scott's Saracens, the European representation of the Muslim, Ottoman, or Arab was always a way of controlling the redoubtable Orient, and to a certain extent the same is true of the methods of contemporary learned Orientalists, whose subject is not so much the East itself as the East made known, and therefore less fearsome, to the Western reading public.

There is nothing especially controversial or reprehensible about such domestications of the exotic; they take place between all cultures, certainly, and between all men. My point, however, is to emphasize the truth that the Orientalist, as much as anyone in the European West who thought about or experienced the Orient, performed this kind of mental operation. But what is more important still is the limited vocabulary and imagery that impose themselves as a consequence. The reception of Islam in the West is a perfect case in point, and has been admirably studied by Norman Daniel. One constraint acting upon Christian thinkers who tried to understand Islam was an analogical one; since Christ is the basis of Christian faith, it was assumed—quite incorrectly—that Mohammed was to Islam as Christ was to Christianity. Hence the polemic name 'Mohammedanism' given to Islam, and the automatic epithet 'imposter' applied to Mohammed.[20] Out of such and many other misconceptions "there formed a circle which was never broken by imaginative

exteriorisation…. The Christian concept of Islam was integral and self-sufficient."[21] Islam became an image— the word is Daniel's but it seems to me to have remarkable implications for Orientalism in general—whose function was not so much to represent Islam in itself as to represent it for the medieval Christian.

> The invariable tendency to neglect what the Qur'an meant, or what Muslims thought it meant, or what Muslims thought or did in any given circumstances, necessarily implies that Qur'anic and other Islamic doctrine was presented in a form that would convince Christians; and more and more extravagant forms would stand a chance of acceptance as the distance of the writers and public from the Islamic border increased. It was with very great reluctance that what Muslims said Muslims believed was accepted as what they did believe. There was a Christian picture in which the details (even under the pressure of facts) were abandoned as little as possible, and in which the general outline was never abandoned. There were shades of difference, but only with a common framework. All the corrections that were made in the interests of an increasing accuracy were only a defence of what had newly been realised to be vulnerable, a shoring up of a weakened structure. Christian opinion was an erection which could not be demolished, even to be rebuilt.[22]

This rigorous Christian picture of Islam was intensified in innumerable ways, including —during the Middle Ages and early Renaissance —a large variety of poetry, learned controversy, and popular superstition.[23] By this time the Near Orient had been all but incorporated in the common world-picture of Latin Christianity— as in the *Chanson de Roland* the worship of Saracens is portrayed as embracing Mahomet *and* Apollo. By the middle of the fifteenth century, as RW Southern has brilliantly shown, it became apparent to serious European thinkers "that something would have to be done about Islam", which had turned the situation around

somewhat by itself arriving militarily in Eastern Europe. Southern recounts a dramatic episode between 1450 and 1460 when four learned men, John of Segovia, Nicholas of Cusa, Jean Germain, and Aeneas Silvius (Pius II), attempted to deal with Islam through *contraferentia*, or 'conference'. The idea was John of Segovia's: it was to have been a staged conference with Islam in which Christians attempted the wholesale conversion of Muslims. "He saw the conference as an instrument with a political as well as a strictly religious function, and in words which will strike a chord in modern breasts he exclaimed that even if it were to last ten years it would be less expensive and less damaging than war." There was no agreement between the four men, but the episode is crucial for having been a fairly sophisticated attempt—part of a general European attempt from Bede to Luther—to put a representative Orient in front of Europe, to the Orient and Europe together in some coherent way, the idea being for Christians to make it clear to Muslims that Islam was just a misguided version of Christianity. Southern's conclusion follows:

> Most conspicuous to us is the inability of any of these systems of thought [European Christian] to provide a fully satisfying explanation of the phenomenon they had set out to explain [Islam] —still less to influence the course of practical events in a decisive way. At a practical level, events never turned out either so well or so ill as the most intelligent observers predicted; and it is perhaps worth noticing that they never turned out better than when the best judges confidently expected a happy ending. Was there any progress [in Christian knowledge of Islam]? I must express my conviction that there was. Even if the solution of the problem remained obstinately hidden from sight, the statement of the problem became more complex, more rational, and more related to experience…. The scholars who labored at the problem of Islam in the Middle Ages failed to find the solution they sought and desired; but they

developed habits of mind and powers of comprehension which, in other men and in other fields, may yet deserve success.[24]

The best part of Southern's analysis, here and elsewhere in his brief history of Western views of Islam, is his demonstration that it is finally Western ignorance which becomes more refined and complex, not some body of positive Western knowledge which increases in size and accuracy. For fictions have their own logic and their own dialectic of growth or decline. Onto the character of Mohammed in the Middle Ages was heaped a bundle of attributes that corresponded to the "character of the [twelfth-century] prophets of the 'Free Spirit' who did actually arise in Europe, and claim credence and collect followers". Similarly, since Mohammed was viewed as the disseminator of a false Revelation, he became as well the epitome of lechery, debauchery, sodomy, and a whole battery of assorted treacheries, all of which derived 'logically' from his doctrinal impostures.[25] Thus the Orient acquired representatives, so to speak, and representations, each one more concrete, more internally congruent with some Western exigency, than the ones that preceded it. It is as if, having once settled on the Orient as a locale suitable for incarnating the infinite in a finite shape, Europe could not stop the practice; the Orient and the Oriental, Arab, Islamic, Indian, Chinese, or whatever, become repetitious pseudo-incarnations of some great original (Christ, Europe, the West) they were supposed to have been imitating. Only the source of these rather narcissistic Western ideas about the Orient changed in time, not their character. Thus we will find it commonly believed in the twelfth and thirteenth centuries that Arabia was "on the fringe of the Christian world, a natural asylum for heretical outlaws,"[26] and that Mohammed was a cunning apostate, whereas in the twentieth century an Orientalist scholar, an erudite specialist, will be the one to point out how Islam is really no more than second-order Arian heresy.[27]

Our initial description of Orientalism as a learned field now acquires a new concreteness.

A field is often an enclosed space. The idea of representation is a theatrical one: the Orient is the stage on which the whole East is confined. On this stage will appear figures whose role it is to represent the larger whole from which they emanate. The Orient then seems to be not an unlimited extension beyond the familiar European world, but rather a closed field, a theatrical stage affixed to Europe. An Orientalist is but the particular specialist in knowledge for which Europe at large is responsible, in the way that an audience is historically and culturally responsible for (and responsive to) dramas technically put together by the dramatist. In the depths of this Oriental stage stands a prodigious cultural repertoire whose individual items evoke a fabulously rich world: the Sphinx, Cleopatra, Eden, Troy, Sodom and Gomorrah, Astarte, Isis and Osiris, Sheba, Babylon, the Genii, the Magi, Nineveh, Prester John, Mahomet, and dozens more; settings, in some cases names only, half-imagined, half-known; monsters, devils, heroes; terrors, pleasures, desires. The European imagination was nourished extensively from this repertoire: between the Middle Ages and the eighteenth century such major authors as Ariosto, Milton, Marlowe, Tasso, Shakespeare, Cervantes, and the authors of the *Chanson de Roland* and the *Poema del Cid* drew on the Orient's riches for their productions, in ways that sharpened the outlines of imagery, ideas, and figures populating it. In addition, a great deal of what was considered learned Orientalist scholarship in Europe pressed ideological myths into service, even as knowledge seemed genuinely to be advancing.

A celebrated instance of how dramatic form and learned imagery come together in the Orientalist theater is Barthelemy d'Herbelot's *Bibliothèque orientale*, published posthumously in 1697, with a preface by Antoine Galland. The introduction of the recent *Cambridge History of Islam* considers the *Bibliothèque*, along with George Sale's preliminary discourse to his translation of the Koran (1734) and Simon Ockley's *History of the Saracens* (1708, 1718), to be "highly important" in widening "the new

understanding of Islam" and conveying it "to a less academic readership".[28] This inadequately describes d'Herbelot's work, which was not restricted to Islam as Sale's and Ockley's were. With the exception of Johann H Hottinger's *Historia Orientalis*, which appeared in 1651, the *Bibliothèque* remained the standard reference work in Europe until the early nineteenth century. Its scope was truly epochal. Galland, who was the first European translator of *The Thousand and One Nights* and an Arabist of note, contrasted d'Herbelot's achievement with every prior one by noting the prodigious range of his enterprise. D'Herbelot read a great number of works, Galland said, in Arabic, Persian, and Turkish, with the result that he was able to find out about matters hitherto concealed from Europeans.[29] After first composing a dictionary of these three Oriental languages, d'Herbelot went on to study Oriental history, theology, geography, science, and art, in both their fabulous and their truthful varieties. Thereafter he decided to compose two works, one a *bibliothèque*, or 'library', an alphabetically arranged dictionary, the second a *florilège*, or anthology. Only the first part was completed.

Galland's account of the *Bibliothèque* stated that 'orientale' was planned to include principally the Levant, although—Galland says admiringly—the time period covered did not begin only with the creation of Adam and end with the "temps ou nous sommes": d'Herbelot went even further back, to a time described as "plus haut" in fabulous histories—to the long period of the pre-Adamite Solimans. As Galland's description proceeds, we learn that the *Bibliothèque* was like "any other" history of the world, for what it attempted was a complete compendium of the knowledge available on such matters as the Creation, the Deluge, the destruction of Babel, and so forth—with the difference that d'Herbelot's sources were Oriental. He divided history into two types, sacred and profane (the Jews and Christians in the first, the Muslims in the second), and two periods, pre- and postdiluvian. Thus d'Herbelot was able to discuss such widely divergent histories as the Mogul, the Tartar, the

Turkish, and the Slavonic; he took in as well all the provinces of the Muslim Empire, from the Extreme Orient to the Pillars of Hercules, with their customs, rituals, traditions, commentaries, dynasties, palaces, rivers, and flora. Such a work, even though it included some attention to "la doctrine perverse de Mahomet, qui a causé si grands dommages au Christianisme," was more capaciously thorough than any work before it. Galland concluded his 'Discours' by assuring the reader at length that d'Herbelot's *Bibliothèque* was uniquely "utile et agréable"; other Orientalists, like Postel, Scaliger, Golius, Pockoke, and Erpenius, produced Orientalist studies that were too narrowly grammatical, lexicographical, geographical, or the like. Only d'Herbelot was able to write a work capable of convincing European readers that the study of Oriental culture was more than just thankless and fruitless: only d'Herbelot, according to Galland, attempted to form in the minds of his readers a sufficiently ample idea of what it meant to know and study the Orient, an idea that would both fill the mind and satisfy one's great, previously conceived expectations.[30]

In such efforts as d'Herbelot's, Europe discovered its capacities for encompassing and Orientalizing the Orient. A certain sense of superiority appears here and there in what Galland had to say about his and d'Herbelot's *materia orientalia*; as in the work of seventeenth-century geographers like Raphael du Mans, Europeans could perceive that the Orient was being outstripped and outdated by Western science.[31] But what becomes evident is not only the advantage of a Western perspective: there is also the triumphant technique for taking the immense fecundity of the Orient and making it systematically, even alphabetically, knowable by Western laymen. When Galland said of d'Herbelot that he satisfied one's expectations he meant, I think, that the *Bibliothèque* did not attempt to revise commonly received ideas about the Orient. For what the Orientalist does is to *confirm* the Orient in his readers' eyes; he neither tries nor wants to unsettle already firm convictions. All the *Bibliothèque orientale* did

was represent the Orient more fully and more clearly; what may have been a loose collection of randomly acquired facts concerning vaguely Levantine history, Biblical imagery, Islamic culture, place names, and so on were transformed into a rational Oriental panorama, from A to Z. Under the entry for Mohammed, d'Herbelot first supplied all of the Prophet's given names, then proceeded to confirm Mohammed's ideological and doctrinal value as follows:

C'est le fameux imposteur Mahomet, Auteur et Fondateur d'une hérésie, qui a pris le nom de religion, que nous appellons Mahometane. *Voyez* le titre d'Eslam.

Les Interprètes de l'Alcoran et autres Docteurs de la Loy Musulmane ou Mahometane ont appliqué à ce faux prophète tous les éloges, que les Ariens, Paulitiens ou Paulianistes & autres Hérétiques ont attribué à Jésus-Christ, en lui ôtant sa Divinité…[32]

(This is the famous imposter Mahomet, Author and Founder of a heresy, which has taken on the name of religion, which we call Mohammedan. See entry under *Islam*.

The interpreters of the Alcoran and other Doctors of Muslim or Mohammedan Law have applied to this false prophet all the praises which the Arians, Paulicians or Paulianists, and other Heretics have attributed to Jesus Christ, while stripping him of his Divinity…)

'Mohammedan' is the relevant (and insulting) European designation; 'Islam', which happens to be the correct Muslim name, is relegated to another entry. The "heresy… which we call Mohammedan" is "caught" as the imitation of a Christian imitation of true religion. Then, in the long historical account of Mohammed's life, d'Herbelot can turn to more or less straight narrative. But it is the *placing* of Mohammed that counts in the *Bibliothèque*. The dangers of free-wheeling heresy arc removed when it is

transformed into ideologically explicit matter for an alphabetical item. Mohammed no longer roams the Eastern world as a threatening, immoral debauchee; he sits quietly on his (admittedly prominent) portion of the Orientalist stage.[33] He is given a genealogy, an explanation, even a development, all of which are subsumed under the simple statements that prevent him from straying elsewhere.

Such 'images' of the Orient as this are images in that they represent or stand for a very large entity, otherwise impossibly diffuse, which they enable one to grasp or see. They are also *characters*, related to such types as the braggarts, misers, or gluttons produced by Theophrastus, La Bruyère, or Selden. Perhaps it is not exactly correct to say that one sees such characters as the *miles gloriosus* or Mahomet the imposter, since the discursive confinement of a character is supposed at best to let one apprehend a generic type without difficulty or ambiguity. D'Herbelot's character of Mahomet is an *image*, however, because the false prophet is part of a general theatrical representation called *orientale* whose totality is contained in the *Bibliothèque*.

The didactic quality of the Orientalist representation cannot be detached from the rest of the performance. In a learned work like the *Bibliothèque orientale*, which was the result of systematic study and research, the author imposes a disciplinary order upon the material he has worked on; in addition, he wants it made clear to the reader that what the printed page delivers is an ordered, disciplined judgment of the material. What is thus conveyed by the *Bibliothèque* is an idea of Orientalism's power and effectiveness, which everywhere remind the reader that henceforth in order to get at the Orient he must pass through the learned grids and codes provided by the Orientalist. Not only is the Orient accommodated to the moral exigencies of Western Christianity; it is also circumscribed by a series of attitudes and judgments that send the Western mind, not first to Oriental sources for correction and verification, but rather to

other Orientalist works. The Orientalist stage, as I have been calling it, becomes a system of moral and epistemological rigor. As a discipline representing institutionalized Western knowledge of the Orient, Orientalism thus comes to exert a three-way force, on the Orient, on the Orientalist, and on the Western 'consumer' of Orientalism. It would be wrong, I think, to underestimate the strength of the three-way relationship thus established. For the Orient ('out there' towards the East) is corrected, even penalized, for lying outside the boundaries of European society, 'our' world; the Orient is thus *Orientalized*, a process that not only marks the Orient as the province of the Orientalist but also forces the uninitiated Western reader to accept Orientalist codifications (like d'Herbelot's alphabetized *Bibliothèque*) as the *true* Orient. Truth, in short, becomes a function of learned judgment, not of the material itself, which in time seems to owe even its existence to the Orientalist.

This whole didactic process is neither difficult to understand nor difficult to explain. One ought again to remember that all cultures impose corrections upon raw reality, changing it from free-floating objects into units of knowledge. The problem is not that conversion takes place. It is perfectly natural for the human mind to resist the assault on it of untreated strangeness; therefore cultures have always been inclined to impose complete transformations on other cultures, receiving these other cultures not as they are but as, for the benefit of the receiver, they ought to be. To the Westerner, however, the Oriental was always *like* some aspect of the West; to some of the German Romantics, for example, Indian religion was essentially an Oriental version of Germane-Christian pantheism. Yet the Orientalist makes it his work to be always converting the Orient from something into something else: he does this for himself, for the sake of his culture, in some cases for what he believes is the sake of the Oriental. This process of conversion is a disciplined one: it is taught, it has its own societies, periodicals, traditions, vocabulary, rhetoric, all in basic ways connected to and supplied by the prevailing cultural and political norms of the

West. And, as I shall demonstrate, it tends to become more rather than less total in what it tries to do, so much so that as one surveys Orientalism in the nineteenth and twentieth centuries the overriding impression is of Orientalism's insensitive schematization of the entire Orient.

How early this schematization began is clear from the examples I have given of Western representations of the Orient in classical Greece. How strongly articulated were later representations building on the earlier ones, how inordinately careful their schematization, how dramatically effective their placing in Western imaginative geography, can be illustrated if we turn now to Dante's *Inferno*. Dante's achievement in *The Divine Comedy* was to have seamlessly combined the realistic portrayal of mundane reality with a universal and eternal system of Christian values. What Dante the pilgrim sees as he walks through the Inferno, Purgatorio, and Paradise is a unique vision of judgment. Paolo and Francesca, for instance, are seen as eternally confined to hell for their sins, yet they are seen as enacting, indeed living, the very characters and actions that put them where they will be for eternity. Thus each of the figures in Dante's vision not only represents himself but is also a typical representation of his character and the fate meted out to him.

'Maometto'—Mohammed—turns up in canto 28 of the *Inferno*. He is located in the eighth of the nine circles of Hell, in the ninth of the ten Bolgias of Malebolge, a circle of gloomy ditches surrounding Satan's stronghold in Hell. Thus before Dante reaches Mohammed, he passes through circles containing people whose sins are of a lesser order: the lustful, the avaricious, the gluttonous, the heretics, the wrathful, the suicidal, the blasphemous. After Mohammed there are only the falsifiers and the treacherous (who include Judas, Brutus, and Cassius) before one arrives at the very bottom of Hell, which is where Satan himself is to be found. Mohammed thus belongs to a rigid hierarchy of evils, in the category of what Dante calls *seminator di scandalo*

e di scisma. Mohammed's punishment, which is also his eternal fate, is a peculiarly disgusting one: he is endlessly being cleft in two from his chin to his anus like, Dante says, a cask whose staves are ripped apart. Dante's verse at this point spares the reader none of the eschatological detail that so vivid a punishment entails: Mohammed's entrails and his excrement are described with unflinching accuracy. Mohammed explains his punishment to Dante, pointing as well to Ali, who precedes him in the line of sinners whom the attendant devil is splitting in two; he also asks Dante to warn one Fra Dolcino, a renegade priest whose sect advocated community of women and goods and who was accused of having a mistress, of what will be in store for him. It will not have been lost on the reader that Dante saw a parallel between Dolcino's and Mohammed's revolting sensuality, and also between their pretensions to theological eminence.

But this is not all that Dante has to say about Islam. Earlier in the *Inferno*, a small group of Muslims turns up. Avicenna, Averroës, and Saladin are among those virtuous heathens who, along with Hector, Aeneas, Abraham, Socrates, Plato, and Aristotle, are confined to the first circle of the Inferno, there to suffer a minimal (arid even honorable) punishment for not having had the benefit of Christian revelation. Dante, of course, admires their great virtues and accomplishments, but because they were not Christians he must condemn them, however lightly, to Hell. Eternity is a great leveler of distinctions, it is true, but the special anachronisms and anomalies of putting pre-Christian luminaries in the same category of 'heathen' damnation with post-Christian Muslims does not trouble Dante. Even though the Koran specifies Jesus as a prophet, Dante chooses to consider the great Muslim philosophers and king as having been fundamentally ignorant of Christianity. That they can also inhabit the same distinguished level as the heroes and sages of classical antiquity is an ahistorical vision similar to Raphael's in his fresco *The School of Athens*, in which Averroës rubs elbows on the

academy floor with Socrates and Plato (similar to Fenelon's *Dialogues des morts* [1700–1718], where a discussion takes place between Socrates and Confucius).

The discriminations and refinements of Dante's poetic grasp of Islam are an instance of the schematic, almost cosmological inevitability with which Islam and its designated representatives are creatures of Western geographical, historical, and above all, moral apprehension. Empirical data about the Orient or about any of its parts count for very little; what matters and is decisive is what I have been calling the Orientalist vision, a vision by no means confined to the professional scholar, but rather the common possession of all who have thought about the Orient in the West. Dante's powers as a poet intensify, make more rather than less representative, these perspectives on the Orient. Mohammed, Saladin, Averroës, and Avicenna are fixed in a visionary cosmology —fixed, laid out, boxed in, imprisoned, without much regard for anything except their 'function' and the patterns they realize on the stage on which they appear. Isaiah Berlin has described the effect of such attitudes in the following way:

> In [such a]... cosmology the world of men (and, in some versions, the entire universe) is a single, all-inclusive hierarchy; so that to explain why each object in it is as, and where, and when it is, and does what it does, is eo ipso to say what its goal is, how far it successfully fulfills it, and what are the relations of co-ordination and subordination between the goals of the various goal-pursuing entities in the harmonious pyramid which they collectively form. If this is a true picture of reality, then historical explanation, like every other form of explanation, must consist, above all, in the attribution of individuals, groups, nations, species, each to its own proper place in the universal pattern. To know the 'cosmic' place of a thing or a person is to say what it is and what it does, and at the same time why it should be and do as it is and does. Hence to be and to have value, to exist and to have a function (and to

fulfill it more or less successfully) are one and the same. The pattern, and it alone, brings into being and causes to pass away and confers purpose, that is to say, value and meaning, on all there is. To understand is to perceive patterns.... The more inevitable an event or an action or a character can be exhibited as being, the better it has been understood, the profounder the researcher's insight, the nearer we are to the one ultimate truth. This attitude is profoundly anti-empirical.[34]

And so, indeed, is the Orientalist attitude in general. It shares with magic and with mythology the self-containing, self-reinforcing character of a closed system, in which objects are what they are because they are what they are, for once, for all time, for ontological reasons that no empirical material can either dislodge or alter. The European encounter with the Orient, and specifically with Islam, strengthened this system of representing the Orient and, as has been suggested by Henri Pirenne, turned Islam into the very epitome of an outsider against which the whole of European civilization from the Middle Ages on was founded. The decline of the Roman Empire as a result of the barbarian invasions had the paradoxical effect of incorporating barbarian ways into Roman and Mediterranean culture, Romania; whereas, Pirenne argues, the consequence of the Islamic invasions beginning in the seventh century was to move the center of European culture away from the Mediterranean, which was then an Arab province, and towards the North. "Germanism began to play its part in history. Hitherto the Roman tradition had been uninterrupted. Now an original Romano-Germanic civilization was about to develop." Europe was shut in on itself: the Orient, when it was not merely a place in which one traded, was culturally, intellectually, spiritually *outside* Europe and European civilization, which, in Pirenne's words, became "one great Christian community, coterminous with the *ecclesia*.... The Occident was now living its own life."[35] In Dante's poem, in the work of Peter the Venerable and other Cluniac Orientalists, in the writings of the Christian polemicists

against Islam from Guibert of Nogent and Bede to Roger Bacon, William of Tripoli, Burchard of Mount Syon, and Luther, in the *Poema del Cid*, in the *Chanson de Roland*, and in Shakespeare's *Othello* (that "abuser of the world"), the Orient and Islam are always represented as outsiders having a special role to play *inside* Europe.

Imaginative geography, from the vivid portraits to be found in the *Inferno* to the prosaic niches of d'Herbelot's *Bibliothèque orientale,* legitimates a vocabulary, a universe of representative discourse peculiar to the discussion and understanding of Islam and of the Orient. What this discourse considers to be a fact—that Mohammed is an imposter, for example—is a component of the discourse, a statement the discourse compels one to make whenever the name Mohammed occurs. Underlying all the different units of Orientalist discourse—by which I mean simply the vocabulary employed whenever the Orient is spoken or written about—is a set of representative figures, or tropes. These figures are to the actual Orient—or Islam, which is my main concern here—as stylized costumes are to characters in a play; they are like, for example, the cross that Everyman will carry, or the particolored costume worn by Harlequin in a *commedia dell'arte* play. In other words, we need not look for correspondence between the language used to depict the Orient and the Orient itself, not so much because the language is inaccurate but because it is not even trying to be accurate. What it is trying to do, as Dante tried to do in the *Inferno*, is at one and the same time to characterize the Orient as alien and to incorporate it schematically on a theatrical stage whose audience, manager, and actors are for Europe, and only *for* Europe. Hence the vacillation between the familiar and the alien; Mohammed is always the imposter (familiar, because he pretends to be like the Jesus we know) and always the Oriental (alien, because although he is in some ways 'like' Jesus, he is after all not like him).

Rather than listing all the figures of speech associated with the Orient—its strangeness, its

difference, its exotic sensuousness, and so forth—we can generalize about them as they were handed down through the Renaissance. They are all declarative and self-evident; the tense they employ is the timeless eternal; they convey an impression of repetition and strength; they are always symmetrical to, and yet diametrically inferior to, a European equivalent, which is sometimes specified, sometimes not. For all these functions it is frequently enough to use the simple copula is. Thus, Mohammed is an imposter, the very phrase canonized in d'Herbelot's *Bibliothèque* and dramatized in a sense by Dante. No background need be given; the evidence necessary to convict Mohammed is contained in the 'is'. One does not qualify the phrase, neither does it seem necessary to say that Mohammed was an imposter, nor need one consider for a moment that it may not be necessary to repeat the statement. It is repeated, he is an imposter, and each time one says it, he becomes more of an imposter and the author of the statement gains a little more authority in having declared it. Thus Humphrey Prideaux's famous seventeenth-century biography of Mohammed is subtitled *The True Nature of Imposture*. Finally, of course, such categories as imposter (or Oriental, for that matter) imply, indeed require, an opposite that is neither fraudulently something else nor endlessly in need of explicit identification. And that opposite is 'Occidental', or in Mohammed's case, Jesus.

Philosophically, then, the kind of language, thought, and vision that I have been calling Orientalism very generally is a form of radical realism; anyone employing Orientalism, which is the habit for dealing with questions, objects, qualities, and regions deemed Oriental, will designate, name, point to, fix what he is talking or thinking about with a word or phrase, which then is considered either to have acquired, or more simply to be, reality. Rhetorically speaking, Orientalism is absolutely anatomical and enumerative: to use its vocabulary is to engage in the particularizing and dividing of things Oriental into manageable parts.

Psychologically, Orientalism is a form of paranoia, knowledge of another kind, say, from ordinary historical knowledge. These are a few of the results, I think, of imaginative geography and of the dramatic boundaries it draws.

1 RW Southern, *Western Views of Islam in the Middle Ages*, Cambridge, Mass.: Harvard University Press, 1962, p. 72. See also Francis Dvornik, The *Ecumenical Councils*, New York: Hawthorn Books, 1961, pp. 65–6: "Of special interest is the eleventh canon directing that chairs for teaching Hebrew, Greek, Arabic and Chaldean should be created at the main universities. The suggestion was Raymond Lull's, who advocated learning Arabic as the best means for the conversion of the Arabs. Although the canon remained almost without effect as there were few teachers of Oriental languages, its acceptance indicates the growth of the missionary idea in the West. Gregory X had already hoped for the conversion of the Mongols, and Franciscan friars had penetrated into the depths of Asia in their missionary zeal. Although these hopes were not fulfilled, the missionary spirit continued to develop." See also Johann W Fück, *Die Arabischen Studien in Europa bis in den Anfang des 20. Jahrhunderts*, Leipzig: Otto Harrassowitz, 1955.

2 Raymond Schwab, *La Renaissance orientale*, Paris: Payot, 1950. See also V-V Barthold, *La Découverte de l'Asie: Histoire de l'Orientalisme en Europe et en Russie*, trans. B Nikitine, Paris: Payot, 1947, and the relevant pages in Theodor Benfey, *Geschichte der Sprachwissenschaft und Orientalischen Philologie in Deutschland*, Munich: Gottafschen, 1869. For an instructive contrast see James T Monroe, *Islam and the Arabs in Spanish Scholarship*, Leiden: EJ Brill, 1970.

3 Victor Hugo, *Oeuvres poétiques*, ed. Pierre Albouy, Paris: Gallimard, 1964, 1: 580.

4 Jules Mohl, *Vingt-sept Ans d'histoire des études orientales: Rapports fails à la Société asiatique de Paris de 1840 à 1867*, 2 vols, Paris: Reinwald, 1879–80.

5 Gustave Dugat, *Histoire des orientalistes de l'Europe du XIIe au XIXe siècle*, 2 vols, Paris: Adrien Maisonneuve, 1868–70.

6 See René Gerard, *L'Orient et la pensée romantique allemande*, Paris: 7 Didier, 1963, p. 112.

7 Kiernan, *Lords of Human Kind*, p. 131.

8 University Grants Committee, *Report of the Sub-Committee on Oriental, Slavonic, East European and African Studies*, London: Her Majesty's Stationery Office, 1961.

9 HAR Gibb, *Area Studies Reconsidered*, London: School of Oriental and African Studies, 1964.

10 See Claude Levi-Strauss, *The Savage Mind*, Chicago: University of Chicago Press, 1967, chap. 1–7.

11 Gaston Bachelard, *The Poetics of Space*, trans. Maria Jolas, New York: Orion Press, 1964.

12 Southern, *Western Views of Islam*, p. 14.

13 Aeschylus, *The Persians*, trans. Anthony J Podleck, Englewood Cliffs, NJ: Prentice-Hall. 1970, pp. 73–4.

14 Euripides, *The Bacchae*, trans. Geoffrey S Kirk, Englewood Cliffs, NJ: Prentice-Hall, 1970, p. 3. For further discussion of the Europe–Orient distinction see Santo Mazzarino, *Fra oriente e occidente: Ricerche di storia greca arcaica*, Florence: La Nuova Italia, 1947, and Denys Hay, *Europe: The Emergence of an Idea*, Edinburgh: Edinburgh University press, 1968.

15 Euripides, *Bacchae*, p. 52.

16 René Grousset, *L'Empire du Levant: Histoire de la question d'Orient*, Paris: Payot, 1946.

17 Edward Gibbon, *The History of the Decline and Fall of the Roman Empire*, Boston: Little, Brown & Co., 1855, 6: 399.

18 Norman Daniel, *The Arabs and Medieval Europe*, London: Longmans, Green & Co., 1975, p. 56.

19 Samuel C Chew, *The Crescent and the Rose: Islam and England During the Renaissance*, New York: Oxford University Press, 1937, p. 103.

20 Norman Daniel, *Islam and the West: The Making of an Image*, Edinburgh: University Press, 1960, p. 33. See also James Kritzeck, *Peter the Venerable and Islam*, Princeton, NJ: Princeton University Press, 1964.

21 Daniel, *Islam and the West*, p. 252.

22 Daniel, *Islam and the West*, pp. 259–60.

23 See for example William Wistar Comfort, 'The Literary Role of the Saracens in the French Epic', *PMLA* 55, 1940: 628–59.

24 Southern, *Western Views of Islam*, pp. 91–2, 108–9.

25 Daniel, *Islam and the West*, pp. 246, 96, and passim.

26 Daniel, *Islam and the West*, p. 84.

27 Duncan Black Macdonald, "Whither Islam?" *Muslim World* 23, January 1933: 2.

28 PM Holt, *Introduction to The Cambridge History of Islam*, ed. PM Holt, Anne KS Lambton, and Bernard Lewis, Cambridge: Cambridge University Press, 1970, p. xvi.

29 Antoine Galland, prefatory 'Discours' to Barthélemy d'Herbelot, *Bibliothèque orientale, ou Dictionnaire universel contenant lout ce qui fait connaître les peuples de l'Orient*, The Hague: Neauime & van Daalen, 1777, 1: vii. Galland's point is that d'Herbelot presented real knowledge, not legend or myth of the sort associated with the "marvels of the East". See R Wittkower, "Marvels of the East: A Study in the History of Monsters", *Journal of the Warburg and Courtauld Institutes* 5, 1942: pp. 159–97.

30 Galland, prefatory 'Discours' to d'Herbelot, *Bibliothèque orientale*, pp. xvi, xxxiii. For the state of Orientalist knowledge immediately before d'Herbelot, see VJ Parry, "Renaissance Historical Literature in Relation to the New and Middle East (with Special Reference to Paolo Giovio)", in *Historians of the Middle East*, ed. Bernard Lewis and PM Holt, London: Oxford University Press, 1962, pp. 277–89.

31 Barthold, *La Découverte de l'Asie*, pp. 137–8.

32 D'Herbelot, *Bibliothèque Orientale*, 2: 648.

33 See also Montgomery Watt, "Muhammad in the Eyes of the West", *Boston University Journal* 22, no. 3, Fall 1974: pp. 61–9.

34 Isaiah Berlin, *Historical Inevitability*, London: Oxford University Press, 1955, pp. 13–14.

35 Henri Pirenne, *Mohammed and Charlemagne*, trans. Bernard Miall, New York: WW Norton & Co., 1939, pp. 234, 283.

ORIENTALISM: CRITICAL ENGAGEMENTS
ZACHARY LOCKMAN

Extract from "Said's Orientalism: A Book and its Aftermath", in *Contending Visions of The Middle East: The History and Politics of Orientalism*, 2004.
Copyright Zachary Lockman 2004, published by Cambridge University Press, reproduced with permission.

Orientalism is regarded by many as one of the most influential scholarly books published in English in the humanities in the last quarter of the twentieth century. Perhaps the best way to enter into an appraisal of the book and its intellectual significance is by discussing some of the responses to it. I will begin with one of its chief targets, Bernard Lewis, who not surprisingly vehemently rejected Said's analysis of Orientalism without really engaging with the substance of Said's critique.

In an essay on "The Question of Orientalism", published in *The New York Review of Books* in June 1982, four years after the appearance of *Orientalism*, Lewis claimed that Said and other critics of Orientalism had accused all those scholars who studied Islam and the Middle East of engaging in a "deep and evil conspiracy" in the service of Western domination.[1] Such attacks on Orientalism were not really new, according to Lewis: he rather insinuatingly mentioned an earlier "outbreak", allegedly inspired by Nazi-linked antisemitism, originating in Pakistan in the mid-1950s, as well as Anouar Abdel-Malek's critique, which Lewis deemed to have remained "within the limits of scholarly debate". Recently, however, Arabs motivated primarily by their ideological opposition to Zionism and Israel and/or by an allegiance to Marxism had initiated a series of crude and intemperate polemical assaults on Orientalism, and among these Edward Said was the leading culprit.

Lewis accused Said of launching reckless and grossly inaccurate attacks, often couched in violent language replete with sexual overtones, on respectable scholars and scholarship. Said was moreover arbitrary in his choice of targets, ignoring major scholars and studies and focusing on marginal figures and unimportant texts, and he was also guilty of neglecting or maligning Arab scholarship while treating the admittedly crude utterances of colonial officials like Cromer on a par with scholarly Orientalist writing. This was, Lewis suggested, because Said knew little or nothing about the scholars and field he presumed to criticize, which led him to ignore very important German and Soviet Orientalists and

commit egregious errors of fact. More broadly, Lewis argued, the claim that "Orientalists were seeking knowledge of Oriental peoples in order to dominate them, most of them being directly or, as Abdel-Malek allows, objectively (in the Marxist sense) in the service of imperialism," was "absurdly inadequate."

Some Orientalists, Lewis acknowledged, may have "served or profited from imperial domination", but the European study of Islam and the Arabs began centuries before the age of European expansion and colonialism, and that study flourished in countries (like Germany) which never exercised domination over Arabs. "The Orientalists are not immune," Lewis asserted, to the dangers of bias, "stereotypes and facile generalizations; nor are their accusers. The former at least have the advantage of some concern for intellectual precision and discipline." Said's baseless critique had focused on the "putative attitudes, motives, and purposes" of Orientalist scholars while ignoring their actual scholarly writings; in fact, Lewis concluded, "the most rigorous and penetrating critique of Orientalist scholarship has always been and will remain that of the Orientalists themselves".

Said responded in kind in the pages of the same journal two months later—at the height, it is worth noting, of Israel's invasion of Lebanon, as its army was bombarding besieged Beirut and tempers were running very high on all sides.[2] "Insouciant, outrageous, arbitrary, false, absurd, astonishing, reckless—these are some of the words Bernard Lewis uses to characterize what he interprets me as saying in *Orientalism* (1978)... Lewis's verbosity scarcely conceals both the ideological underpinnings of his position and his extraordinary capacity for getting everything wrong." Said asserted that Lewis had attacked him by "suppressing or distorting the truth and by innuendo, methods to which he adds that veneer of omniscient tranquil authority which he supposes is the way scholars talk".

Said insisted that he had never said that "Orientalism is a conspiracy" or that "'the West'

is evil... On the other hand it is rank hypocrisy to suppress the cultural, political, ideological, and institutional contexts in which people write, think, and talk about the Orient, whether they are scholars or not." Said continued:

> And I believe that it is extremely important to understand the fact that the reason why Orientalism is opposed by so many thoughtful Arabs and Muslims is that its modern discourse is correctly perceived as a discourse of power. In this discourse, based mainly upon the assumption that Islam is monolithic and unchanging and therefore marketable by "experts" for powerful domestic political interests, neither Muslims nor Arabs recognise themselves as human beings or their observers as simple scholars.

Lewis's defense of Orientalism was, Said went on, "an act of breathtaking bad faith, since as I shall show, more than most Orientalists he has been [not the objective, politically disinterested scholar he presented himself as but rather] a passionate political partisan against Arab causes in such places as the US Congress, *Commentary*, and elsewhere". Lewis was, for example, a "frequent visitor to Washington where his testimony before the likes of Senator Henry Jackson mixes standard Cold War bellicosity with fervent recommendations to give Israel more, and still more, arms—presumably so that it may go on improving the lot of Muslims and Arabs who fall within the range of its artillery and airpower".

Lewis's next response to Said added little of value to the exchange. "It is difficult to argue with a scream of rage", Lewis began, and he concluded by asserting that while the question of how societies perceive each other was of profound significance, "[t]he tragedy of Mr. Said's *Orientalism* is that it takes a genuine problem of real importance, and reduces it to the level of political polemic and personal abuse". At its 1986 annual meeting, held in Boston, the Middle East Studies Association featured a debate between Said and Lewis, each of whom

was (in the manner of an old-fashioned duel) accompanied by a "second". But while the event may have been good theatre, it did not yield much useful elucidation of the intellectual issues at stake. Lewis was apparently never able to grasp (or cogently address) Said's treatment of Orientalism's defects as the product of its character as a systematic (and power-laden) discourse, rather than as a problem stemming from error, bias, stereotyping, racism, evil-mindedness or imperialist inclinations on the part of individual scholars. Nor could Lewis accept Said's premise that, like all human endeavors, Orientalist scholarship was at the very least partially shaped by the contexts within which it was conducted and thus that it was not hermetically sealed off from wider cultural attitudes about, and political engagements with, Islam and the Muslim world, for centuries Europe's (often threatening) "other" and an ongoing "problem" for the United States. This left the two with little or no common ground on which to conduct a useful debate, had they even wanted to.

Said's critique of Orientalism generated a large number of more complex, nuanced and interesting responses, of which I will discuss only a few in order to convey something of the range of reactions to the book and of its intellectual impact.

For its review of *Orientalism*, *The New York Times Book Review* turned to JH Plumb, professor of history at Cambridge University and an authority on eighteenth-century England.[3] "There is a profoundly interesting concept in this book," Plumb wrote, "and underneath the self-posturing verbiage there is an acute analytical mind at work, but the book, unfortunately, is almost impossible to read." Plumb actually agreed with much of what Said had to say and asserted that "there is much in this book that is superb as well as intellectually exciting… The fundamental concept that one society's view of another's culture may be used, like an interpretation of the

past, to sanctify its own institutions and political aggression is a very fruitful one that could be applied, and should be, to other constellations of nationalist or racist thought." But Plumb complained that the book was "so pretentiously written, so drenched in jargon".

It is perhaps not surprising that Plumb, an older, rather mainstream historian, was put off by Said's heavy recourse to contemporary European theory (especially Foucault) as well as by the dense, allusive and sometimes elusive mode of writing not uncommon in literary studies but often seen by historians as unnecessarily convoluted and impenetrable. More broadly, while a good many historians—especially those who studied parts of the world outside the West—saw *Orientalism* as a work of major intellectual importance and were prepared to accept much or all of its central thrust, there was also unease with what some saw as the book's sometimes extravagant language, sweeping arguments, heavy focus on literary texts, and insufficient interest in carefully situating individuals, texts and institutions in their historical contexts.[4]

One of the key reviews of *Orientalism* from within US Middle East studies was written by Malcolm H Kerr (1931–1984) and published in 1980 in the field's leading scholarly journal, the *International Journal of Middle East Studies*.[5] Kerr's parents taught at the American University of Beirut for many years, so Kerr spent much of his childhood and youth in Lebanon. He studied international relations at Princeton under Philip Hitti and received his PhD in that subject from Johns Hopkins University, though he wrote his dissertation largely under the guidance of Hamilton Gibb of Harvard. Kerr spent 20 years teaching at UCLA but returned often to the Arab world, and in 1982 he assumed the presidency of his beloved American University of Beirut. He was assassinated outside his campus office by radical Islamist gunmen two years later.

Kerr described *Orientalism* as "a book that in principle needed to be written, and for which

the author possessed rich material. In the end, however, the effort misfired."

The book contains many excellent sections and scores many telling points, but it is spoiled by overzealous prosecutorial argument in which Professor Said, in his eagerness to spin too large a web, leaps at conclusions and tries to throw everything but the kitchen sink into a preconceived frame of analysis. In charging the entire tradition of European and American Oriental studies with the sins of reductionism and caricature, he commits precisely the same error.

Said had demonstrated convincingly that many French and British writers, travelers and scholars had depicted the Middle East in an essentialist and derogatory fashion; but then, Kerr went on, he "turns from an imaginative critic to a relentless polemicist", assuming what he purports to demonstrate and forgoing the opportunity to test his claims by examining the work of Orientalist scholars who were neither French nor British. Said's sample of US-based scholars was unrepresentative, Kerr argued, and had he "looked further afield he would have gotten quite different results", including a great deal of work which manifested "consistent *resistance* to the themes of denigration and caricaturization of Eastern peoples of which Said complains." Middle East studies in the United States had its shortcomings and prejudices, Kerr acknowledged; but "whether it is the Western tradition of Orientalist scholarship that is primarily to blame—in fact, whether that tradition has, in the net, really contributed to the problem—is another question". Said's claim that "whatever the individual goodwill of the scholars, they are all prisoners of the establishment" and guilty of "propagating the old racist myths of European Orientalism in order to further the cause of Western imperial domination of the East" is at best "a preconceived argument, and a highly debatable one".

Maxime Rodinson, the French Marxist scholar of whom Said himself cited approvingly as a

scholar who had been trained as an Orientalist but had nonetheless produced important and honest scholarly work, assessed Orientalism along somewhat similar lines.[6] Rodinson acknowledged that there were "many valuable ideas" in Said's book: "Its great merit, to my mind, was to shake the self-satisfaction of many Orientalists, to appeal to them (with questionable success) to consider the sources and the connections of their ideas, to cease to see them as a natural, unprejudiced conclusion of the facts, studied without any presumptions." Unlike Lewis, Rodinson understood what Said was trying to get at by examining Orientalism as a coherent, systematic discourse. But he also noted what he found problematic in Said's critique:

[Said's] militant stand leads him repeatedly to make excessive statements. This problem is accentuated because as a specialist of English and comparative literature, he is inadequately versed in the practical work of the Orientalists. It is too easy to choose, as he does, only English and French Orientalists as a target. By so doing, he takes aim only at representatives of huge colonial empires. But there was an Orientalism before the empires, and the pioneers of Orientalism were often subjects of other European countries, some without colonies. Much too often, Said falls into the same traps we old Communists fell into some forty years ago [i.e., of being excessively polemical, partisan and schematic]… The growth of Orientalism was linked to the colonial expansion of Europe in a much more subtle and intricate way than he imagines. Moreover, his nationalistic tendencies have prevented him from considering, among others, the studies of Chinese or Indian civilization, which are ordinarily regarded as part of the field of Orientalism… even Arab nations in the West receive less than their due in his interpretation.

The Oxford historian of the modern Middle East Albert Hourani shared much of Rodinson's appraisal of *Orientalism*, as did Roger Owen, a historian of the modern Middle East who had been among the early critics of Orientalism and a champion of political economy as an alternative approach.[7] In an early review of the book Owen offered strong praise for Said's critique of Orientalism. But like Rodinson, Hourani and others, Owen lamented the fact that Said had ignored German and other European scholars and suggested that Said's exploration of Orientalism was sometimes overly broad and lacked nuance and subtlety. Owen also rejected Said's embrace of a Foucauldian (or poststructuralist) approach: "if we cannot make any connection between such studies [of the Middle East] and the reality they are supposed to describe, there is no way of showing how they have changed as a result of changing Middle-Eastern (and not just European) circumstances. Nor is it possible to suggest how they might be improved in the future." Owen further faulted Said for a lack of interest in how the study of the Middle East could be made better. "It is not a question of first destroying the old and then rebuilding the new. The old contains material and concepts which need to be examined, to be challenged, and in some cases to be reconstructed, in terms of a science of society which transcends national boundaries and in the use of which everyone, Middle Eastern or European or American, can share." For Owen (as for the sociologist Bryan Turner somewhat earlier), that "science of society" was some variant of political economy, which left him unhappy with Said's relentless focus in *Orientalism* on how Western cultures represented the Orient, hence on images, texts, ideas and discourses, rather than on economic, social and political structures, relations, interests and conflicts.

In an important 1981 essay titled "Orientalism and Orientalism in Reverse", the noted Syrian philosopher Sadik Jalal al-'Azm addressed what he saw as the strengths and weaknesses of Said's *Orientalism* from a perspective that, like Rodinson's and Owen's, was influenced by Marxism.[8] Writing in the journal *Khamsin*, which had emerged in the 1970s as a forum for a group of exiled Middle-Eastern left-wing intellectuals, al-'Azm suggested that Said had used Orientalism in two distinct senses: Institutional Orientalism, by which al-'Azm meant the whole set of institutions, ideologies, beliefs, images and texts linked to European expansion, and Cultural-Academic Orientalism, by which al-'Azm meant "a developing tradition of disciplined learning whose main function is to 'scientifically research' the Orient".

Al-'Azm agreed that Said had very usefully devoted the bulk of his book to deflating the latter's "self-righteous" claims to impartiality and truth, "its racist assumptions, barely camouflaged mercenary interests, reductionistic explanations and anti-human prejudices", and to demonstrating its links to Institutional Orientalism. And Said had quite accurately shown that both forms of Orientalism shared a "deep-rooted belief… that a fundamental ontological difference exists between the essential natures of the Orient and the Occident, to the decisive advantage of the latter. Western societies, cultures, languages and mentalities are supposed to be essentially and inherently superior to the Eastern ones."

However, al-'Azm went on, "the stylist and polemicist in Edward Said very often runs away with the systematic thinker."

In an act of retrospective historical projection we find Said tracing the origins of Orientalism all the way back to Homer, Aeschylus, Euripides and Dante. In other words, Orientalism is not really a thoroughly modern phenomenon, as we thought earlier, but is the natural product of an ancient and almost irresistible European bent of mind to misrepresent the realities of other cultures, peoples, and their languages, in favor of Occidental self-affirmation, domination and ascendancy. Here the author seems to be saying that the "European mind," from Homer to Karl Marx and HAR Gibb, is inherently bent on distorting all human realities other than its own for the sake of its own aggrandisement.

This way of construing the origins of Orientalism, al-'Azm argued, drew on the same essentializing dichotomy between East and West, and the same monolithic and static conception of culture, which Said saw as central to Orientalism and set out to demolish. It made much more sense, al-'Azm argued, to treat both forms of Orientalism as modern phenomena rather than as pervasive in some timeless, monolithic and inevitably essentialized "Western culture" since its very inception. Al-'Azm also found problematic what he saw as Said's implication that it was Orientalism as a deeply rooted Western cultural tradition which was the real source of Western political interest in the Orient. As al-'Azm understood him, Said seemed to be arguing (implicitly or explicitly) that it was Cultural-Academic Orientalism which had given rise to Institutional Orientalism. "One cannot escape the impression," al-'Azm went on, "that for Said somehow the emergence of such observers, administrators and invaders of the Orient as Napoleon, Cromer and Balfour was made inevitable by [Cultural-Academic] 'Orientalism', and that the political orientations, careers and ambitions of these figures are better understood by reference to [the Enlightenment thinker] d'Herbelot and Dante than to more immediately relevant and mundane [political, strategic and economic] interests."

Al-'Azm also found troubling Said's suggestion that the Orient was essentially a representation, a projection by the West, and that all representations of one culture by another are inevitably misrepresentations. If as Said says "the Orient studied by Orientalism is no more than an image and a representation in the mind and culture of the Occident… then it is also true that the Occident in doing so is behaving perfectly naturally and in accordance with the general rule—as stated by Said himself—governing the [inevitably distorting] dynamics of the reception of one culture by another." Moreover, al-'Azm argued, Said's criticism of Gibb and others for making broad declarative statements about the character of the Orient, Islam, etc. was misplaced. The problem was not that all these assertions

were entirely wrong, for they often contained some grain of truth; the problem was that they were overly broad, grossly ahistorical, did not allow for the possibility of change, and were often linked to ongoing European efforts to dominate the Orient.

On this same ground al-'Azm defended Karl Marx against Said's depiction of him as "no exception to all the Europeans who dealt with the East in terms of Orientalism's basic category of the inequality between East and West." Al-'Azm insisted that the contrary was true: "there is nothing specific to either Asia or the Orient in Marx's broad theoretical interpretations of the past, present and future… Marx, like anyone else, knew of the superiority of modern Europe over the Orient. But to accuse a radically historicist thinker like Marx of turning this contingent [i.e. temporary] fact into a necessary reality for all time [as did the Orientalists] is simply absurd."

In concluding, al-'Azm reiterated his appreciation of Said's forceful critique of the assumption—central to Orientalism—that the differences between "Islamic cultures and societies on the one hand and European ones on the other are neither a matter of complex processes in the historical evolution of humanity nor a matter of empirical facts to be acknowledged and dealt with accordingly" but rather "a matter of emanations from a certain enduring Oriental (or Islamic) cultural, psychic or racial essence, as the case may be, bearing identifiable fundamental unchanging attributes." However, al-'Azm warned, some in the Arab and Muslim lands had succumbed to what he called "Orientalism in Reverse", which accepted the basic dichotomy between East and West but insisted that it was the East (or Islam) which was superior to the corrupt, decadent, materialistic West. He had in mind (among others) Islamists who rejected secularism, nationalism, Marxism, democracy, etc. as alien Western imports and insisted that only (their interpretation of) Islam was authentic and could solve the political, economic, social and cultural problems facing their societies. For the Islamists as for Hamilton Gibb and Bernard

Lewis, Islam was always Islam, an essence with a single, unchanging meaning, except that whereas the latter saw Islam as defective, inferior and in decline, the former saw it as perfect and perceived the West as spiritually and morally inferior. "Ontological Orientalism in Reverse," al-'Azm concluded, "is, in the end, no less reactionary, mystifying, ahistorical and anti-human than Ontological Orientalism proper."

A less balanced and more stridently negative assessment of *Orientalism* came from the Indian Marxist literary scholar Aijaz Ahmad. In an essay published in 1992, Ahmad acknowledged that Said was one of the most significant cultural critics writing in the English language and that his own thought had long been deeply engaged with, and influenced by, Said's.[9] He also expressed deep admiration for Said's courage in risking his standing as a scholar, and even his life in the face of death threats, by speaking out as a Palestinian critical not only of Zionism but also of various Palestinian and Arab leaders and policies. Nonetheless, Ahmad proclaimed himself in fundamental disagreement with Said. Like others, Ahmad criticized what he saw as Said's theoretical and methodological inconsistencies and eclecticism as well as his implication that there was a more or less continuous Western tradition or discourse of Orientalism stretching from the ancient Greeks down to the present, a claim that Ahmad deemed both un-Foucauldian (since Foucault rejected such long-term continuities) and ahistorical. Moreover, Ahmad complained that Orientalism

examines the history of Western textualities about the non-West quite in isolation from how these textualities might have been received, accepted, modified, challenged, overthrown or reproduced by the intelligentsias of the colonized countries: not as an undifferentiated mass but as situated social agents impelled by our own conflicts, contradictions, distinct social and political locations of class, gender, religious affiliation, and so on… the only voices we encounter in the book are precisely those

of the very Western canonicity which, Said complains, has always silenced the Orient. Who is silencing whom, who is refusing to permit a historicized encounter between the voice of the so-called "Orientalist" and the many voices that "Orientalism" is said so utterly to suppress, is a question that is very hard to determine as we read this book.

Like al-'Azm, Ahmad felt that Said had not only essentialized the West but implied that the Western assertion of power over the Orient had its roots in a basically literary Orientalism, thereby ignoring other more material causes and factors. And also like al-'Azm, Ahmad was unhappy with Said's apparent rejection (following Foucault) of the possibility of true statements, of accurate representation. This led, Ahmad claimed, both to a form of irrationalism which had pernicious intellectual but also political effects and to pandering to "the most sentimental, the most extreme forms of Third-Worldist nationalism". By not only jettisoning but trying to discredit Marxism as unredeemably corrupted by Orientalism, and by blaming colonialism not only for "its own cruelties but, conveniently enough, for ours too", like communalism, tribalism and the caste system, Said's critique of Orientalism had, Ahmad charged, helped "upwardly mobile professionals" from Third World countries immigrating to the West develop "narratives of oppression that would get them preferential treatment…" All in all, Ahmad put forward a harsh critique not only of Orientalism but of Said's work and intellectual stances more generally.

In a widely cited essay on Orientalism published in his 1988 book The Predicament of Culture, the anthropologist James Clifford offered a more appreciative (though by no means uncritical) appraisal of Said's book from a non-Marxist perspective.[10] Clifford began by suggesting that Said's work could usefully be seen as part of an effort to understand how "European knowledge about the rest of the planet [has] been shaped by a Western will to power", an effort he traced back to the Martinique poet Aimé Cesaire and

the négritude movement he helped launch in the late 1930s. The "objects" of the Western gaze, the colonized peoples who had been observed and studied (and dominated) by Westerners, had begun to assert their political but also cultural independence and "write back", demanding and making room for their own perspectives, histories and visions and offering an anticolonial "alternative humanism".

Clifford went on to explore the ambivalences which he felt informed much of Said's argument: between seeing the Orient as a mental construct produced by Orientalism and treating it as a real (if misrepresented) place; between accepting and rejecting the possibility that true knowledge about the Orient, its peoples and their histories is attainable; and between a commitment to a rigorous Foucauldian discourse analysis and a humanist appreciation for individual authors and texts. Clifford pointed out that Orientalism was "a pioneering attempt to use Foucault systematically in an extended cultural analysis", developing it to "include ways in which a cultural order is defined externally, with respect to exotic 'others'".

Clifford defended Said's much-criticized decision to ignore the German Orientalists. "If Said's primary aim were to write an intellectual history of Orientalism or a history of Western ideas of the Orient, his narrowing and rather obviously tendentious shaping of the field could be taken as a fatal flaw." But that was not his goal, and so even if his "genealogy" of Orientalism "sometimes appears clumsily rigged", "one need not reject the entire critical paradigm". In part, Clifford argued, the problem lay in Said's effort to derive Orientalism as a discourse, in Foucault's sense, from his inventory of Orientalism as a tradition, relying heavily on a survey of literary and scholarly texts. In so doing, and by focusing on individual authors rather than on the underlying discourse which from a Foucauldian perspective would be seen as structuring what they wrote, Said not only "relapses into traditional intellectual history", but also "gives himself too easy a target".

Nonetheless, Clifford concluded, "though Said's work frequently relapses into the essentializing modes it attacks and is ambivalently enmeshed in the totalising habits of Western humanism, it still succeeds in questioning a number of important anthropological categories, most important, perhaps, the concept of culture." Indeed, the effect of his argument is "not so much to undermine the notion of a substantial Orient as it is to make problematic 'the Occident'". Said's work thus contributes to, and furthers, the effort to move beyond "casual [and largely unquestioned] references to 'the West,' 'Western culture,' and so on" and examine concretely the ways in which "the West" came to be constituted as a category in relation to various "others", including Muslims, other "exotic" cultures, fictions of the primitive, and so on.

Clifford saw Said's own background as importantly related to his own "complex critical posture." "A Palestinian nationalist educated in Egypt and the United States, a scholar deeply imbued with the European humanities… Said writes as an 'oriental,' but only to dissolve the category. He writes as a Palestinian but takes no support from a specifically Palestinian culture or identity, turning to European poets for his expression of essential values and to French philosophy for his analytical tools. A radical critic of a major component of the Western cultural tradition, Said derives most of his standards from that tradition." Said's complex location is not "aberrant", Clifford insisted; the "unrestful predicament of Orientalism, its methodological ambivalences, are characteristic of an increasingly general global experience", and in that sense we can see Said's idealistic commitment to humanism as "a political response to the present age in which, as [Joseph] Conrad wrote, 'we are camped like bewildered travelers in a garish, unrestful hotel.' It is the virtue of Orientalism that it obliges its readers to confront such issues at once personally, theoretically, and politically."

Edward Said shared his own thoughts on the critical reception of Orientalism and on the tasks facing left-wing intellectuals in a 1985 essay

titled "Orientalism Reconsidered".[11] He noted what he saw as "a remarkable unwillingness to discuss the problem of Orientalism in the political or ethical or even epistemological contexts proper to it. This is as true of professional literary critics who have written about my book as it is of course of the Orientalists themselves." Yet nothing, Said insisted, "not even a simple descriptive label, is beyond or outside the realm of interpretation", to be taken as "plain fact" or absolute truth. He went on to acknowledge earlier critiques of Orientalism, by Anouar Abdel-Malek and Talal Asad among others, who had received little attention in his book, and to attack the unregenerate Bernard Lewis as well as Daniel Pipes, a younger right-wing writer on the Middle East and Islam.

Said also praised recent efforts, by scholars as well as writers and activists in many parts of the world, to "dissolve" and "decenter" dominant and oppressive forms of knowledge and move beyond them to new and potentially liberatory approaches. He envisioned these disparate efforts, addressing many different issues and diverse audiences, as part of a common endeavor that was "consciously secular, marginal and oppositional" and sought "the end of dominating, coercive systems of knowledge". However, he warned against the danger of "possessive exclusivism", for example the claims that "only women can write for and about women, and only literature that treats women or Orientals well is good literature… [or that] only Marxists, anti-Orientalists, feminists can write about economics, Orientalism, women's literature". The emancipatory intellectual project Said envisioned called for "greater crossing of boundaries, for greater interventionism in cross-disciplinary activity, a concentrated awareness of the situation—political, methodological, social, historical—in which intellectual and cultural work is carried out… Lastly, a much sharpened sense of the intellectual's role both in the defining of a context and in changing it, for without that, I believe, the critique of Orientalism is simply an ephemeral pastime."

1 Bernard Lewis, "The Question of Orientalism", *The New York Review of Books*, 24 June, 1982.

2 Edward W Said, "Orientalism: An Exchange", *The New York Review of Books*, 12 August, 1982.

3 JH Plumb, *The New York Times Book Review*, 18 February, 1979.

4 For a discussion of historians' response to Orientalism, see the essays in "Orientalism Twenty Years On", a special section of *The American Historical Review* 105, 2000.

5 *International Review of Middle East Studies* 12, 1980, pp. 544–547.

6 Maxime Rodinson, *Europe and the Mystique of Islam*, trans. Roger Veinus, Seattle: University of Washington Press, 1987, pp. 130–131, n. 3.

7 See "The Road to Morocco", Albert Hourani's review of *Orientalism*, in *The New York Review of Books*, March 8, 1979, but also Gabriel Piterberg's chapter on Hourani and Orientalism in *Middle Eastern Politics and Ideas: A History from Within*, ed. Moshe Ma'oz and Ilan Pappé, London: IB Tauris, 1997; Roger Owen, "The Mysterious Orient", *Monthly Review* 31, 1979.

8 Sadik Jalal al-'Azm, "Orientalism and Orientalism in Reverse", *Khamsin* 8, 1981, pp. 5–26.

9 Ahmad, "Orientalism and After".

10 James Clifford, "On Orientalism", *The Predicament of Culture: Twentieth-Century Ethnography, Literature, and Art*, Cambridge, MA: Harvard University Press, 1988, ch. 11. 18 Edward W Said, "Orientalism Reconsidered", in *Europe and its Others*, ed. Francis Barker, Peter Hulme, Margaret Iversen and Diana Loxley, vol. I, Colchester: University of Essex, 1985; also published in Race & Class 27, 1985, pp. 1–15, and in Alexander Lyon Macfie, ed., Orientalism: A Reader, New York: New York University Press, 2000, ch. 35.

11 Edward W Said, "Orientalism Reconsidered", *Europe and its Others*, ed. Francis Barker, Peter Hulme, Margaret Iversen and Diana Loxley, vol. 1, Colchester: University of Essex, 1985; also published in *Race & Class* 27, 1985: 1–15, and in Alexander Lyon Macfie, ed., *Orientalism: A Reader*, New York: New York University Press, 2000, ch. 35.

INTERVIEW: NEGAR AZIMI
SENIOR EDITOR, *BIDOUN*

Negar Azimi is senior editor of the New York-based magazine *Bidoun*. She has written extensively on culture and politics in the Middle East and is a regular contributor to several publications, including *The New York Times Magazine* and *The Nation*. Before moving to the US she worked as a curatorial assistant at the Townhouse Gallery and as a curator of the Van Leo Collection at the American University in Cairo.

BIDOUN DECLARES ITS FOCUS AS THE MIDDLE EAST YET TAKES IN ART, CULTURAL EVENTS AND CRITICISM FROM ACROSS THE WORLD. THERE SEEMS TO BE A BLURRING OF BOUNDARIES BETWEEN CULTURES AS DIALOGUES FROM WILDLY DIFFERENT POSITIONS AND ORIGINS RUB UP AGAINST EACH OTHER. IS THIS PART OF A DELIBERATE MANIFESTO FOR THE MAGAZINE, OR A NATURAL RESULT OF TRYING TO CAPTURE THE CULTURAL IDENTITY OF SUCH A DIVERSE AND SHIFTING GEOGRAPHICAL REGION?

The Middle East is simply a point of departure for us—it's where we started out. But in that way, it's only a departure point, a confusing geography that raises many questions for us about how one can begin to talk about a place, and how one can begin to talk about culture in a locale that, as you say, is always in flux. So yes, we are interested in the guy with the German name who grew up in Delhi with his mother, who is a Calcuttan Jew via Baghdad. That peculiar lineage, incidentally, describes one of our favourite writers. In fact all of us have grown up in between places. It seems more and more the rule rather than the exception. The blurring you mention is not intentional, it just is what it is.

THE CONTENT OF BIDOUN IS IN STARK CONTRAST TO THE IMAGE OF MIDDLE-EASTERN CULTURE THAT OFTEN APPEARS IN THE PRESS IN THE WEST, EVEN TODAY. WHY DO YOU THINK THERE IS STILL SUCH A VACUUM BETWEEN INTERNATIONAL PRECONCEPTIONS AND THE REALITY OF CULTURAL PRODUCTION AS IT ACTUALLY EXISTS?

I doubt the problem of 'mainstream' representations of the Middle East in the Western press or really any press is going anywhere anytime soon. I mean, it's just too tempting. Liberation movements, imagined clashes between tradition and modernity, oppressed women who must hide in claustrophobic homes to read Nabakov! All of it lends itself to hysterical Hollywood narratives and also facile morality tales—which is in part why it is so politically expedient. But the hysterical reading is also not particular to the Middle East. I am sure that many Americans still think of Japan as the land of the geisha or imagine that entire

meals are built around pieces of sushi named after California. You need a mainstream to have an alternative to it, and I suppose that this is in part where *Bidoun* comes in. That said, our vision is not a corrective one. The clichés are just as real as the rest. Our version of the Middle East does not claim to be any more accurate than anyone else's. It's just one more version to add to the mix.

BIDOUN RAN A 'PULP' ISSUE IN 2008. SOME OF THE MATERIAL COLLATED BY YOUR ART DIRECTOR BABAK RADBOY IS SURPRISINGLY REVELATORY. THERE IS ALSO SOMETHING A BIT PULPY ABOUT THE FEEL AND LOOK OF BIDOUN ITSELF, IF NOT IN THE CONVENTIONAL SENSE. DO YOU THINK THERE IS MUCH TO LEARN FROM THE 'PULP' IN TODAY'S SOCIETY?

Pulp is the stuff of popular culture. It's what we grew up reading and watching on television and taping to our walls and is as much a part of our inherited vocabulary as toilet paper is. And just as useful. *Bidoun* has always been interested in 'low-culture', for lack of a better rubric. We took that interest to an extreme in the PULP issue by rummaging through the stacks of a West Beirut bookshop. We wanted the issue to be about pulp, but also of it. We can only hope that years from now old issues of PULP end up in second hand bookstalls in Beirut or New York or Tehran and beyond as some sort of strange cultural trace, eliciting the inevitable question: "What exactly happened here?" or better, "What is wrong with these people?"

IN AN EARLY ISSUE YOU RAN A SERIES OF INTERVIEWS WITH INFLUENTIAL NAMES RANGING FROM RESPECTED THINKER HOMI K BHABHA TO MOHAMMED FARES, THE FIRST SYRIAN IN SPACE; IT IS A DIVERSE LIST. EDITORIALLY, TO WHAT EXTENT DOES THE MAGAZINE ALLOW ITSELF TO BE LED BY ITS OWN PERSONAL TASTES?

When it comes to personal taste, we are 100% informed by it. This is a magazine mediated by a handful of people, their experiences, and their particular sensibilities. We suffer sometimes from this notion that we 'should' or 'could' cover this and that—but at the same time, the launch

of other magazines with mandates related to the Middle East in our midst has taken some of that unnecessary pressure off. In this way, we could be more honest about the fact that the world of *Bidoun* as manifest in our pages is a matter of personal taste, as you say. It is simply a magazine of what we find most compelling, interesting, strange, and finally, important.

CRITICAL DISCOURSE SURROUNDING THE MIDDLE EAST ENDLESSLY COMES BACK TO THE ORIENTALIST DEBATE, A DEBATE THAT IS ALSO INTRODUCED IN THE APPENDIX TO THIS VOLUME. IS IT TIME TO PUSH THE DISCUSSION ON, OR WILL THE SPECTRE OF ORIENTALISM ALWAYS BE THERE? DO YOU THINK THERE IS A PRESSURE ON MIDDLE-EASTERN ARTISTS TO EXTEND THEIR WORK OUTWARD TO ITS INTERNATIONAL AUDIENCE AND ANSWER TO ITS PRECONCEPTIONS?

Maybe it's time to rethink Orientalism. Or celebrate it. Or something. I for one have read too many PhD dissertations about how the West has consistently misrepresented the East care of photography or cinema or literature and so on. The Middle-Eastern subject is always a victim in these accounts. I'm more interested in what happened with the history of photography when the Orientalists moved out of cities like Jerusalem or Beirut and their Armenian assistants opened their own studios and pioneered their own styles and traditions and so on. And by the way, this incessant representation/victimisation narrative is not at all Edward Said's fault, but rather, his legacy—how his notion of 'Orientalism' has been appropriated, even hijacked, and rearticulated. Orientalism has become part of our critical vocabulary, it forms the structured taboos many of us surround ourselves with. Even at *Bidoun*, it is why we roll our eyes at the mention of women's issues, why we avoid any trace of the veil in our pages, why we avoid mention of terrorism—mostly unconsciously. I hope we can one day create a space to really come to terms with these taboos. It will be called the 'Vive Orientalism' issue. That is only partly a joke, and is the beginning of a thought that we must see through.

INTERVIEW: ROSE ISSA
FREELANCE CURATOR

Rose Issa is an independent curator, producer and writer specialising in art and film from the Middle East and North Africa. She has curated numerous film festivals and exhibitions, including *Iranian Contemporary Art* at the Barbican Centre, London in 2001.

CONTEMPORARY ART FROM THE MIDDLE EAST IS EVOLVING INTO A CATEGORY OF ITS OWN—MUCH LIKE CHINESE AND INDIAN ART, BOTH OF WHICH HAVE RECENTLY BECOME MORE CLEARLY DEFINED AND SOUGHT AFTER. IS THE FOCUS ON ART FROM THE MIDDLE EAST JUST A PROCESS OF IDENTIFYING WHAT IS ALREADY THERE, OR DOES IT ALSO HAVE TO DO WITH EMERGING MOVEMENTS AND NEW AESTHETIC LANGUAGES?

There were several new wave movements in the Middle East. First in the late 1950s and 60s was the Saqqakhaneh School, a Folk Iranian Pop art group that included artists such as Hossein Zenderoudi, Parviz Tanavoli and Jazeh Tabatabai. This coincided with similar movements after the post-independences in the Arab world. Then Iranian cinema in the late 80s, by blending documentary and fiction, created a genre that is still inspiring visual artists in Iran and the Arab world.

The artists were always there, but what they needed was a bit of encouragement and promotion, plus some financial support, to help them develop their ideas and be more ambitious in scale. The recent Western interest, whether a result of 'politics' or market value, of course brings curators to the region and produces better contacts; better awareness of what international institutions want to display or collect. This is also why the artists of the region have to work much harder in terms of their personal artistic statements, their presentation and quality of execution. Middle-Eastern art has had different aesthetic languages over the decades. In the last 20 years the influence of Iranian cinema, based on what I call the 'real fiction' approach, has encouraged a mix of documentary films and photography mixed with fiction. This has led to a new aesthetic language.

THERE ARE DISTINGUISHED ARTISTS SUCH AS MONIR SHAHROUDY FARMANFARMAIAN—WHO RECENTLY EXPERIENCED A RESURGENCE OF INTEREST IN HER WORK—AND PARVIZ TANAVOLI, WHO BROKE THE RECORD FOR A MIDDLE EASTERN ARTIST AT THE AUCTIONS IN DUBAI LAST YEAR, AND THERE ARE

ACCOMPLISHED DIASPORA ARTISTS SUCH AS MONA HATOUM AND SHIRIN NESHAT, WHO LIVE IN LONDON AND NEW YORK RESPECTIVELY, AND WHO SEEM TO BELONG TO THE CONTEMPORARY CANON, AND NOT NECESSARILY WITH THE EPITHET 'MIDDLE-EASTERN'. IF ONE TRIES TO CATEGORISE ARTISTS FROM THE REGION IT SOON BECOMES IMPOSSIBLE, AS IT IS REALLY A CONSTRUCTED CATEGORY. THE SURGE OF INTEREST IN THIS TOPIC IS OF COURSE A POSITIVE DEVELOPMENT, BUT ARE YOU CONCERNED ABOUT PIGEONHOLING OR INDEED OVER-SIMPLIFYING THE ARTWORK?

Many artists worry about being pigeonholed. However I have not seen a British artist or an American artist being offended by being labelled British or American. So what we have here is a matter of confidence.

I do not worry about pigeonholing, as long as the work is good, because if a work is good it will make it to the international scene, in principle. You need luck, of course. For the last 25 years I managed to give some visibility to artists from the Middle East, and of course no funds were available anywhere in the UK, where I am based, to publish books, catalogues or monographs. So any opportunity at all was a good one, to introduce artists to each other, to public institutions, create links, themes, occasions for modest catalogues, some for future documentation. Now, it seems Western institutions are paying curators to tour the region and fish for talent. Why not? Any excuse is good to bring out new talent and give artists opportunities.

You know, even the artists who made it in the West have mostly used their personal 'Middle-Eastern' stories and aesthetic to shine, to be different from others. Once you are well known you can do anything, and you can do good things because the money is there, the support is there, and you do not need others to promote you any more. The work promotes itself. But the beginning can be tough. For everyone, even young British artists.

IN GENERAL, IT IS OFTEN IMPOSSIBLE TO DISCUSS ART WITHOUT SOMEHOW TOUCHING ON POLITICAL ISSUES, SPECIFICALLY IN THE CASE OF MIDDLE-EASTERN ART. DOES THIS FOCUS ON GEOPOLITICS SOMETIMES MAKE FOR QUITE AN AHISTORICAL VIEW OF ARTISTIC PRACTICES? IRAN, FOR INSTANCE, HAS HAD A VERY DYNAMIC ART HISTORY. WOULD THE MIDDLE-EASTERN ART WORLD ALSO BENEFIT FROM CLOSER ART-HISTORICAL SCRUTINY?

Of course the Middle-Eastern art world could benefit from closer art-historical scrutiny. But Western art history could also profit from a lot of missing and misleading information! How many dictionaries of art include non-Western references? Non-Western films, directors, artists? The art history of the West is quite self-centred and market driven. It has just opened its doors to China, India, the Middle East, the Gulf, mostly because it needs these regions for economic exchange, for profit—and art is one excuse to get a foot through the door. Imagine all that is missing in books published about art history. Even in London few people know about French or Spanish artists.

For a long time people looked at Egypt, or the Islamic world in general, in terms of antiquities, as if its culture died centuries ago. Yet we are here, alive and kicking, maybe with some malaise, but we also have to sort out our histories—our political, colonial, artistic and economic histories, because they are all linked. We in the Middle East are not in post-colonial times; we are deeply in modern colonial times. So things need to be sorted, stories told, published and documented.

Art was always linked to a market, to sponsors, to patrons, and if we do not have patrons, or patron states, then our art history suffers. Also the way in which our histories are told needs to be corrected, and since politicians are not doing this, people hungry for truth ask political questions from artists, because deep down they know what the media gives them is incorrect.

I worked for seven years for the International Rotterdam Film Festival promoting Iranian and

Arab film-makers, and enjoyed every moment of it. I remember one evening a lovely young man came up to me and a group of young film directors from the Middle East who were with me, and said:"I knew there were beautiful people there, but we never see them. Thank you for bringing them to us."To me, that one sentence is a good enough reward for all my years of work.

YOU RECENTLY PUBLISHED A BOOK ON CONTEMPORARY IRANIAN PHOTOGRAPHY. THIS SHOWCASES MANY INTERESTING MIDDLE-EASTERN AND NORTH-AFRICAN ARTISTS WORKING WITH PHOTOGRAPHY AND SEVERAL OF THEM ARE ENGAGED IN DOCUMENTARY PRACTICES, BUT THERE ARE ALSO SOME VERY THOUGHT-PROVOKING PRACTICES THAT DEPLOY THE TRADITIONS OF STUDIO PHOTOGRAPHY. DO YOU THINK PHOTOGRAPHY HAS A SPECIAL SIGNIFICANCE IN IRAN?

Photography came to the forefront in Iran when, right after the 1979 revolution, the universities were closed following the outbreak of the Iran–Iraq war, which American politicians now admit they encouraged Saddam to undertake. This war caused so much unnecessary loss—of human life, the natural environment and architecture—that artists wanted to document their towns, their families, their history. Photography was the easiest and cheapest way to do this. Photography and cinema prospered in the 80s because artists had to document what they could lose the next day. By the time the war ended in 1988, a new generation of artists had access to film and photography schools, cameras, cine cameras and other materials. Today this medium also travels fast and easily, via internet—so it is more accessible.

MANY OF THE ARTISTS YOU HAVE WORKED WITH AS A CURATOR AND WRITER ARE WOMEN, AND NEARLY HALF OF THE ARTISTS IN THIS BOOK ARE WOMEN. THIS SHOULD NOT NECESSARILY BE AN ISSUE, BUT AS POPULAR MISCONCEPTIONS OF THE MIDDLE EAST OFTEN INCLUDE A VIEW OF WOMEN AS BEING DISADVANTAGED AND REPRESSED, IT SEEMS NOTEWORTHY. DO THE CONDITIONS OF PRODUCTION DIFFER SIGNIFICANTLY FOR MALE AND FEMALE ARTISTS, AND DO YOU FIND IT IMPORTANT OR PRODUCTIVE TO THINK ABOUT SEXUAL DIFFERENCES IN RELATION TO ART PRACTICE?

You know, when I introduced women film directors from Iran or the Arab world to the public in London, Rotterdam or Berlin, few in the audience could mention other American or European women directors of the same age. So here is the paradox—Iran, the same country that supposedly represses women, can also produce Samira Makhmalbaf, Rakhshan Bani Etemad, Mania Akbari, and Forouq Farrokhzad, even in the 50s and 60s; while in Tunisia Moufida Tatli took Europe by storm in the mid-90s with *Silences of the Palace*. In Lebanon in the midst of war there came a group of women filmmakers among whom Danielle Arbid (*In the Battlefields of Love*) won the Camera d'Or in Cannes. So we do have shining stars in all fields of art.

Many young Iranian women photographers, some included in my book, went to Afghanistan and Baghdad, in the worst circumstances and at the height of war, by bus—not special US military planes! They documented the life of their neighbours there. These are fantastically courageous young women, and men too, with no financial support. They went out of sheer courage, curiosity and humanity, in order to document. Their talent and hard work transformed them from mere photographers to artists.

So, no, the conditions for women there are not better or worse, even if some women claim it is better for men while others say the opposite. It all depends on whether you have something to say, and how strongly you feel about saying it. I think you produce work because you have something to say, and you have no other choice but to produce. A true artist has no other choice.

WITH THE RISE OF INTEREST IN, AND INDEED THE POPULARITY OF, ART FROM THE MIDDLE EAST, AS WELL AS THE INCREASING NUMBER OF NEW INSTITUTIONS AND EVENTS, HOW DO YOU THINK ART IN THE REGION WILL DEVELOP OVER THE NEXT 10 TO 15 YEARS?

It will develop, then maybe stagnate, and later develop again. Who knows? History will tell. Time always tells. Great movements and moments are rare; we have to capture this moment of attention and give it visibility while we can before the curtain is drawn, or another source of energy or attention takes the media to other spheres. Those with interest in their own culture, or somebody else's culture, will deepen their knowledge. And that is what remains— documents of an era, and great moments of hope.

ANDREW RENTON
CURATOR, ART TLV

Andrew Renton works as an independent curator and is the Director of Curating at Goldsmiths, University of London. In 2008 he curated the first Art TLV, an international art event to be held biannually in Tel Aviv.

IN A RECENT ISSUE OF *FRIEZE* MAGAZINE TEL AVIV IS DESCRIBED AS A VIBRANT URBAN SPACE WITH A BUZZING ART SCENE. CONVERSELY, THE CITY IS ALSO DESCRIBED AS A 'BUBBLE': AS BEING LARGELY DETACHED FROM THE FRAUGHT GEO-POLITICAL SITUATION OF THE REGION. IN RELATION TO THE ART SCENE, IS THIS SOMETHING YOU HAVE EXPERIENCED WORKING IN ISRAEL?

Sometimes it feels as if Tel Aviv is detached not only from the Middle East, but also from Israel itself. It is hardly contested territorially, is entirely secular and, of course, the Modern city, par excellence. It certainly isn't the Holy Land. So much of Israel's self-articulation is through an ancient history and in sacred sites, but Tel Aviv grew out of the sand dunes, from scratch, 100 years ago, and works differently. It's a modern city, and not just because of the thousands of International Style buildings and its sexy beach. It is self-consciously modern. I called my project for the biennial "Open Plan Living", with a nod to several layers of faded ideologies. There is the old kibbutz socialism, the ideological architecture; today it's more a case of Ikea.

But of course you can't forget where you are. The city is marked by sites of tragedy. No-one talks about it because there is an ongoing feeling of exhaustion. Many artists have moved from Jerusalem over the past decade, in part because the main galleries are focused in Tel Aviv, but also to escape what I see as the internal struggle between secular and religious life. Even the post-graduate programme of Bezalel, the first art school, made this dramatically 'post-zionist' move from Jerusalem.

AT A RECENT SYMPOSIUM ON MIDDLE-EASTERN ART AT THE TATE IN LONDON, YOU SAID THAT YOU LEARNT ABOUT PALESTINE THROUGH REPRESENTATIONS IN ISRAELI ART, OR MORE PRECISELY, THROUGH WHAT WAS NOT REPRESENTED IN ISRAELI ART. WHAT CAN WE LEARN FROM THESE OMISSIONS AND HOW DOES IT AFFECT CONTEMPORARY ART PRODUCTION IN ISRAEL TODAY?

My involvement with Israeli art began at a time of enormous political optimism, during the era of the Oslo Accords. There were many, many initiatives to develop Israeli and Palestinian art in parallel. And there was open dialogue. Culture tends to slip under the political radar, and you could get things done; you could sit at the table and you could hang paintings side by side. But today the dialogue is behind the scenes and there is little overt collaboration, understandably, despite a huge desire from the Israeli side. Israelis don't show in Palestinian territories and Palestinians won't show in Israel. Important scholarship is coming out of Israel about Palestinian art, but even that sits uncomfortably within the Palestinian discourse. Israeli museums have tried to show and acquire Palestinian art in recent years, but few are prepared to be represented in this way. Yet. I remain ever the optimist.

ISRAEL PROBABLY SITS MORE UNCOMFORTABLY AMONGST ITS NEIGHBOURS WITHIN THE MIDDLE EAST THAN ANY OTHER COUNTRY IN THE REGION, AND ITS CONSEQUENT PROBLEMS ARE WELL DOCUMENTED. HAVE YOU EXPERIENCED DIFFICULTIES IN GAINING SYMPATHY FOR WHAT YOU ARE TRYING TO DO WITHIN THE CONTEMPORARY ISRAELI ART SCENE?

I think the anomaly is getting worse as the interest in the Middle East art scene increases. In the critical discourse it's not even that Israel doesn't fit, but more a case that it isn't located in the Middle East at all.

I suppose it is not so much about gaining sympathy, but a case of constantly trying to frame Israel as a legitimate site to explore ideas. It is completely counter-intuitive, for example, to propose cultural or academic boycotts in relation to Israel, when those involved in such fields are precisely the people who might serve as agents for change, or at least useful commentary from within. I have to believe in Israel's legitimacy before doing anything. It doesn't mean I like what goes on in the name of the country. I loathe much of the politics, but

that doesn't delegitimise the state. But equally, I feel quite strongly that art should not have to be about the condition of Israel or even critique it. It is political enough to place an object there— whatever the object.

Culturally, Israel always forged links to Europe. I think the most significant fact is that it won the Eurovision Song Contest three times. But it is a very lonely place these days when it comes to cultural exchange. It is no secret that Art TLV, for example, has tried to join forces with the Athens and Istanbul biennials, for example, but post-Gaza it was not welcomed at all. I understand why the Riwaq biennale cannot join forces, but it is heartbreaking. So where else?

ISRAEL INHABITS A STRANGE SPACE AS A 60-YEAR OLD COUNTRY BORN OUT OF DISPLACEMENT, AND IS STILL STRUGGLING WITH THE SAME ISSUES THAT FACED IT AT ITS INCEPTION. HOW DOES THE LIMITED AND FRAUGHT HISTORY OF THE COUNTRY IMPACT THE ART THAT IT PRODUCES?

Strangely, I always felt there was an absence of reference to the troubles in the work I saw. Only in the past five years or so have we seen the appropriation of images from popular media, that one would have assumed a perfect source for contemporary art. I suspect this was because the media themselves could do the job better. The images hit hard enough. Consequently, art addressed other issues. I used to have a theory about Israeli sculpture that it was made out of the old heavy European furniture that the artist's grandparents had dumped in a skip in Jaffa because it didn't fit inside the apartment block. One generation throws it away in the hope of a fresh start, and the next seeks a kind of rootedness in something.

Israel as an idea was always about generating images. The pale weak Jew of European anti-Semitism was recast as tanned and strong and working in the field. I chose a work of Jacob Mishori for Art TLV, which collaged such images. But they were embedded within an abstract painting together with images from lifestyle

magazines. Ideology only goes so far. Artists today don't want to have to deal with this, and many want to evade it entirely. Many were educated in New York or London and refuse to draw a distinction between their practice and that of their colleagues elsewhere. Certainly the least useful Israeli art addresses Israel directly as a subject. Berlin—where many Israeli artists are choosing to live—seems closer in spirit to Tel Aviv than Damascus, Beirut or Ramallah.

THE EARLY, IDEALISTIC IMAGERY OF EARLY 'KIBBUTZ' LANDSCAPE ART SEEMS A FAR CRY FROM WHERE ISRAEL IS TODAY. FROM YOUR EXPERIENCE DOES CONTEMPORARY ISRAELI ART SHOW AN AWARENESS OR ENGAGEMENT WITH THIS ASPECT OF ITS IDEOLOGICAL ART HISTORY?

I guess few young Israeli artists would be marked by an ideology other than pragmatism. That's the way it should be. There needs to be a type of 'business-as-usual' art, without the need to preface anything with an ideological disclaimer.

But there are some very important lessons to be learned from the first generations of art in Israel and Palestine pre-1948. When Bezalel Academy was founded over a hundred years ago, the tradition was a European one, imported into the new-old land. Its founder, the East-European Boris Schatz wanted to immerse himself in the Middle East. But it is an ambiguous type of colonisation. There's a great photograph of him standing outside Bezalel around 1910, dressed in white robes!

I remember Larry Abramson the painter taking me out into the landscape to show just how constructed much of this 'biblical' landscape was. The first Israeli painters saw only what they wanted to see. Larry used to make his students climb a hill and look at the same view of an early Israeli landscape painting. Immediately they saw an abandoned Arab village that was never represented from the same perspective within the painting. There was a kind of painterly looseness, or late-impressionism, that employed style to fudge the issue, literally blurring the

tricky subject. The painters of first generation Zionism had to unsee the view in favour of their idealised landscape.

I see a photographer such as Sharon Ya'ari, for example, as a contemporary antidote to this. He seduces you into the landscape, observing clues to the constructedness of the scene—a pipe or a cable or some piece of debris.

But perhaps the landscape is always destined to be too charged. Yehudit Sasportas also makes landscapes, but they bear no relation at all to Israel. She speaks about the arid view from her parents' home in a concrete block in the desert town of Ashdod. There was a fading tourist poster in her mother's kitchen of some chocolate box scene that provided an alternative view to the one out of the window. Perhaps this is what percolates through her highly articulated forest images. But there isn't a trace of nostalgia within her work; rather a rendering of detachment and strangeness. Perhaps an art that looks awry might be the strongest form of engagement with the impossibility of being in the place.

INTERVIEW: WIJDAN ALI
DIRECTOR, JORDAN NATIONAL GALLERY OF FINE ARTS

Wijdan Ali is a painter and art historian. She has written, edited and contributed to a number of publications on traditional and contemporary art from the Islamic world. She is the founder of the Royal Society of Fine Arts, 1979, and the National Gallery of Fine Arts, 1980, in Jordan, as well as the founder and dean of the faculty of Arts and Design at the University of Jordan, 2001–2005.

YOU HAVE SAID THAT WHEN YOU WERE WORKING IN THE 1960S AND 1970S, IT WAS DIFFICULT TO GAIN INTERNATIONAL EXPOSURE AS A JORDANIAN ARTIST. HOW HAS THIS SITUATION CHANGED, AND WHAT ROLE DO YOU BELIEVE YOUR ESTABLISHMENT OF THE JORDAN NATIONAL GALLERY IN 1980 PLAYED?

It was difficult to gain recognition not only for Jordanian artists but for all artists from the developing world unless they left their own countries and moved to a Western capital, in which case they would be recognised as artists of their adopted country. Since the last decade of the twentieth century, Middle-Eastern, African and Chinese art have gained a sort of notorious recognition and popularity in Western capitals as well as among collectors from the West and the developing world.

I do believe that the Jordan National Gallery has contributed to this awakening for two reasons. One is due to its unique permanent collection that comprises contemporary works from the developing world. The second is the number of exhibitions from its Permanent Collection that have been travelling to various capitals and cities all over the Western hemisphere. The exhibition *Contemporary Art from the Islamic World* held at the Barbican Centre was the first of its kind in the UK. When discussing the catalogue with the authorities at the Barbican they told me that the public had no clue about what contemporary Islamic art meant; hence, instead of a catalogue, I had to come up with a book, for which I was editor and contributor. It contained chapters on the contemporary art movement in 19 countries who were represented in the exhibition. The exhibition 'Breaking the Veils: Women Artists from the Islamic World' was launched in Crete in 2002 and has been on the road since. It was shown in museums and galleries in major European cities including Athens, Paris, Barcelona, Valencia, Rome, Milan, Napoli, Lichtenstein, among others, before going to Australia. Last April it began its USA tour at the Clinton Library in Little Rock and is now showing at the Kennedy Center as part of *Ärabesque: Festival of Art from the Arab World*.

I am sure that this exhibition, alongside the lectures and seminars that accompanied it, has contributed to change the typical stereotype among many Westerners of women living in the Islamic countries.

YOU TRAINED UNDER THE TUTELAGE OF ARTIST MUHANNA DURRA, WHO PIONEERED MODERN ABSTRACTION IN JORDAN. WHAT INFLUENCE DID HE HAVE OVER YOUR SUBSEQUENT PRACTICE?

Durra opened my eyes to abstract painting and made me not only see abstraction in a new light but also understand and appreciate it. He certainly was the main factor for me to take up abstraction in my works in the 1960s and 1970s.

YOU HAVE CONTRIBUTED TO DEBATES ON MIDDLE-EASTERN ART IN MANY PUBLICATIONS AND HAVE FOCUSED ON BOTH TRADITIONAL AND CONTEMPORARY ART PRACTICE. YOUR WORK ALSO SEEMS TO COMBINE THE TWO. HOW IMPORTANT IS TRADITIONAL JORDANIAN ART FOR YOU AS A CONTEMPORARY PRACTITIONER?

I do not believe that my work has any traditional aspect in it. It is true that since the 1990s I have been using calligraphy as well as calligrafitti, which is my own handwriting and scribbling, but the calligraphy is there for its graphic element in the composition as well as its content. I am not a calligrapher, so I do not practice traditional Islamic art, though I wish I could.

YOU HAVE IMPLIED IN THE PAST THAT CULTURAL UNDERSTANDING CAN PLAY A ROLE IN OVERCOMING CONFLICT. DO YOU THINK THAT THE INCREASED GLOBAL INTEREST IN ART FROM THE MIDDLE EAST CAN HELP IN THE DEVELOPMENT OF A MORE COMPLEX UNDERSTANDING OF THE REGION INTERNATIONALLY?

I am a staunch believer that cultural exchange does give a deep insight into the 'Other's' psyche, thus opening new channels, not only of knowledge but also of acceptance and appreciation. In Islamic civilisation, architecture was the means that transferred a message to friends and adversaries— the Dome of the Rock, the Great

Mosque of Qairawan, the Great Mosque of Cordoba are but a few such examples. Today we have many means to communicate with the so-called Other; however, the aesthetics in art, be it visual fine art or music, can reveal the nature of the Other much faster and at times more clearly than audio-visual means. So I also believe that through cultural exchange the concept of peace is humanised and can seem attainable. We look at our enemy and think it is a monster, but when we see a beautiful art work or hear a piece of music by that same enemy we cannot but think that if someone can produce such beauty then it cannot really be all that bad. We might even find some common ground between it and us.

IN WHAT DIRECTION DO YOU THINK THE FUTURE OF ART FROM JORDAN IS HEADING?

In our age of communications and technology they are constantly being exposed to various influences from different sources; Jordanian contemporary art is witnessing many changes of direction and will soon go through an immense revolution, especially at the hands of a generation of young artists. At the Jordan National Gallery there were many ground-breaking exhibitions that gave exposure to its public, especially to the young. The first exhibition of installations in Jordan was held at the Gallery. The first show of works by Picasso in the Arab world was also at the Gallery. I would like to think that throughout almost 30 years the Jordan National Gallery has indeed contributed to introducing new trends, styles and modes to a generation of artists, both young and not so young, who have subsequently embarked on daring experiments in their art works. The political and economic challenges in our region that we all are obliged to face and deal with also has its effect on our art work. Each artist reflects these frustrations in a different way, as is obvious in the socio-political trend of Arab art as well as the Modern Calligraphic style. I believe Jordanian artists are moving towards internationalism and sooner or later will positively contribute to it in their own way and through their own works.

INTERVIEW: SAVITA APTE
CHAIR, ABRAAJ CAPITAL ART PRIZE

Savita Apte is the Chair of the Abraaj Capital Art Prize and Education Director of Art Dubai. A curator and writer, she lectures regularly on South Asian art and is currently a PhD candidate at the School of Oriental and African Studies, University of London.

WHAT WAS THE MOTIVATION BEHIND SETTING UP THE ABRAAJ ART PRIZE?

There really have been no prizes instituted in the past that recognised and rewarded artistic excellence in the Middle East, and prior to the Abraaj Capital Art Prize, there was little or no evidence of corporate sponsorship of the arts either. It was really as a response to a personal passion—that of the CEO of Abraaj Capital—that the prize was set up. From the very beginning it was clear that it was going to have to differentiate itself from other art prizes, but more importantly to respond to the needs of the region. It was envisaged as a way of engaging corporate patronage so that artists as well as the corporate entity could benefit. The award money was generous enough to allow winning artists to create a potentially phenomenal and previously unrealised project. Apart from signing up with commercial galleries, there was little in the region that encouraged artists to think outside their safety zones and to feel connected to the global art world.

WHAT QUALITIES HAVE YOU BEEN LOOKING FOR IN THE ARTISTS/CURATORS DURING THE SELECTION PROCESS?

We have a broad selection committee, with experience from across the art world. As the applications submitted jointly by the international curators and artists from the region outlined project ideas, the first task of the selection committee was to determine which projects could be actualised in the time the artists would have. The second task was also pragmatic: as the final works were going to be part of a corporate collection, the selection committee had to ensure that the works would not involve prohibitive conservation. But primarily the committee looked for innovation both in concept and in the use of medium; for an aesthetic that was rooted in the area and yet transcended the local, for a dream that could be accomplished and for a collaborative project where the curators and artists worked together to push each others' boundaries. The three winners of this inaugural year—Kutlug

Ataman with Cristiana Perella, Nazgol Ansarinia with Leyla Fakhr and Zoulikha Bouabdellah with Carol Solomon—embody all these criteria.

WHAT DO YOU HOPE TO SEE COME OUT OF THE PRIZE?

What we have already seen is an international interest in artists from the MENASA region and we hope that the prize encourages the active exchange of global and local ideas. A wide geographic spread of curators collaborated with regional artists to apply for the prize, which in itself plays a role in opening up the area artistically to a broader audience. We hope the prize encourages even further the role of creativity in the region as well as a recognition of the deeply important role of the artist in society and a pride in regional excellence and innovation. Since the announcement of the winners we discovered that Nazgol and Zoulikha have become role models for other young women artists. In addition several student artists have told us that the prize raised awareness of the role of artists. What was considered a superfluous profession seems to have gained a new respect. We are hoping that in the future this will translate to a vibrant art scene, with museums, galleries, salons, curatorial practices, artists residencies and the like all enlivening the artistic thought-process of the region. We are also hoping that this may be the start of greater corporate involvement in the arts.

THE PRIZE REWARDS BOTH ARTIST AND CURATOR. HOW IMPORTANT IS THE ROLE OF THE CURATOR IN THE DEVELOPMENT OF THE ART SCENE IN THE MIDDLE EAST?

To date there has been little curatorial intervention in contemporary Middle Eastern art. Hopefully the inception of the prize has been instrumental in paving the way. The role of the curator is crucial. They are the bridge between the local and the global, contextualising the artist and the work within an increasingly global network of ideologies and practices. This is perfectly illustrated in the collaboration of Zoulikha Bouabdellah and Carol Solomon. Carol has helped Zoulikha to work out

the process and the best medium and has been both a calming and an encouraging influence on Zoulikha. Most importantly Carol's curatorial experience is as evident in the work as Zoulikha's artistic ingenuity.

HAVE YOU SEEN CHANGES IN THE MIDDLE EAST ART SCENE AS IT HAS BECOME INCREASINGLY SUBJECT TO INTERNATIONAL ATTENTION AND FINANCIAL INFLUENCE?

There is probably no region in the world that has not to some extent been influenced by the internationalisation of art and its markets. Many artists in the Middle East have caught the sense of immediacy that the confluence of art commerce, the search for novelty and art world celebrity bestows on a region. Even in an established art world these are not easy matters to negotiate; in an emerging art scene they are even more difficult as there are no experienced people to help. The rapid expansion of auction house activities catapulted art from the region onto the consciousness of the wider art world. This too had its advantages and disadvantages. Whilst there was a certain transparency of pricing, often artists were forced to produce work rapidly to meet accelerating demands sometimes at the cost of quality. On the positive side there has been an explosion of exhibition spaces, publications and critical discourse—all of which enhance artistic thought and production.

INTERVIEW: JOHN MARTIN
DIRECTOR, ART DUBAI

John Martin is director and co-founder of Art Dubai. He has been involved with the London contemporary art world for 16 years and continues to run a gallery there.

HOW DID ART DUBAI FIRST COME ABOUT AND HOW HAS IT DEVELOPED?

Art Dubai actually began as the Gulf Art Fair in 2007, but my business partner Ben Floyd first suggested the idea as early as 2005 and on a visit to the Film Festival that December, I felt we had found the perfect venue at the Madinat Jumeirah. In the first year our priority was to establish the credibility of the event, particularly in terms of quality and intellectual content. The 40 galleries taking part were selected from over 150 applications, and the seriousness with which the galleries took the event was matched by our partnership with the Dubai International Financial Centre (DIFC), a link that gave us the resources to create the Global Art Forum, a talks programme that attracted artists and curators from around the world. Since then we have expanded the fair with more participating galleries and further talks programmes, performances, book launches, sculptures, installations, video programmes and tours around the fair and the city. The 2009 fair, which took place alongside the Ninth Sharjah Biennial, was a great success for us; it featured the most extensive programme of contemporary art events ever to take place in the United Arab Emirates and attracted over 5000 international visitors.

WHAT IS THE DRIVING FORCE BEHIND THE SELECTION PROCESS FOR THE FAIR? IS IT PURELY COMMERCE OR DOES IT HAVE A BROADER AGENDA?

The selection process involves a committee of seven international gallery owners. We create a shortlist from about 300 proposals, and try to keep a balance between established international galleries and younger, emerging galleries. The final selection process then looks in more depth at their exhibition proposals, the proposed artists and ultimately makes further enquiries about the reputation of the galleries with collectors, the quality of the catalogues they produce and their commitment to their artists. our aim is to create a diverse, stimulating and well-balanced international fair of exceptional quality and an event that visitors will enjoy.

DO YOU FEEL ART DUBAI HAS HAD A DIRECT IMPACT ON ARTISTS LIVING AND WORKING IN THE MIDDLE EAST?

Primarily Art Dubai is no more than a meeting place (some people might call it a market place, but as more than half the events are non-commercial I prefer calling it a meeting place). As a major international event it has become an essential place to be for anyone involved in the art scene in the Middle East. For us, the value of the fair lies in the opportunities it creates and the possibilities that can arise out of it; gallerists will meet new collectors; curators, critics and collectors discover new artists, and in turn seeds will be sown for lasting friendships and collaborations. There was clearly a huge need for an event like this in the region and our aim now is to keep it as relevant and as accessible as possible, without ever compromising our high standards.

ART DUBAI OFFERS A PLATFORM FOR CUTTING-EDGE CONTEMPORARY ART. WHAT ROLE DOES TRADITIONAL MIDDLE-EASTERN ART PLAY IN THE FAIR, AND HAS IT INFLUENCED THE MORE CONCEPTUAL ARTISTS OPERATING TODAY?

Traditional art continues to have a far greater influence on younger, cutting-edge artists than many outside observers would immediately think. Critics love creating inflexible divisions between painting, sculpture and new media; in reality the links that exist between art across eras, geographies and traditions usually unravels any neat categorisation by art historians. The whole history of modernism is a series of reactions against the work of previous artists—but this is by no means a destructive process, and I would not even say that it is disrespectful. It is entirely a part of the evolution of art, something that allows it to change and remain relevant. The question also brings up a very interesting idea about how artists today consider their own work alongside earlier artists, some whose work stretches back over thousands of years. For instance, a great recent exhibition in Paris called Picasso and the Masters clearly shows the enormous influence—even competitiveness— that Picasso felt towards earlier artists like Velasquez, Ingres and Goya.

He was not ridiculing their work; he reopened a dialogue with these earlier painters, and in pitting himself against them he made their ideas relevant to another generation.

IS CENSORSHIP A PROBLEM AT THE DUBAI ART FAIR, AND HAS THE SCOPE OF THE FAIR HAD ANY POSITIVE EFFECTS IN THIS AREA?

All the galleries and artists participating in the fair understand that in an Islamic country, certain images would be considered offensive. It is not an issue of censorship as no specific authorities come round to censor the work. It is left to the common sense of the galleries and artists. I don't think it has made any impact to the innovative and experimental work that Art Dubai tries to encourage. In a more global culture our understanding of what constitutes censorship has to take into account a much greater need for understanding and respect between Western and non-Western cultures. So long as artists have the freedom to express themselves and create work, there will always be a way to bring their work into the public domain. We don't consider the age restrictions placed on films as censorship and I don't think the restrictions on some artworks for religious reasons is censorship either. In a world where artworks are destroyed or banned, artists and writers regularly imprisoned, killed and tortured, we must remain focused on the essence of censorship and not use the term lightly.

INTERVIEW: GERHARD HAUPT AND PAT BINDER
EDITORS, *NAFAS ART MAGAZINE*

Dr Gerhard Haupt and Pat Binder set up *Universes in Universe—Worlds of Art* as an independent web project for the visual arts, in particular Africa, Asia and Latin America, in 1997. It later expanded to include *Nafas*, a web-based magazine focusing on the Middle East, which has since become the most exhaustive online resource for information about artistic output in the region.

NAFAS ART MAGAZINE PROVIDES THE MOST EXHAUSTIVE AND UP-TO-DATE COMMENTARY ON CONTEMPORARY MIDDLE-EASTERN ART ONLINE. WHAT PROMPTED YOU TO SET IT UP?

In 2002, as part of their wider push for encouraging European-Islamic dialogue the German Institute for Foreign Cultural Relations (IFA) asked us if we would dedicate a special area of our website *Universes in Universe* to the 'Islamic World'. After considering various possible approaches we came up with the idea of an online magazine based on direct cooperation with the protagonists in and from the region, as well as with specialists around the world. *Nafas Art Magazine* confronts homogeneous views—not only in the 'West'—of a supposed 'Islamic World' with a rich diversity of individual artistic positions. By doing this, the magazine aims to increase the awareness of the endless variety of cultural, religious, social, personal and other contexts that exist in the region, which spans from the Maghreb to Southeast Asia, from Central Asia to the Middle East.

WHEN YOU ORIGINALLY SET UP *NAFAS*, IT WAS CALLED *CONTEMPORARY ART FROM THE ISLAMIC WORLD*. WHAT PROMPTED YOU TO RECONSIDER IT?

In full consciousness of its questionable status, we took up a widely used term that suggests a generalising view of the countries and regions that have a majority Muslim population. We wanted to speak to stereotypical ideas in order to deconstruct them by confronting them with works by artists who do not fit the usual clichés. We have repeatedly underscored—and in the course of the years also demonstrated with articles and works—that the point of this project is to foster not only a differentiated perception of artistic practices, but also of the complex reality of life in the so-called 'Islamic world'. This is primarily done by presenting a large number of individual artistic positions behind which a broad range of personal, cultural, religious, social and other contexts become visible. While the strategy of using the first title functioned quite well as far as the audience in the 'West' is concerned, it sometimes caused unease,

especially among artists who did not want to be categorised by a label tied to a religion.

For this reason, we decided to give the online magazine a less limiting title. In fact, the process of renaming already began in 2006, when we curated the *Nafas* exhibition for the IFA Galleries in Berlin and Stuttgart, the conceptual starting point of which was this magazine. If you ask people who speak Arabic, Farsi, Urdu, Malay, or Indonesian what they understand by the word *nafas*, you get almost identical answers: breath, breathing. A variation with the same origin is the Turkish nefes. The root of the word is nafs, which means 'self' or 'soul' in Arabic. We chose *Nafas* as the title and metaphor for the concept and framework of this project not only because the word is present with similar meanings in many of the countries included in the magazine, but also because it is etymologically tied to the existence of the individual, and even some of its derivations can be directly applied to creative work.

We realised much later that *Nafas* as a title complements and rounds up the name of our encompassing website *Universes in Universe*, which points out the universal values within all the cultures and individuals, defending at the same time their uniqueness, despite of all the interactions and influences as a result of globalisation.

THIS VOLUME RAISES SIMILAR QUESTIONS OF CATEGORISATION AND INCLUSION WITH ITS TITLE CONTEMPORARY ART FROM THE MIDDLE EAST. HOW DO YOU APPROACH AND DEAL WITH SUCH ISSUES EDITORIALLY WITHIN *NAFAS*? WHERE DO YOU DRAW YOUR BOUNDARIES?

Based on the conceptual approach we have just been discussing, *Nafas* focuses on contemporary whose essential point of origin or reference is in the so-called Islamic World. This also includes the work of artists who live elsewhere, but who see their cultural home in these countries and regions. But beyond this, with *Nafas* we aim to contribute to a real dialogue among cultures, understood as communication between

individuals from different cultural realms who grant each other self-determined and also changing identities, and who do not deduce these, as rigid constructs, from the mere origin of the other.

HAVE THEIR BEEN ANY DEFINING MOMENTS IN THE FIRST SIX YEARS OF YOUR ONLINE PUBLICATION?

Two weeks after the launch of the online magazine, we were able to present it at the Symposium of the Sharjah Biennial 2003, which allowed us to increase and strengthen our direct contacts to the art scene in the Middle East very fast. The Sharjah Biennial had invited us, expecting that we would include the event in the Biennial's section of *Universes in Universe*, which we did extensively by showing works from 71 artists. The 2003 edition was in fact a ground-breaking turning point for the Sharjah Biennial, with far-reaching effects for the arts in the whole Gulf region. From 2003 on—when there were very few foreign guests in Sharjah because of the start of the Iraq War —and in the following editions up to the current one, *Universes in Universe* has contributed substantially to give the event visibility and to make it known internationally. In this case it became clear how beneficial and effective the interrelation between the *Nafas Art Magazine* and the other sections of *Universes in Universe* are.

Another moment was in 2006, when—thanks to a grant of the German Federal Cultural Foundation—we could start the Arabic version of the magazine, allowing all the contents translated and made available in Arabic as well as English and German. Since then, we have been able reach a wider audience in the Arabic World, as well as being easily available to art schools, universities and schools in Arabic countries.

DO YOU THINK THERE ARE ANY SPECIFIC ADVANTAGES TO COVERING ART FROM THIS DIVERSE REGION ONLINE AS OPPOSED TO IN TRADITIONAL PRINT?

Of course we know the value and importance of physical publications. However, we prefer an

online version of the magazine because we see fundamental advantages in web publication. We certainly reach a far larger audience than a comparable print publication might. The *Nafas Art Magazine* is visited by more than 25,000 different computers every month, around 43% of which are located in countries of the so-called Islamic World. It also allows us to react immediately to current exhibitions and events. Besides the trilinguality of all the contributions, it is important that all published contents remain permanently accessible in an online archive systematically ordered according to sections, countries and artists, and with this, the amount of content available for free expands constantly—another benefit of the online system. And of course an online magazine is less expensive to produce, since the high print and distribution expenses disappear, meaning that the bulk of our budget can go towards content.

HAVE YOU NOTICED ANY CHANGES IN RUNNING THE MAGAZINE AS INTEREST IN ART FROM THE MIDDLE EAST HAS INCREASED DURING THE LAST FEW YEARS?

Without doubt, the interest in contemporary art from the Middle East has strikingly increased in the last years, and this is not simply a temporary or politically motivated development. The tighter the fabric of information about the art from this region is made available, the more notable becomes its vitality, and the quality and diversity of strong individual artistic positions.

CONTRIBUTORS

NAT MULLER

Nat Muller is an independent curator and critic based in Rotterdam. Her main interests include media and art in the Middle East and she recently spent nine months in Cairo as the first curator in residence of the Townhouse Gallery. She holds a BA in English Literature from Tel Aviv University and an MA in Literature from Sussex University.

LINDSEY MOORE

Lindsey Moore is the author of *Arab, Muslim, Woman: Voice and Vision in Postcolonial Literature and Film*, Routledge, 2008, and a lecturer in English Literature at Lancaster University. Her research areas include postcolonial theory, visual media and feminist theory.

TJ DEMOS

TJ Demos is a critic and lecturer in the Department of History of Art, University College London. Demos writes widely on modern and contemporary art and his most recent book is *The Exiles of Marcel Duchamp*, MIT Press, 2007. He is currently working on a book on contemporary art and globalisation.

SUZANNE COTTER

Suzanne Cotter has been Senior Curator and Deputy Director at Modern Art Oxford since 2002 and has previously organised exhibitions at the Hayward Gallery, the Whitechapel and at the Serpentine Gallery. Her distinguished career as a curator includes the 2006 exhibition *Out of Beirut* and she also edited the book of the same name.

CHRISTINE ANTAYA

Christine Antaya is a freelance writer and translator based in London. She holds an MA in History of Art from University College London.

ARTIST BIOGRAPHIES

LIDA ABDUL
Afghan, b. 1973 in Kabul. Lives and works in Kabul and Los Angeles, USA
EDUCATION
2000 MFA University of California, Irvine, USA
1998 BA Philosophy, California State University, Fullerton, USA
1997 BA Political Science, California State University, Fullerton, USA
SELECTED GROUP EXHIBITIONS
2007 Global Feminisms, Brooklyn Museum, New York, USA
2006 Sao Paulo Biennial, Brazil
2006 Singapore Biennial, Singapore
2005 Video Lounge, South London Gallery, London, UK
SELECTED SOLO EXHIBITIONS
2006 Lida Abdul, Giorgio Persano Gallery, Torino, Italy
2006 Lida Abdul, Pino Pascali Contemporary Art Museum, Polignano, Italy
2005 Venice Biennale, Italy

ARWA ABOUON
Libyan, b. 1982. Lives and works in Canada
EDUCATION
BFA, Design Art/Photography, Concordia University, Montreal, Canada
SELECTED GROUP EXHIBITIONS
2007 'Anybody', Art House Gallery, Tripoli, Libya
2006 'Figure/Ground: Four Women and their Surroundings',
 The Third Line Gallery, Dubai, UAE
2004 'Take My Picture', VAV Gallery, Montreal, Canada

MALIHEH AFNAN
Iranian, b. 1935 in Haifa, Palestine. Lives and works in the UK
EDUCATION
1955 BA American University of Beirut
SELECTED SOLO EXHIBITIONS
2000 England & Co, London, UK
1994 Théâtre de Beyrouth, Beirut, Lebanon
1987 Galerie Arcadia, Paris, France
1980 Galerie Brigitte Schehadé, Paris, France
1978 Galerie Principe—Anne Merlet, Paris, France
SELECTED GROUP EXHIBITIONS
2008 Routes, Waterhouse & Dodd, London, UK
2007 The Dance of Quill and Ink, The State Hermitage Museum, St. Petersburg, Russia
2006 Word into Art, The British Museum, London, UK
1986 Salon Comparisons, Grand Palais, Paris, France
1973 Young Artists Exhibition sponsored by the United Nations,
 New York, USA
1971 Centre D'Art de Beyrouth Gallery, Beirut, Lebanon

TAREK AL GHOUSSEIN
Palestinian/Kuwaiti, b. 1962 in Kuwait. Lives and works in UAE
EDUCATION
1989 MA Photography, University of New Mexico, Albuquerque, USA
1985 BA Photography, New York University, New York, USA
SELECTED GROUP EXHIBITIONS
2008 New Ends, Old Beginnings, Blue Coat Gallery, Liverpool, UK
2008 The Jerusalem Show, edition 0.1, Al-Ma'mal Foundation for Contemporary
 Art, Jerusalem, Palestine
2008 Dubai Next, Vitra Design Museum, Zaha Hadid Fire Station,
 Weil um Rhein, Germany
SELECTED SOLO EXHIBITIONS
2009 D Series, The Third Line Gallery, Dubai, UAE

WIJDAN ALI
Jordanian, b. 1939 in Baghdad, Iraq. Lives and works in Amman
EDUCATION
1993 Ph.D., Islamic Art, School of Oriental and African Studies (SOAS), University of
 London, England.
1990 MA Islamic Art, SOAS, University of London
1961 BA History, Lebanese American University, Beirut, Lebanon
SELECTED GROUP EXHIBITIONS
1994 Laila Shawa: The Walls of Gaza and Wijdan: Calligraphic Abstractions,
 The October Gallery, London, UK
1993 Re-creations, Le Centre Culturel Francais, Amman, Jordan
1993 Sixth Asian Art Biennial, Dhaka, Bangladesh
SELECTED SOLO EXHIBITIONS
2001 al-Riwaq Gallery Manama, Bahrain
1993 Calligraphy in Watercolour, The Gallery, Amman, Jordan
1979 Middle East Institute, Washington DC, USA

SHIRIN ALIABADI
Iranian, b. 1973 in Tehran
EDUCATION
Art History and Art, University of Paris, France
SELECTED GROUP EXHIBITIONS
2008 Art Dubai, part of The Third Line booth, Dubai, UAE
2004 Far Near Distance, House of World Cultures, Berlin
SELECTED SOLO EXHIBITIONS
2006 Room installation, I3 Vanak st. Gallery, January, Tehran
2006 Operation Supermarket, collaboration with Farhad Moshiri,
 The Counter Gallery, London

AYAD ALKADHI
Iraqi, b. 1972 in Baghdad. Lives and works in New York, USA
EDUCATION
2004 MFA Tisch School of Art, New York, USA
SELECTED GROUP EXHIBITIONS
2009 Translation/Tarjama, Queens Museum of Art, New York, USA
2009 Einstein on Witherspoon Street: Expressions for Social Justice.
The Bronfman Center Gallery, New York, USA
2008 Iraqi Artists in Exile, The Station Museum, Houston, USA
SELECTED SOLO EXHIBITIONS
1999 Aeotea Gallery, Auckland, New Zealand

DOA ALY
Egyptian, b. 1976 in Cairo. Lives and works there
EDUCATION
2001 BA painting, Faculty of Fine Arts in Cairo, Egypt
SELECTED GROUP EXHIBITIONS:
2009 VacuumNoise, Trafo House of Contemporary Art, Budapest, Hungary
2007 In Focus, Tate Modern, London, UK
 The Maghreb Connection, Movements of life across North Africa, Centre d´Art
 Contemporain Geneve, Geneva, Switzerland
2006 Snap Judgments—New Positions in Contemporary African Photography,
 International, Center of Photography, New York, USA
SELECTED SOLO EXHIBITIONS:
2003 Doa Aly, Townhouse Gallery, Cairo, Egypt

GHADA AMER
Egyptian, b. 1963 in Cairo. Lives and works in New York, USA
EDUCATION
1989 MFA Ecole Pilote Internationale d'Art et de Recherche,
 Villa Arson, Nice, France
1986 BFA Ecole Pilote Internationale d'Art et de Recherche,
 Villa Arson, Nice, France
SELECTED GROUP EXHIBITIONS
2007 Global Feminisms, Brooklyn Museum, New York, USA
2006 Without Boundary, Museum of Modern Art, New York, USA
2000 Whitney Biennial, New York, USA
1999 Venice Biennale, Italy
1995 Istanbul Biennale, Turkey
SELECTED SOLO EXHIBITIONS
2008 Ghada Amer: Love Has No End, Brooklyn Museum, New York, USA
2006 Ghada Amer, Gagosian Gallery, New York, New York, USA
2000 Ghada Amer Drawings, Anadil Gallery, Jerusalem, Israel
1997 Ghada Amer, Espace Karim Francis, Cairo, Egypt
1993 Ghada Amer, Galerie Météo, Paris, France

HALEH ANVARI
Iranian, b. 1962 in Tehran. Lives and works there
SELECTED GROUP EXHIBITIONS
2008 15 Minutes Photographs, Etemad Gallery, Tehran, Iran
SELECTED SOLO EXHIBITIONS
2006 Chador-dadar Photographs, Etemad Gallery, Tehran, Iran

FEREYDOUN AVE
Iranian, b. 1945 in Tehran. Lives and works in Tehran and Paris, France
EDUCATION
1969-1970 New York University, Film School, New York, USA
1964 University of the Seven Seas, Orange, USA
1963-1969 Arizona State University, Tempe, USA
SELECTED GROUP EXHIBITIONS
2009 Malekeh Nayiny and Fereydoun Ave - Demons and D-artboards, Rossi & Rossi,
 London, UK
2008 Creek Art Fair, Dubai, UAE
SELECTED SOLO EXHIBITIONS
2007 Lal Dahlias, B21 Progressive Art Gallery, Dubai, UAE

YTO BARRADA
Moroccan, b. 1971 in Paris, France. Lives and works in Paris and Tangier
SELECTED GROUP EXHIBITIONS
2009 Transmission Interrupted, Modern Art Oxford, UK
2009 Face of Our Time, SFMOMA, San Francisco, USA
2008 Snap Judgments—New positions in Contemporary African
 Photography, Stedelijk Museum, Amsterdam, Netherlands
2007 Venice Biennale, Italy
SELECTED SOLO EXHIBITIONS
2004 Witte de With Center for Contemporary Art, Paris, France
2001 Galerie Delacroix, Tangier, Morocco

ANNABEL DAOU
Lebanese, b. 1967 in Beirut. Lives and works in New York, USA
EDUCATION
1989 BA Barnard College, Columbia University, USA
SELECTED GROUP EXHIBITIONS
2006 The Dreamland Artist's Club, presented by Creative Time,
 Coney Island, New York, USA
1998 Scratch, Rachel Harris Gallery, Fort Worth, Texas, USA
SELECTED SOLO EXHIBITIONS
2007 A Book of Hours, Gallery Joe, Philadelphia, USA
2006 America, Josee Bienvenu Gallery, New York, USA
2001 Slipping, Conduit Gallery, Dallas, Texas, USA
1997 Fleshpots, Entwistle Gallery, London, UK

HASSAN DARSI
Moroccan, b. 1961 in Casablanca, Morocco. Lives and works there
SELECTED GROUP EXHIBITIONS
2008 In the desert of modernity, Haus der Kulturen der Welt,
 Berlin, Germany
2007 Galerie Venise Cadre, Casablanca, Morocco
SELECTED SOLO EXHIBITIONS
2009 Portraits de Familles, La source du Lion, Casablanca, Morocco

AFSHIN DEHKORDI
Iranian, b. 1975 in Tehran. Lives and works in Woking, UK
EDUCATION
1997 BA Mathematics, University College London, UK
SELECTED GROUP EXHIBITIONS
2008 Urban Jealousy Biennale, Amsterdam, Netherlands
2007 Jen Bekman Gallery HHS Group exhibition, New York City, US
2007 Reloading Images group exhibition, Berlin
2006 Stop Moving exhibition, London, UK

OSAMA ESID
Syrian, b. 1970 in Damascus, Syria. Lives and works in USA
EDUCATION
1994 Fashion & design in Damascus and Beirut, Lebanon
1992 Technical Institute of Damascus, Syria
SELECTED GROUP EXHIBITIONS
2008 Art Dubai
2008 Fes International photo exhibition, Fes, Morocco
2005 Pink Palace, Cairo-Atelier Gallery, Cairo, Egypt
SELECTED SOLO EXHIBITIONS
2007 Orientalism and Stereotype. Cairo workers and street photography studio Teatro
 Cómico Principal, Cordoba, Spain
2007 The Egyptian Experiment, Palace of Contemporary Art Cairo, Egypt
2006 Nostalgia, Portrait Gallery Cairo, Egypt

LALLA ESSAYDI
Moroccan, b. 1956. Lives and works in Boston, USA
EDUCATION
2003 MFA School of the Museum of Fine Arts, Boston
1999 BFA Tufts University, Massachusetts, USA
SELECTED GROUP EXHIBITIONS
2008 Girls on the Verge: Portraits of Adolescence, Chicago Art Institute, USA
2007 On the Wall: Aperture Foundation 2005/06, New York, USA
2006 NAZAR, IFA Gallery, Berlin, Germany
2002 Group Photography show, Museum of Fine Arts, Boston, USA
SELECTED SOLO EXHIBITIONS
2008 Crossroads, Waterhouse & Dodd, London, UK
2005 Converging Territories, Columbus Museum of Art, Ohio, USA

MONIR SHAHROUDY FARMANFARMAIAN
Iranian, b. 1924 in Qazvin. Lives and works in Tehran
EDUCATION
1951 Cornell University, Ithaca, USA
1949 Parsons School of Design, New York, USA
1946 Faculty of Fine Art, Tehran, Iran
SELECTED GROUP EXHIBITIONS
2009 Living Traditions, National Art Gallery Pakistan, Islamabad, Pakistan
2008 Art Dubai, Third Line booth, UAE
2008 Routes, Waterhouse & Dodd, London, UK
SELECTED SOLO EXHIBITIONS
2009 Recollection: Works by Monir Shahroudy Farmanfarmaian, The Third Line,
 Dubai, UAE
2008 'Geometry of Hope', Leighton House Museum, London, UK
2006 Victoria and Albert Museum, London, UK
1975 Jacques Kaplan Gallery, New York and Washington DC, USA

GOLNAZ FATHI
Iranian, b. 1972 in Tehran. Lives and works there
EDUCATION
2003 3-month scholarship at the Cite Internationale des Arts,
 Paris, France
1996 Diploma in Iranian Calligraphy, Iran Calligraphy Association
1995 BA Graphic design, Azad Art University, Tehran
SELECTED GROUP EXHIBITIONS
2005 Espace SD, Beirut, Lebanon
2004 Depot Square Gallery, Boston, USA
2001 Maison du Livre, Brussels, Belgium
2000 AZTECA Gallery, Madrid, Spain
SELECTED SOLO EXHIBITIONS
2005 Third Line Gallery, Dubai
2005 ESPACE SD, Beirut, Lebanon
2004 Agence Le Carre Bleu, Paris, France
2004 L'Oeil du Huit Gallery, Paris, France
2004 Golestan Gallery, Tehran, Iran

MOUNIR FATMI

Moroccan, b. 1970 in Tangier. Lives and works in Paris

EDUCATION

1991 School of Fine Arts, Rome, Italy

1989 School of Fine Arts, Casablanca, Morocco

SELECTED GROUP EXHIBITIONS

2009 Out of Line, Lombard-Freid Projects, New York, USA

2007 52nd International Venice Biennale, Venice, Italy

2005 Africa Remix: Contemporary Art of a Continent, Hayward Gallery, London, UK

SELECTED SOLO EXHIBITIONS

2007 Fuck Architects: chapter I, Lombard-Freid Projects, New York, USA

2004 He who Laughs last laughs longest, Centre d'art contemporain le Parvis, Ibos, France

SHADI GHADIRIAN

Iranian, b. 1974 in Tehran, Iran. Lives and works there

EDUCATION

BA, Photohraphy, Azad University, Tehran, Iran

SELECTED GROUP EXHIBITIONS

2008 Singapore Biennale

2003 Sharjah Biennale, UAE

SELECTED SOLO EXHIBITIONS

2007 B21 Gallery, Dubai, UAE

BARBAD GOLSHIRI

Iranian, b. 1982 in Tehran. Lives and works there

EDUCATION

2004 BA Painting, The School of Art and Architecture, Azad University, Tehran

SELECTED GROUP EXHIBITIONS

2009 Unveiled; New Art from the Middle East, Saatchi Gallery, London, UK

SELECTED SOLO EXHIBITIONS

2009 Video installation, 'Exhibition; (A Twenty-One Thousand, Eight Hundred and Four Minute Unworsenable Aplastic), Göteborgs Konstmuseum, Gothenburg, Sweden

NEDA DANA HAERI

Iranian, b. Shiraz, lives and works in London, UK

SELECTED GROUP EXHIBITIONS

2008 More Better, London, UK

2008 No Unifying Demographic, London, UK

2007 Within and Without, London, UK

KHOSROW HASSANZADEH

Iranian, b. 1963 in Tehran. Lives and works there

EDUCATION

1999 Persian Literature, Azad University, Tehran

1991 Painting, Mojtama-e-Honar University, Tehran

SELECTED GROUP EXHIBITIONS

2006 Word into Art, British Museum, London, UK

2004 Far Near Distance: Contemporary Positions of Iranian Artists, Haus de Kulturen der Welt, Berlin, Germany

2002 Second Exhibition of Iranian Conceptual Art, Tehran Museum of Contemporary Art, Tehran, Iran

SELECTED SOLO EXHIBITIONS

2006 Khosrow Hassanzadeh, B21 Art Gallery, Dubai, UAE

2002 Iranian Printing Art, Iranian Institute for Promotion of Visual Arts, Zagreb, Croatia

1999 Life, War & Art: Paintings of Khosrow Hassanzadeh, Diorama Arts Centre, London, UK

MONA HATOUM

Palestinian, b. 1952 in Beirut. Lives and works in London, UK

EDUCATION

1981 The Slade School of Art, London, UK

1979 The Byam Shaw School of Art, London, UK

1972 Beirut University College, Lebanon

SELECTED GROUP EXHIBITIONS

2009 History of Violence, Haifa Museum of Art, Haifa

2004 Turning Points: 20th Century British Sculpture, Tehran Museum of Contemporary Art, Tehran, Iran

1995 The Turner Prize 1995 exhibition, Tate Gallery, London, UK

SELECTED SOLO EXHIBITIONS

2008 Mona Hatoum, Parasol Unit Foundation of Contemporary Art, London, UK

2004 Mona Hatoum, Hamburger Kunsthalle, Hamburg; Kunstmuseum Bonn; Magasin 3 Stockholm Konsthall, Stockholm, Sweden

1994 Mona Hatoum, Musée national d'art moderne, Centre Georges Pompidou, Paris, France

HILDA HIARY

Jordanian, b. 1969 in Amman. Lives and works in Amman, Jordan

EDUCATION

2003 BA Fine Art, Zitouna University, Tunisia

SELECTED GROUP EXHIBITIONS

2008 Algerian National Modern Art Museum—L'Art au Feminin, Algeria

2006 Tenth International Cairo Biennale, Cairo, Egypt

2002 Eleventh Asian Art Biennale, Bangladesh

SELECTED SOLO EXHIBITIONS

2007 XVA Gallery UAE, Dubai, UAE

2002 Culture Street Gallery, Amman, Jordan

SHIRAZEH HOUSHIARY

Iranian, b. 1955 in Shiraz. Lives and works in London, UK
EDUCATION
1979 Chelsea School of Art, London, UK
SELECTED GROUP EXHIBITIONS
2008 Tropismi-Valentina Moncada, Arte Contemporanea, Rome, Italy
2007 What Is Painting? - Contemporary Art from the Collection, Museum of Modern Art, New York, USA
2003 From Dust to Dusk - International exhibition of contemporary art, Kunsthal Charlottenborg, Copenhagen, Denmark
SELECTED SOLO EXHIBITIONS
2007 Douglas Hyde Gallery, Dublin, Ireland
2003 Lehmann Maupin Gallery, New York, USA
1993 Shirazeh Houshiary: Dancing Around My Ghost, Camden Arts Centre, London, UK

DANI KARAVAN

Israeli, b. 1930 in Tel Aviv. Lives and works in Tel Aviv, Paris and Florence
EDUCATION
1943–1949 Studied art in Tel Aviv with the painters Avni, Steimatsky, Streichmann and Marcel Janco as well as at the Academy of Fine Arts of Bezalel in Jerusalem with the painter Ardon
SELECTED GROUP EXHIBITIONS
2004 Writing Images Ideas—Walter Benjamin and the Art of the Present Day, Haus am Waldsee, Berlin, Germany
2001 'Requiem for the Staircase', group exhibition, CCCB, Barcelona, Spain
SELECTED SOLO EXHIBITIONS
2005 Dani Karavan: drawings and sculptures-Galerie Jeanne Bucher, Paris, France
2002 Dani Karavan Site Specific Works, Moscow State Museum of Architecture, Moscow, Russia

AMAL KENAWY

Egyptian, b. 1974 in Cairo. Lives and works there
EDUCATION
1999 BA painting, Faculty of Fine Arts, Cairo, Egypt
SELECTED GROUP EXHIBITIONS
2008 You will be Killed, Ifa Gallery Berlin, Germany
2005 Home Works III - A Forum on Cultural Practices, Beirut, Lebanon
SELECTED SOLO EXHIBITIONS
2008 La Bank Gallery, Paris, France
2007 Darat El Funun, Amman, Jordan
2007 Angels Dream, Town house gallery, Cairo, Egypt

AFSHAN KETABCHI

Iranian, b. 1966 in Tehran. Lives and works there
SELECTED GROUP EXHIBITIONS
2005 Western Biennale of Art - John Natsoulas Center for the Arts, Davis, USA
2002 The NewArt Exhibition - Tehran Museum of Contemporary Art, Tehran, Iran
SELECTED SOLO EXHIBITIONS
2003 Pure Look, Simple Smile, Iranian Artist Forum
2000 Y2K Tehran

AHLAM LEMSEFFER

Moroccan, b. 1950, in El Jadida
SELECTED GROUP EXHIBITIONS
2006 Tenth Cairo Biennale, Egypt
2007 24th Alexandria Biennale for Mediterranean Countries, Alexandria
2007 Galerie Bab Rouah, Rabat
SELECTED SOLO EXHIBITIONS
2008 Interactions, French Institute, Casablanca, Morocco
1997 Galerie IRIS, Madrid, Spain

NJA MAHDAOUI

Tunisian, b. 1937 in Tunis
EDUCATION
Academia Santa Andrea, Rome, Italy
1967 Ecole du Louvre, Paris, France
SELECTED GROUP EXHIBITIONS
2009 Perspectives: Arab & Iranian Modern Masters, Saatchi Gallery, London, UK
2008 Routes, Waterhouse & Dodd, London, UK
2006 Word into Art, British Museum, London, UK
SELECTED SOLO EXHIBITIONS
2008 Dar Al Funoon, Kuwait City, Kuwait

FARHAD MOSHIRI

Iranian, b. 1963 in Shiraz
EDUCATION
1984 CALARTS (California Institute of the Arts), Valencia, California, USA
SELECTED GROUP EXHIBITIONS
2006 Word into Art, British Museum, London, UK
2004 Far Near Distance, House of World Cultures, Berlin, Germany
2003 Rooseum Center for Contemporary Art, Malmo, Sweden
1993 Painting Biennial of Tehran, Museum of Contemporary Art, Tehran, Iran
SELECTED SOLO EXHIBITIONS
2007 The Third Line Gallery, Dubaim UAE
2004 Kashya Hildebrand Gallery, New York, USA
2003 Leighton House Museum, London, UK
2001 Heaven, installation, 13 Gallery, Tehran, Iran
1992 Painting exhibition, Seyhoun Gallery, Tehran, Iran

LAILA MURAYWID

Syrian, b.1956 in Damascus. Lives and works in Paris, France
SELECTED GROUP EXHIBITIONS

2008 Routes, Waterhouse & Dodd, London, UK

2007 Mediterraneo: A Sea that Unites, Italian Cultural Institute, London, UK

1994 Forces of change, National Museum of Women in the Arts, Washington DC, USA

YOUSSEF NABIL

Egyptian, b. 1972 in Cairo and lives and works in New York, USA
EDUCATION

2003 The Seydou Keita Prize for Portraiture, Rencontres Africaines de la Photographie, Bamako, Mali

SELECTED GROUP EXHIBITIONS

2008 Last of the Dictionary Men, BALTIC Centre for Contemporary Art, Newcastle, UK

2006 Word into Art, The British Museum, London, UK

SELECTED SOLO EXHIBITIONS

2009 I Will Go to Paradise, The Third Line Gallery, Dubai, UAE

2007 Sleep in my arms, Michael Stevenson Gallery, Cape Town, South Africa

2001 Obsesiones, Centro de la Imagen, Mexico City, Mexico

1999 Premiere, Cairo-Berlin Art Gallery, Cairo, Egypt

SHIRIN NESHAT

Iranian, b. 1957 in Qazvin, Iran. Lives and works in New York, USA
EDUCATION

1982 MFA University of Calif. of Berkeley, USA

1981 MA University of Calif. of Berkeley, USA

1979 BA University of Calif. of Berkeley, USA

SELECTED GROUP EXHIBITIONS

2007 After The Revolution: Women Who Transformed Contemporary Art, Dorsky Gallery Curatorial Programs, Long Island City, New York, USA

2005 Translation, Palais de Tokyo, Paris, France

2004 Far Near Distance, House of World Culture, Berlin, Germany

2003 Bill Viola and Shirin Neshat, The State Hermitage Museum, St Petersburg, Russia

2002 New Art, Tehran Museum of Contemporary Art, Iran

SELECTED SOLO EXHIBITIONS

2008 Shirin Neshat, Gladstone Gallery, New York, US

2006 Shirin Neshat, Stedelijk Museum CS, Amsterdam, Netherlands

2001 Musée d'Art Contemporain de Montreal, Canada

2000 Serpentine Gallery, London, UK

1998 Tate Gallery, London, UK

BABAK RADBOY

Iranian, b. 1983 in Tehran. Lives and works in New York, USA
Creative director of *Bidoun* magazine
SELECTED GROUP EXHIBITIONS

2008 Object Salon, White Space Gallery, London, UK

SARA RAHBAR

Iranian, b. 1976 in Tehran. Lives and works in New York, USA and Iran
EDUCATION

2004-2005 Fine Art, Central Saint Martins Collage of Art and Design, London, UK

1996-2000 Design, The Fashion Institute of Technology, New York, USA

SELECTED GROUP EXHIBITIONS

2009 Unveiled; New Art from the Middle East, Saatchi Gallery, London, UK

2008 Persian Arts Festival: Weaving the Common Thread: Perspectives from Iranian Artists, Queens Museum of Art, New York, USA

2008 On a clear day you can see forever, Hilger Contemporary, Vienna, Austria

MARWAN RECHMAOUI

Lebanese, b. 1964 in Beirut. Lives and works there
SELECTED GROUP EXHIBITIONS

2009 Unveiled; New Art from the Middle East, Saatchi Gallery, London, UK

2008 Art Now in Lebanon, Amman, Jordan

2003 Contemporary Arab Representations, Bildmuseet, Umeå, Sweden

2003 Home Works II: A Forum on Cultural Practices, Beirut, Lebanon

SELECTED SOLO EXHIBITIONS

1998 Centre Culturel Français, Beirut, Lebanon

FAISAL SAMRA

Saudi Arabian, b. 1980 in Bahrain. Lives and works there
EDUCATION

1983 Fine Arts and Graphics Consultant, Insitut Du Monde Arabe, Paris, France

1980 Honours degree, Ecole National Superieure des Beaux Arts, Paris, France

SELECTED GROUP EXHIBITIONS

2002 Institut du monde Arabe (Kinda collection), Paris, France

2001 Eighth International Cairo Biennale, Egypt

1998 Liberté 98 United Nations exhibition, New York, USA

1991 Seoul International Festival of Art, Seoul, Korea

SELECTED SOLO EXHIBITIONS

2000 Rochan Gallery, Jeddah, Saudi Arabia

1996 Darat Al-Funun, Amman, Jordan

1996 Vision Gallery, Manama, Bahrain

1974 Cultural & Artists Association, Riyadh, Saudi Arabia

HRAIR SARKISSIAN

Syrian, b. 1973 in Damascus. Lives and works there
SELECTED GROUP EXHIBITIONS

2008 New Ends, Old Beginnings, Open Eye Gallery, Edinburgh, UK

2008 Constructio Galería Antonio de Barnola, Barcelona, Spain

SELECTED SOLO EXHIBITIONS

2004 Le Creux de l'enfer - centre d'art contemporain, Thiers, France

YEHUDIT SASPORTAS

Israeli, b. 1969 in Ashdod. Lives and works in Tel Aviv

EDUCATION

1999 MFA Bezalel Academy of Art and Design in collaboration with the Hebrew University, Jerusalem, Israel

1993 BFA Bezalel Academy of Art and Design, Jerusalem, Israel

SELECTED GROUP EXHIBITIONS

2007 Venice Biennale, Italy

2006 Raft of the Medusa, National Museum, Warsaw, Poland

2005 25 Jahre Sammlung Deutsche Bank, Deutsche Guggenheim, Berlin, Germany

2002 Personal Plans, Kunsthalle, Basel, Switzerland

1999 Istanbul Biennale, Turkey

1998 Women Artists in Israel, Haifa Museum of Art, Israel

SELECTED SOLO EXHIBITIONS

2009 Yehudit Sasportas, DA2 Domus Atrium, Salamanca, Spain

2005 The Pomegranate Orchard, Galerie EIGEN + ART, Berlin, Germany

2004 The Guardian of the Pearl's Shadow Part 1, Sommer Contemporary Art, Tel Aviv, Israel

2004 The Guardian of the Pearl's Shadow Part 2, Tilton Gallery, Los Angeles, USA

2000 The Carpenter and the Seamstress, Tel Aviv Museum of Art, Tel Aviv, Israel

1994 Yehudit Sasportas, Jerusalem Artists' House, Jerusalem, Israel

SHIRANA SHAHBAZI

Iranian, b. 1974 in Tehran. Lives in Zürich, Switzerland

SELECTED GROUP EXHIBITIONS

2006 Without Boundary; Seventeen Ways of Looking, Museum of Modern Art, New York, USA

2005 Homeworks III, Ashkal Alwan Forum, Beirut, Lebanon

2004 Far Near Distance, Haus der Kulturen der Welt, Berlin, Germany

SELECTED SOLO EXHIBITIONS

2007 New Commission, The Curve, Barbican Centre, London, UK

2006 Milton Keynes Gallery, Milton Keynes, UK

2005 Silk Road Gallery, Tehran, Iran

MOHAMMED AL SHAMMAREY

Iraqi, b. 1962 in Baghdad

2002 Participation of the Spanish Cultural Centre

SELECTED GROUP EXHIBITIONS

2004 Ninth Cairo International Biennale, Egypt

2003 Before, After, Now: Visions of Iraq, Deluxe Gallery, London, UK

2000 From the Ocean to the Gulf and Beyond: Modern Arab Art, Jordan National Gallery of Fine Arts, Amman, Jordan

1990 Modern Iraqi Art Exhibition, Baghdad, Iraq

SELECTED SOLO EXHIBITIONS

2004 Dar Al Anda Gallery, Amman, Jordan

2002 Orfaly Gallery, Amman, Jordan

1998 Al Balqa' Open Gallery, Jordan

LAILA SHAWA

Palestinian, b. 1940 in Gaza. Lives and works in London, UK

1964 Italian Accademia di Belle Arti, Rome, Italy
Accademia San Giacomo, Rome, Italy

SELECTED GROUP EXHIBITIONS

1994 Forces of Change: Artists of the Arab World, The National Museum of Women in the Arts, Washington DC, USA

1989 Contemporary Art from the Islamic World, Barbican Centre, London, UK

SELECTED SOLO EXHIBITIONS

1992 The Gallery, London, UK

1990 The National Art Gallery, Amman, Jordan

1968 The Book Centre Gallery, Beirut, Lebanon

PARVIZ TANAVOLI

Iranian, b. 1937 in Tehran. Lives and works in Vancouver, Canada

EDUCATION

1959 Accademia di Belle Arti in Brera, Milan, Italy

1957 Accademia di Belle Arti in Carrara, Italy

1956 Tehran School of Arts, Tehran, Iran

SELECTED GROUP EXHIBITIONS

2006 Word into Art, The British Museum, London, UK

2001 Iranian Contemporary Art, Barbican Centre, London, UK

1999 Atrium Public Gallery, Vancouver, Canada

SELECTED SOLO EXHIBITIONS

2006 Elliott Louis Gallery, Vancouver, Canada

2003 Retrospective, Tehran Museum of Contemporary Art, Tehran, Iran

1989 Rudolf Mangisch Galerie, Zurich, Switzerland

1971 Martin Gallery, Minneapolis, USA

BIBLIOGRAPHY

SUGGESTED READING

ABDOH, SALAR, *Urban Iran*, New York: Mark Batty, 2008

ABEDINI, REZA, *New Visual Culture of Modern Iran*, London: Mark Batty, 2006

ALDRED, CYRIL, *Egyptian Art (World of Art)*, London: Thames and Hudson, 1985

ALI, WIJDAN, *Contemporary Art from the Islamic World*, Essex: Scorpion Press, on behalf of the Royal Society of Fine Arts, Amman, Jordan, 1987

ALI, WIJDAN, *Modern Islamic Art: Development and Continuity*, Gainesville: University Press of Florida, 1997

AMER, GHADA, and ANDREW RENTON, *Ghada Amer*, New York: Gagosian Gallery, 2004

BAILEY, DAVID A and GILANE TAWADROS, eds, *Veil: Veiling, Representation and Contemporary Art*, London: Institute of International Visual Arts, 2003

BALAGHI, SHIVA, and LYN GUMPERT, eds, *Picturing Iran, Art, Society and Revolution*, London: IB Taurus

BARRADA, YTO, *A Life Full of Holes*, London: ABP Autograph Editions, 2005

BLAIR, SHEILA, *Islamic Calligraphy*, Edinburgh: Edinburgh University Press, 2006

BOULLATA, KAMAL, *Palestinian Art From 1850 to the Present*, London: Saqi Books, 2009

CHELKOWSKI, PETER, AND HAMID DABASHI, *Staging a Revolution: the Art of Persuasion in the Islamic Republic of Iran*, New York: New York University Press, 1999.

DAVID, CATHERINE, ed., *Tamáss 1: Contemporary Arab Representations—Beirut/Lebanon*, Rotterdam: Witte de With, 2004

DAVID, CATHERINE, ed., *Tamáss 2: Contemporary Arab Representations—Cairo*, Rotterdam: Witte de With, 2002

ESSAYDI, LALLA, *Converging Territories*, London: Power House Books, 2005

FARAJ, MAYSALOUN, *Strokes Of Genius: Contemporary Iraqi Art*, London: Saqi Books, 2001

FARMANFARMAIAN, MONIR, *A Mirror Garden*, London: Vintage, 2008

HALASA, MALU, MAZIAR, BAHARI, *Transit Tehran: Young Iran and Its Inspirations*, London: Garnet Publishing, 2008

ISSA, ROSE, *Shadi Ghadirian: A Woman Photographer from Iran*, London: Saqi Books, 2009

ISSA, ROSE, *Iranian Photography Now*, Hatje Cantz, 2008

ISSA, ROSE, *Iranian Contemporary Art*, London: Booth-Clibborn Editions, 2001

JAVAHERIAN, FARYAR, *Thirty Years of Solitude: A Selection of Iranian Contemporary Films and Photographs by Women*, Cambridge: New Hall, 2007

KARNOUK, LILIANE, *Modern Egyptian Art 1910–2003*, American University in Cairo Press, 2005

KRAVAGNA, CHRISTIAN, *Emily Jacir: Belongings*, Folio, 2004

LLOYD, FRAN, ed., *Contemporary Arab Women's Art: Dialogues of the Present*, London: IB Tauris, 1999

MOORE, LINDSEY, *Arab, Muslim, Woman: Voice and Vision in Postcolonial Literature and Film*, London: Routledge, 2008

NESHAT, SHIRIN, *Women of Allah*, Marco Noire Editore, 1999

SHABOUT, NADA, *Modern Arab Art: Formation of Arab Aesthetics*, Gainesville: University Press of Florida, 2007

TOHME, CHRISTINE, ET AL, *Home works: a forum on cultural practices in the region: Egypt, Iran, Iraq, Lebanon, Palestine and Syria*, Beirut: Lebanese Association for Plastic Arts, 2003

WILSON-GOLDIE, KAELEN, et al, *Home works II: a forum on cultural practices*, Beirut: Lebanese Association for Plastic Arts, 2005

WINEGAR, JESSICA, *Creative Reckonings: The Politics of Art and Culture in Contemporary Egypt*, Stanford: Stanford University Press, 2006

WITTNER, BEN, SASCHA THOMAS, NICOLAS BOURQUIN, eds, *Arabesque: Graphic Design from the Arab World and Persia*, Berlin: Gestalten 2008

ZOLGHADR, TIRDAD, ed, *Ethnic Marketing*, Zürich: JRP Ringier, 2007

ESSAYS AND ARTICLES

BULLER, RACHEL EPP, "Un/Veiled: Feminist Art from the Arab/ Muslim Diaspora", in *Al-Raida*, XXIV, nos. 116–117, Winter/ Spring 2007

DADI, IFTIKHAR, "Rethinking Calligraphic Modernism", *Discrepant Abstraction*, ed. Kobena Mercer, MIT Press, 2006

DEMOS, TJ, "Out of Beirut", *ArtForum*, October 2006

DEMOS, TJ, "Life Full of Holes", *Grey Room*, no. 24, Fall 2006

DEMOS, TJ, "Curating Beirut: a conversation on the politics of representation", in *Art Journal*, Summer 2007

GALLOIS, CHRISTOPHE, "Interview with Mounir Fatmi", *Metropolis M*, no. 6, 2009

GARB, TAMAR, "Hairlines", de Zegher and Armstrong, *Women Artists at the Millenium*, MIT Press, 2006

HERRSCHAFT, FELICIA, "Democratic Articulations of Cultural Identity: The Arts in Afghanistan", *Asien*, 104, July 2007

MALIK, AMNA, "Dialogues Between Orientalism and Modernism: Shirin Neshat's Women of Allah (1993–)", in Jeffrey, Celina and Minissale, Gregory, eds, *Global and Local Art Histories*, Newcastle: Cambridge Scholars Pub., 2007

MOORE, LINDSEY, "Frayed Connections, Fraught Projections: The Troubling Work of Shirin Neshat", *Women: A Cultural Review* 13: 1, Spring 2002

ROGERS, SARAH, "Out of History: Postwar Art in Beirut", *Art Journal*, Summer 2007

EXHIBITION CATALOGUES

AFNAN, MALIHEH, *Maliheh Afnan Retrospective*, England & Co, London

CARAGLIANO, RENATA et al, eds, *Lida Abdul*, Naples: Museo Archeologico Nazionale, 2008

Contemporary Art in Syria, Damascus: Gallery Atassi, 1998

DAFTARI, FERESHTEH, *Without Boundary: Seventeen Ways of Looking*, New York: Museum of Modern Art, 2007

GARB, TAMAR, JO GLENCROSS and JANINE ANTONI, *Mona Hatoum*, Salamanca: Centro de Arte de Salamanca, 2002

GURALNIK, NEHAMA, *Ghada Amer: Intimate Confessions*, Tel Aviv: Tel Aviv Museum of Art, 2000

Harem Fantasies and New Scheherazades, Barcelona: Centre de Cultura Contemporània de Barcelona, 2003

MENDELSOHN, AMITAI, ed., *Real Time: Art in Israel 1998–2008*, Jerusalem: The Israel Museum, 2008

MOAVEN DOUST, DARIUSH, *Aletheia: The Real of Concealment*, Göteborg: Göteborgs Konstmuseum, 2003

MOSHIRI, FARHAD, *Welcome*, London: Kashya Hildebrand Gallery, 2005

Occidente visto desde Oriente, exhibition catalogue, Barcelona: CCCB, Instituto de Ediciones de la Diputación de Barcelona, 2005

PERSEKIAN, JACK, et al., *DisORIENTation: Contemporary Arab Artists from the Middle East*, Berlin: Haus der Kulturen der Welt, 2003

PORTER, VENETIA, *Word into Art: Artists from the Modern Middle East*, London: The British Museum Press, 2006

SAID, EDWARD, and SHEENA WAGSTAFF, *Mona Hatoum: The Entire World as a Foreign Land*, London: Tate galley Publishing Ltd, 2000

RAAD, WALID, *Walid Raad: The Atlas Group*, Cologne: Walther Konig, 2008

SHATANAWI, MIRJAM, ed., *Tehran Studio Works: The Art of Khosrow Hassanzadeh*, London: Saqi Books, 2007

TUMARKIN GOODMAN, SUSAN, *Dateline Israel: New Photography and Video Art*, London: Yale University Press, 2007

The Dance of Pen and Ink: Contemporary Art of the Middle East, St Petersburg: State Hermitage Museum, 2007

Unveiled: New Art from the Middle East, London: Booth-Clibborn Editions, 2009

SELECT BIBLIOGRAPHY CITED IN THE BOOK

AHMED, SARA, CLAUDIA CASTANEDA, ANNE-MARIE FORTIER and MIMI SHELLER, "Introduction", *Uprootings/Regroundings: Questions of Home and Migration*, Oxford: Berg, 2003

ALLOULA, MALEK, *The Colonial Harem*, trans. Myrna Godzich and Wlad Godzich, Manchester: Manchester University Press

ANKORI, GANNIT, "'Dis-Orientalisms': Displaced Bodies/ Embodied Displacements in Contemporary Palestinian Art", in Sara Ahmed, Claudia Castaneda, Anne-Marie Fortier and Mimi Sheller, eds, *Uprootings/Regroundings: Questions of Home and Migration*, Oxford: Berg, 2003

BAKALLA, MH, Arabic *Culture through its Language and Literature*, London: Kegan Paul International, 1984

BETTERTON, ROSEMARY, *An Intimate Distance: Women, Artists and the Body*, London: Routledge, 1996

BOER, INGE, *Disorienting Vision: Rereading Stereotypes in French Orientalist Texts and Images*, Amsterdam: Rodopi, 2004

CIXOUS, HÉLÈNE, "Albums and Legends", Mireille Calle-Gruber and Hélène Cixous, *Hélène Cixous, Rootprints: Memory and Life Writing*, London: Routledge, 1997

CIXOUS, HÉLÈNE "My Algeriance", *Stigmata: Escaping Texts*, London: Routledge, 1998

DERRIDA, JACQUES, *Monolingualism of the Other or The Prosthesis of Origin*, trans. Patrick Mensah, Stanford: Stanford University Press, 1998

DERRIDA, JACQUES, *Of Hospitality*, trans. Rachel Bowlby, Stanford: Stanford University Press, 2000

DERRIDA, JACQUES, *The Truth in Painting*, trans. Geoffrey Bennington and Ian McLeod, Chicago: Chicago University Press, 1987

DJEBAR, ASSIA, *So Vast the Prison*, trans. Betty Wing, New York: Seven Stories Press, 2001

ENWEZOR, OKWUI, *Archive Fever: Uses of the Document in Contemporary Art*, New York: Steidl/ICP, 2008

FANON, FRANTZ, "Algeria Unveiled", *A Dying Colonialism*, trans. Haakon Chevalier, London: Writers and Readers Publishing Cooperative, 1980

FORTIER, ANNE-MARIE, *Multicultural Horizons: Diversity and the Limits of the Civil Nation*, London: Routledge, 2008

GRAHAM-BROWN, SARAH, *Images of Women: The Portrayal of Women in Photography of the Middle East*, 1860-1950, London: Quartet, 1988

GREGORY, DEREK, *The Colonial Present: Afghanistan, Palestine, Iraq*, Malden, MA: Blackwell, 2004

GREWAL, INDERPAL, *Home and Harem: Nation, Gender, Empire, and the Cultures of Travel*, London: Leicester University Press, 1996

GREWAL, INDERPAL and CAREN KAPLAN, *Scattered Hegemonies: Postmodernity and Transnational Feminist Practices*, Minneapolis: University of Minnesota Press, 1994

HALL, STUART, "Cultural Identity and Diaspora", Jonathan Rutherford, ed., *Identity: Community, Culture, Difference*, London: Laurence and Wishart, 1990

HILLAUER, REBECCA, Encyclopedia of *Arab Women Filmmakers*, Cairo: American University Press, 2005

KHANNA, RANJANA, *Algeria Cuts: Women and Representation, 1830 to the Present*, Stanford: Stanford University Press, 2008

LAZREG, MARNIA, "Feminism and Difference: The Perils of Writing as a Woman on Women in Algeria", in Marianne Hirsch and Evelyn Fox Keller, eds, *Conflicts in Feminism*, New York: Routledge, 1990

LEWIS, REINA, *Gendering Orientalism: Race, Femininity and Representation*, London: Routledge, 1996

LEWIS, REINA, *Rethinking Orientalism: Women, Travel and the Ottoman Harem*, London: IB Tauris, 2004

MACKENZIE, JOHN M, *Orientalism: History, Theory and the Arts*, Manchester: Manchester University Press, 1995

MELMAN, BILLIE, "The Middle East/Arabia: 'The Cradle of Islam'", Peter Hulme and Tim Youngs, eds, *The Cambridge Companion to Travel Writing*, Cambridge: Cambridge University Press, 2002

MELMAN, BILLIE, *Women's Orients: English Women and the Middle East, 1718–1918: Sexuality, Religion and Work*, Basingstoke: Macmillan, 1992

MOORE, LINDSEY, 'Frayed Connections, Fraught Projections: The Troubling Work of Shirin Neshat', *Women: A Cultural Review* 13: 1, Spring 2002

NOCHLIN, LINDA, *The Politics of Vision: Essays on Nineteenth-Century Art and Society*, NY: Harpers & Row, 1989

RAMADAN, DINA, "Regional Emissaries: Geographical Platforms and the Challenges of Marginalisation in Contemporary Egyptian Art", *Proceedings of Apexart Conference 3*, Honolulu, Hawai, 2004, http://apexart.org/conference/ramadan.htm

EL SAADAWI, NAWAL, *Daughter of Isis: The Autobiography of Nawal el Saadawi*, trans. Sherif Hetata, London: Zed, 1999

SAID, EDWARD, *Orientalism*, London: Penguin, 1978

SAID, EDWARD, "Reflections on Exile", *Reflections on Exile and Other Literary and Cultural Essays*, London: Granta, 2000

SALTI, RASHA, "The Unbearable Weightlessness of Indifference", *Akram Zaatari: The Earth of Endless Secrets*, Portikus, Frankfurt: Galerie Sfeir-Semler, 2008

SARDAR, ZIAUDDIN, *Orientalism*, Buckingham: Open University Press, 1999

SHOHAT, ELLA, *Taboo Memories, Diasporic Voices*, Durham: Duke University Press, 2006

TOUFIC, JALAL, *Two or Three Things I'm Dying to Tell You*, The Post-Apollo Press, Sausalito, California, 2005

VOGL, MARY, *Picturing the Maghreb: Literature, Photography, (Re)presentation*, Lanham, MD: Rowman and Littlefield, 2003

WALL, JEFF "'Marks of Indifference', Aspects of Photography in, or as, Conceptual Art", 1995, originally published in Ann Godlstein and Anne Rorimer, *Reconsidering the Object of Art, 1965–1975*, Los Angeles Museum of Contemporary Art, 1995, reprinted in Douglas Fogle, *The Last Picture Show: Artists Using Photography 1960–1982*, Walker Art Center, Minneapolis, 2003

WANDSCHNEIDER, MIGUEL, *Walid Raad: Culturegest*, Cologne: Walther Konig, 2008

WILSON-GOLDIE, KAELEN, "Archaeology and the Street: The Imagined City in Contemporary Arab Art", *In the Arab World… Now*, ed. Jérôme Sans, Paris: Galerie Enrico Navarra, 2008

YEGENOGLU, MEYDA, *Colonial Fantasies: Towards a Feminist Reading of Orientalism,* Cambridge: Cambridge University Press, 1998

YUVAL-DAVIS, NIRA and FLOYA ANTHIAS, eds, *Woman-Nation-State*, Basingstoke: Macmillan, 1989

WEBSITES

Al-Ma'mal Foundation for Contemporary Art
www.almamalfoundation.org

The Arab Image Foundation
www.fai.org.lb

Ashkal Alwan—The Lebanese Association
for Plastic Arts
www.ashkalalwan.org

Bidoun Magazine
www.bidoun.com

Center for Contemporary Art Afghanistan
www.ccaa.org.af/index.php

Darat Al Funun
www.daratalfunun.org

Mayman Farhat
http://maymanahfarhat.wordpress.com

Nafas
http://universes-in-universe.de/english.htm

INDEX

ACKNOWLEDGEMENTS

This volume would not have been possible without the dedicated help and good will of many people for whom the subject was their passion. First and foremost I would like to thank Christine Antaya, whose contribution to the project helped make it what it is; a particular thanks also to Nat Muller, whose essay set the tone for the volume; and to Lindsey Moore, Suzanne Cotter and TJ Demos for their contributions to the book within the demands of a tight deadline. Thanks also to all the artists included, who without exception were incredibly accommodating and supportive of the project in general.

I would also like to thank Stephen Deuchar in particular for taking time out from his busy schedule to take an in-depth look at the book in progress and give his words of advice.

Many galleries were also extremely supportive throughout the project. Thanks especially to Tarané Ali Khan at the Third Line Gallery in Dubai; Jemimah Patterson and Ray Waterhouse at Waterhouse & Dodd, and Janet Rady at Janet Rady Fine Art, all of whom went beyond the call of duty in providing help and advice. Particular thanks also to Aleya Hamza, Andrew Renton, Chili Hawes at the October Gallery, Nicole Rampa at Kashya Hildebrand, the B21 Gallery, the Silk Road Gallery and White Cube.

At Black Dog, I would like to thank Nikos Kotsopoulos and Aimee Selby for their help throughout, and to Brooke Sperry for her help at the closing stages of the process. And finally, a special thanks to Matt Bucknall, both for his patience and for his elegant and minimal design, which beautifully holds the volume together.

Paul Sloman

الخط الثالث
the third line

WATERHOUSE & DODD CONTEMPORARY
Waterhouse & Dodd Gallery, 26 Cork Street, London W1S 3ND, UK. www.artroutes.com

COLOPHON

© 2009 Black Dog Publishing Limited, London, UK, and the authors. All rights reserved.

Edited by Paul Sloman at Black Dog Publishing.
Designed by Matt Bucknall at Black Dog Publishing.

Black Dog Publishing Limited
10A Acton Street
London WC1X 9NG
info@blackdogonline.com

British Library Cataloguing-in-Publication Data. A CIP record for this book is available from the British Library.

ISBN 978 1 906155 56 8

Black Dog Publishing Limited, London, UK, is an environmentally responsible company. *Contemporary Art in the Middle East: Artworld* is printed on 170 gsm Garda Matt and 120 gsm Dito woodfree offset, both papers are FSC certified.

Cover image: Shadi Ghadirian, From *Be Colourful* Series, 2006, C-print, 60 x 90 cm. Courtesy the artist.

architecture art design
fashion history photography
theory and things

www.blackdogonline.com